# Simplicissimus

## 180 Satirical Drawings from the Famous German Weekly

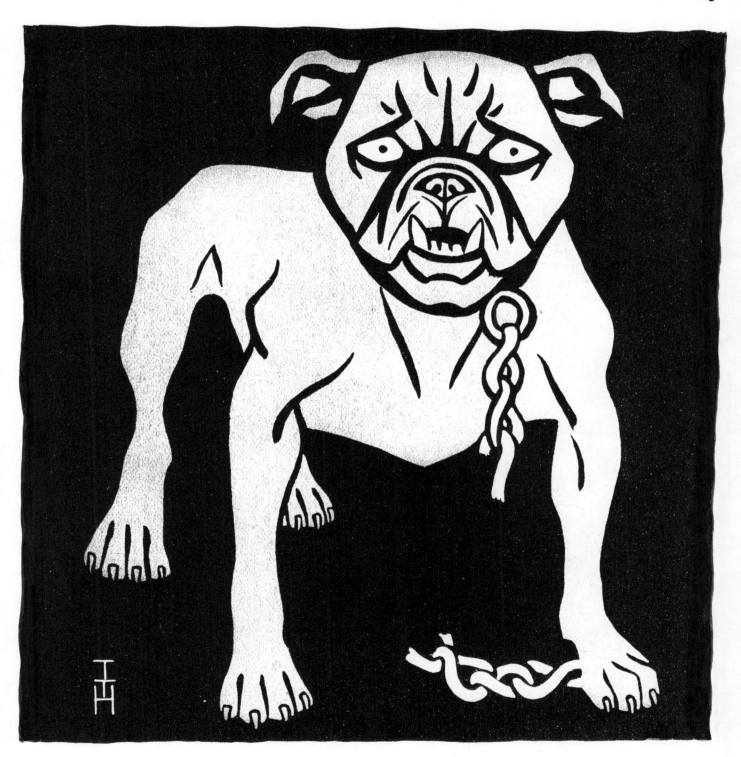

## Selection, Translations and Text by Stanley Appelbaum

Dover Publications, Inc., New York

*Simplicissimus: 180 Satirical Drawings from the Famous German Weekly* is a new work,
first published by Dover Publications, Inc., in 1975.

*International Standard Book Numbers:*
*0-486-23098-8 (paperbound edition)*
*0-486-23099-6 (clothbound edition)*

*Library of Congress Catalog Card Number: 74-79171*

Manufactured in the United States of America
Dover Publications, Inc.
180 Varick Street
New York, N.Y. 10014

# CONTENTS

The color section, which begins on page 1, includes 16 additional drawings by Arnold, Heine, Paul, Reznicek, Thöny and Wilke.

# iNTROduCTiON

One of the greatest picture magazines in the history of journalism, *Simplicissimus* appears in retrospect as a monument of German culture in the first half of the twentieth century. A nationally oriented publication, it nevertheless had contributors from all over Europe and was internationally acclaimed and imitated. Although created as an illustrated literary journal, featuring such writers as Rilke, Schnitzler and Thomas Mann, its art soon became its outstanding feature and its raison d'être. Unlike many other satirical magazines, it printed only drawings of extremely high quality.

The present volume is a selection of 180 drawings by twenty-four artists, chosen from an unbroken run of the magazine's first thirty years (April 1896 to March 1926) and reproduced directly from the original issues. It includes the work of the most important staff artists (T. T. Heine, Gulbransson, Thöny, Arnold), of major artists who were associated with the magazine over long periods (Kubin, Kley, Pascin, Zille), guest artists of the highest caliber (Barlach, Kollwitz, Grosz, Slevogt) and others. The drawings have been selected for their artistic value above all, but an attempt has been made to include pieces that are representative of the magazine's chief themes and preoccupations without suffering from excessive topicality or parochialism.

Even though this volume is intended as an anthology of outstanding drawings and not as a pictorial history of *Simplicissimus,* still it seems right to offer a brief history of the magazine and of the climate in which these works of art originated.

*Der Simpl* (for brevity and variety, it will be handy occasionally to use the pet name by which the magazine was known to its staff and its admirers) was the creation of Albert Langen. A well-to-do Rhinelander born in Antwerp on

July 8, 1869, Langen went to Paris in his early twenties to try his hand at paint-
ing and writing. There he made the acquaintance of many talented Frenchmen
and became an intimate of the important colony of Scandinavian intellectuals
that included Strindberg. Fascinated by the work of Knut Hamsun, Langen
decided to turn publisher in order to bring out the Norwegian's latest
manuscript, the Berlin firm of S. Fischer having rejected it after the unsatisfac-
tory sales of the German-language edition of Hamsun's preceding novel
*Hunger* (now a classic of world literature). Thus in 1893 Hamsun's *Mysterien*
(Mysteries) became the first book published by a great firm that still exists
today (as the Albert Langen-Georg Müller Verlag in Munich).

Langen soon became interested in providing Germany with an illustrated
satirical weekly that might compare with *Punch* or the many lively Parisian
magazines of the time (*Le Rire, Le Chat noir, L'Assiette au beurre, Gil Blas il-
lustré,* etc.). *Kladderadatsch,* which had been created in Berlin in the revolution
year of 1848 and would keep running until 1944, was never strong in the
graphic arts. The time-honored Munich *Fliegende Blätter,* founded in 1844 (it
had published drawings by Moritz von Schwind, Carl Spitzweg, Adolf
Oberländer and, above all, Wilhelm Busch), still had many years ahead of it,
but its striking-power had waned. Germany was ripe for a new approach in this
area. As it turned out, *Pan* beat *Simplicissimus* to the stands by a year or so,
and *Jugend* by three months, but *der Simpl* proved to be worth waiting for.

Part of the delay had been due to problems of funding, but it had also been
important to find the right base of operations (not only for the magazine, but
also for Langen's books, which he wanted to have illustrated). A German-
oriented art magazine could not operate out of Paris, and Leipzig proved to be
too stuffy. The shining light was Munich, one of the great art capitals of
Europe at the turn of the century, battleground of an entrenched Academy and
a kaleidoscope of international trends and experiments, an oasis of
bohemianism all the more piquant for its Bavarian setting of reactionism in
politics and religion. To Munich Langen went to find a ready supply of artists;
in a few years German and foreign artists would flock to Munich because
*Simplicissimus* was there.

The staff of *Fliegende Blätter* yielded up Reznicek, Engl and the artist who
did most to shape the policies of *der Simpl* over the years: Thomas Theodor
Heine. The landscape painters Bruno Paul (who helped to choose the art cadre)
and Reinhold Max Eichler soon joined them, as did the outstanding cartoonists

Thöny and Wilke. Langen's Parisian friendships, too, were to be beneficial to his magazine before long. His Scandinavian connections (he even married a daughter of the Norwegian playwright and patriot Bjørnsterne Bjørnson) brought in, among others, the artists Kittelsen and Blix and, above all, Gulbransson, who became one of the *Simplicissimus* stalwarts. Among the French artists published by *der Simpl* in its earliest years were Steinlen, Chéret and Willette.

Moreover, it would seem as if the above-mentioned Parisian journal *Gil Blas illustré* not only inspired *der Simpl* with its verve, but was also influential in providing it with its name. Gil Blas was the hero of the French writer Alain René Lesage's picaresque novel set in Spain, *L'Histoire de Gil Blas de Santillane* (published between 1715 and 1735). For the title of his own magazine, Langen (with the aid of his staff) chose the name of a German *pícaro*, the hero of the greatest prose work of seventeenth-century Germany, the novel *Der abenteuerliche Simplicissimus teutsch* (1669) by Hans Jakob Christoffel von Grimmelshausen (who also wrote the story on which Brecht based his play *Mother Courage*). In the novel, the clever (though at first naïve and uninformed) Simplicius Simplicissimus undergoes many transformations, but Langen and his people had in mind especially the episode in the character's youth when, pretending to be simpleminded, he becomes a sort of court jester and wittily castigates the failings of all his listeners, whether of high rank or low.

This is clear from the manifesto-poem by staff writer Frank Wedekind (shortly to be notorious as the author of the Lulu plays) that was published anonymously in the first issue of *der Simpl*, dated April 4, 1896. The jester-magazine proclaims itself "free and young and without forebears," its aim being "to strike the lazy nation with hot words." This first issue was run off in the incredibly large printing of 480,000—more for publicity reasons than from optimism. About 10,000 copies were sold. *Simplicissimus* did not set the world on fire immediately, but it was only a matter of weeks or months before it hit its stride and readers, colleagues and rivals everywhere took notice.

It was a handsome magazine physically, much larger than its competitors (10⅝" by 14⅞"), with really good presswork in both black-and-white and color, even in its regular edition (10 pfennige for eight pages, one of which contained ads; the luxury edition, printed on a bright-white coated stock, cost 25 pfennige). The drawings were reproduced by an advanced and expensive zinc-

etching process (many of them bear an engraver's name along with the artist's signature).

Several schools of contemporary art were influential on *der Simpl*'s graphic styles (of course, in slightly popularized form, since this was distinctly a commercial venture): Art Nouveau in its varied manifestations, but less of the "pure" Belgian and French type than of the German *Jugendstil* and the British post-Beardsley versions; assorted Post-Impressionist trends, but especially that of the Nabis; the work of Edvard Munch and other symbolists and "pre-Expressionists"; and, to a great extent, a healthy dose of late nineteenth-century academic art, in which most of the contributors had been trained. These early influences became sacrosanct, owing partly to the longevity of the founding artists and partly to the proprietary, inbred attitudes they developed. The *Simplicissimus* artists were not incapable of growth, younger blood did gain admittance and Expressionism got a showing, but *der Simpl* was not an experimental organ, and such movements as Futurism, Cubism, Dadaism and Surrealism appear in it only as objects of ridicule.

The "hot words" promised in the first issue soon took effect. Perhaps the encouraging growth in circulation was partially due to the (still somewhat mild) measures taken against *der Simpl* by the state almost at once (banning it from railroad cars, destroying its posters in Vienna, etc.). The magazine was viewed officially as immoral, revolutionary and socialistic. A more serious incident occurred in 1898, when Langen published an issue that outspokenly jeered at the Kaiser's pan-Islamic diplomacy in the Palestine region. The responsible artist and author, T. T. Heine and Frank Wedekind, were jailed for six months, and Langen had to escape from Germany, not to return until 1903, and then only upon payment of a heavy fine. But, while never again daring to attack the monarch so directly, *Simplicissimus* continued to lampoon objectionable government policies, the German bureaucracy, the many vestiges of feudalism, the military, the politically reactionary clergy (both Protestant and Catholic), the smug bourgeois and other readily available victims. It maintained its distinctly pro-French policy up to the First World War, but was always hostile to England, especially during the Boer War. Meanwhile its reputation soared, and its circulation in an average week of 1904 reached at least 65,000—some say 85,000.

A "palace revolution" took place in the editorial offices in 1906. Up to then *Simplicissimus* had been owned outright by Langen. Now Heine led a group of

staff artists and writers in a successful demand for profit-sharing and a greater say in the direction of affairs. There was another change as well: in the earliest days, the magazine—that is, Langen—claimed ownership of the original drawings reproduced in its pages and offered them for sale to the public, a certain percentage going to the artist. Now the artists retained ownership of their own works.

The fall of 1908 and spring of 1909 were sad times for *der Simpl*. It lost two of its chief artists, Reznicek and Rudolf Wilke, and its founder-publisher, Langen (April 30, 1909). The rest of the staff, already used to decision-making, carried on without any major problems until the outbreak of the First World War, when one of their most momentous conferences was held. The entire staff felt that Germany was in the right. Some wished to cease publication, since the nation should not be ridiculed in wartime. The other group, led by Heine, won the day: publication would continue, but as a patriotic sheet. This entailed a brusque *volte-face* with regard to France; during the war it was an enemy (even then, however, not so savagely attacked as England), but in the Twenties, too (especially during the occupation of the Rhineland and the Ruhr), it was still depicted as something unclean.

After the war, *Simplicissimus* was in a bad situation (by 1926 its circulation was down to 30,000). Some of its truly liberal subscribers had been alienated by its wartime jingoism; its faithful military readership (which apparently loved to see itself pilloried by Thöny and others) had been dispersed; and the nation's frightful financial crisis was emptying the pockets and altering the standards and outlook of many former lower-middle-class citizens. Furthermore, the magazine never again attained a consistent political viewpoint. It attacked statesmen of all factions, even the most honest and promising—though it did consider the radicals of the right, such as Hitler, to be enemies just as dangerous as the left-wing Communists and Spartacists. As historians of the magazine have pointed out, during the Twenties (and, for the purposes of this anthology, it is early in 1926 that we take leave of *der Simpl*), it was more valuable as a social than as a political commentator, training its guns on the depraved tastes of the time (at least they were so in its eyes), the mindless fads, the selfishness and the lack of traditional values. In this way it is a worthy counterpart of such other German productions of the era as the Brecht-Weill operas.

1933 was another year of decision. Hitler, now in power, could have crushed

the magazine that had mocked him, but he chose to let it continue—partly, it has been suggested, out of affection for his younger days in Munich's bohemian quarter. Yet it would continue emasculated. T. T. Heine fled, to live another fifteen years in exile. Those who remained had to conform to the new standards. *Simplicissimus* became largely a pretty-pretty instrument of propaganda. With Thöny, Gulbransson and Arnold still associated with it (they had joined *der Simpl* in 1897, 1902 and 1907, respectively), publication dragged on until the final issue of September 13, 1944.

A new *Simplicissimus*, with only the name of the old one, commenced publication in 1954, but it was not distinctive enough to hold its own in what was by then a sea of competitors, and it went under in 1967.

But the spirit of the old *Simplicissimus* is very much alive. Its continental European outspokenness on sexual topics and preoccupation with the night side of life could never have appeared in English or American publications of the same period, and these German drawings—some going back to the end of the nineteenth century—strike us as part of our contemporary scene, such is their impudence and unashamedness.

The present anthology is arranged alphabetically by artists' names and chronologically within the work of each artist. The date of the issue in which each drawing appeared is given in square brackets at the end of the English captions. From its second through its ninth years, *Simplicissimus* followed the unfortunate practice of not dating its issues, but only giving them volume (=year) and issue (=week) numbers. In the present book it has been found best to adhere to this system, but for convenience we have added in parentheses the year to which each volume pertains: e.g., Vol. II (1897/8). (Remember that a *Simplicissimus* year began in the first days of April!)

The German headings and captions have been retained as part of the original artwork. The new English captions are intended to be as accurate translations as possible, while avoiding pedantry or hairsplitting. A limited attempt has been made to render into English levels of correctness in the German diction, but none at all to render dialect, even though this is part of the original verbal humor. Readers who know German will get the flavor thus imparted; those who do not would probably lose more than they would gain if a necessarily imperfect or false American counterpart (Southern drawl, Yankee twang, etc.) were used. It should be noted, in general, that many of the Bavarian characters

speak in their own dialect, all of Zille's people speak Berlin dialect, and so on; sometimes one character in a dialogue will speak in standard educated German and the other will reply in dialect.

When captions require some elucidation, brief editorial remarks accompany them within square brackets. Longer explanations, in two or three cases, will be found in the biographical and critical section called "The Artists" that follows this Introduction. In that section we have refrained from discussing the full careers of those artists (like Barlach and Käthe Kollwitz) whose work belongs to universal art history. In those cases we have concentrated on their beginnings and on their specific connection with *Simplicissimus*. We have summarized the careers of the other artists somewhat more fully, while keeping within the bounds of what is essentially a pictorial volume.

The color section, in which six of the twenty-four artists are represented (this section has its own separate alphabetic arrangement), gives some idea of the boldness and originality with which color was handled in the magazine.

# THE ARTISTS

**Karl Arnold** (pp. 1−3 & 17−32). Arnold, an illustrator and painter, was one of the most important artists in the history of *Simplicissimus*. Though the magazine was over ten years old when his work first appeared in its pages (1907) and his most characteristic contributions did not begin until ten years later, when he became a profit-sharing staff artist, he was associated with *der Simpl* until it folded, helping to give it its "look" during the vital Twenties and Thirties, and taking a significant part in policy decisions.

Born on April 1, 1883, in Neustadt near Coburg (Upper Franconia), he moved to Munich at the age of 17. He studied at the Academy there and spent some time in Paris in 1910. By 1913 he was active in artistic groups in Munich, and had already begun to contribute to *der Simpl*, as well as to *Jugend* and *Lustige Blätter*. The captions printed with his drawings were his own.

In the army during World War I, Arnold worked for a service newspaper published in Lille in the German-occupied sector of northern France. From 1917 on, his career was linked to *Simplicissimus*. In the Twenties he corresponded from various European cities, including Berlin (see the *Berlin Scenes*). He was director of *der Simpl* from 1934 to 1936. Ill and relatively inactive in the Forties, he died in Munich on November 29, 1953.

The Arnold drawings reproduced here date from late 1918 to early 1926. The chronological sequence demonstrates the shift in his style from various kinds of shading and hatching to almost pure contours, sometimes with applied areas of flat color. His work in the Twenties is heavily indebted to George Grosz (whose characteristic rugged style was fully in evidence by 1915); the *Berlin Scenes*, of course, are a direct *hommage* to the Berlin-based artist who was Arnold's junior by ten years, but the other drawings, too, are largely a less crude and less

cruel version of Grosz. And not in style only: Arnold shared Grosz's obsession with greed, seaminess and perversion. An interesting feature of Arnold's drawings that may owe something to T. T. Heine's pervasive dog symbolism is his frequent use of lapdogs that reflect the physical and moral traits of their masters in an even more distorted fashion.

**Ernst Barlach** (p. 33). No attempt will be made here to trace with any completeness the minutely documented career of Barlach, who was not only one of the outstanding sculptors of the twentieth century, but was also of great importance as a woodcut artist, lithographer, draftsman and writer of plays and novels.

Barlach was born at Wedel in Holstein on January 2, 1870, and died in Rostock on October 24, 1938. Between 1888 and 1896 he studied art in Hamburg, Dresden and Paris. From 1897 to 1902 he contributed drawings to the magazine *Jugend*. His draftsmanship in these youthful years was remarkable for both virtuosity and variety; Barlach had mastered the decorative intricacies of every contemporary style.

What is loosely known as his artistic "conversion" took place during eight weeks in August and September of 1906, when Barlach visited a brother living in southern Russia. The endless plains and the severe simplicity of the peasants' lives inspired him to emphasize the sobriety and monumentality that had been latent in his earlier work. He soon became well known for his stylized depictions of Russian peasants, both in the round and in drawings and prints that reflected his sculptor's outlook in the rendering of volumes and planes. (The long, loose Russian peasant coat was to envelop many of his figures even in later years.)

It was in 1907 and 1908, shortly after this decisive trip to Russia, that Barlach made his few contributions to *Simplicissimus*. Unfortunately, only one of them was clearly enough printed to warrant inclusion here. No one who is familiar with the religiosity of Barlach's nature will be surprised that he did not hit it off with the staff of *der Simpl*. A letter he wrote to his brother on October 10, 1908, casts an interesting light on the situation:

"I'm now on strike against *Simplicissimus*. Too much work in comparison with the results. I need nervous energy for these little jokes and I don't want to waste it for nothing. They are artists who treat their 'colleagues' like

businessmen. It would be quite possible to draw satirical cartoons for *Simplicissimus* on the subject of its own business operations. Nepotism in the highest degree and tickling of the grosser instincts for purposes of mass circulation."

**Ragnvald Blix** (pp. 34 & 35). Blix was a humorous artist of paramount importance in Norway and Denmark, and for ten years a steady contributor to *Simplicissimus*.

He was born in Oslo (then Christiania) on September 12, 1882. His family was well-to-do. As an artist he was self-taught; Gulbransson was his idol. Blix left Norway in 1903 and spent some time in Paris and Copenhagen. In 1908 influential Norwegians in Munich urged Blix to join them there. He did so and remained on the staff of *Simplicissimus* through 1918.

After the Armistice he returned to Oslo, where he originated the highly regarded humor magazine *Exlex* and edited it from 1919 to 1921. From 1921 on, he worked for *Tidens Tegn* (Signs of the Times) in Oslo (Gulbransson was on the staff, too, from 1922 to 1927) and other Norwegian and Danish publications. He aided T. T. Heine during the latter's stay in Norway while exiled from Germany.

Blix, who was still active in his profession around 1950, died in May of 1958.

**Jules Chéret** (p. 36). Though he was also a designer, draftsman and painter of canvases and murals, Chéret is best remembered as the father of the artistic lithographic poster.

Chéret was born in Paris on May 31, 1836. Poor and without formal art education, he became a master lithographer. A successful poster for the première of Offenbach's *Orpheus in the Underworld* in 1858 did not help Chéret to rise above relative obscurity, but the patronage of the great cosmetics manufacturer Rimmel enabled him to open his own printing shop in 1866. In 1881 he sold the shop to Chaix, staying on as the firm's artistic director. By the Nineties, Chéret's colorful and sprightly posters were world-famous. He died in Nice at a ripe old age on September 23, 1932.

His artistic inspiration came from the works of Turner, Tiepolo and—above all—Watteau. The last-named master was the obvious source for the Carnival Pierrette illustrated here.

**Franz Christophe** (p. 37). This Austrian draftsman and etcher of French descent was born in Vienna on September 23, 1875. A self-taught artist, he did book illustration and contributed drawings to the magazines *Jugend* and *Narrenschiff* (Ship of Fools) as well as to *Simplicissimus*. George Grosz named him as one of the major influences on his own style. Christophe was still living, in Berlin, in 1953. No death date is given in the latest source available to us (1961).

**Reinhold Max Eichler** (pp. 38–44). Eichler, a painter and illustrator, was born on March 4, 1872, in Mutzschen near Hubertusburg in Saxony. His family moved to Dresden when he was nine, and he studied art at the Dresden Academy. In 1893 he moved to Munich, which became his lifelong home.

His specialty was landscape painting; Bruno Paul was one of his friends and colleagues. They both contributed to *Jugend* when it began publication in 1896, and Eichler is credited with the development of that magazine's typical color-illustration style. His contributions to *Simplicissimus* include poetic landscapes and genre scenes like those he did for *Jugend*, but also more humorous and acerb illustrations.

In 1899 Eichler joined the Munich artistic group of idyllic landscape painters known as "die Scholle" (the sod). He died in Munich on March 16, 1947.

A word is in order on his drawing "The Victor of Sadowa" (p. 42). By far the most famous victor of Sadowa was Crown Prince Friedrich Wilhelm of Prussia (later German Emperor as Friedrich III for three months in 1888), who personally directed the decisive victory over Austria in 1866 in a battle fought between the towns of Sadowa (Sadová) and Königgrätz (now Hradec Králové in Czechoslovakia). Yet the seventeenth-century costume in the museum painting, the reference to an ambitious commoner, and the Bavarian flags carried by the children would all seem to point to some earlier military engagement near Sadowa, which was in a combat zone during the Thirty Years' War.

**Joseph Benedikt Engl** (p. 45). Engl was born in Austria—at Schallmoos near Salzburg, on July 2, 1867—but spent practically his whole life in Munich. One historian of *Simplicissimus* speaks of him as "the only artist from Munich itself" on the staff of *der Simpl* in its early days.

He enrolled in the School of Applied Art in 1885. By 1888 he was on the staff

of the magazine *Radfahr-Humor* along with Thöny and Reznicek. Next he worked for the revered old magazine *Fliegende Blätter*, where he had Reznicek and T. T. Heine as colleagues. Meanwhile he continued his art studies in evening classes at the Academy.

Engl's real success and lasting fame were due to his association with *Simplicissimus* from its inception until his premature death, in Munich, on August 25, 1907. He invented the situations and wrote the captions for his drawings. His folksy humor and casual draftsmanship (not as sophisticated as that of other staff artists, more like modern cartoons) soon moved off the magazine's fancier pages and found their own niche on the back advertising pages. But Engl had a faithful following, and many humbler readers of *Simplicissimus* are said to have looked forward week after week to his contribution more than any other.

**George Grosz** (pp. 46–48). Grosz's drawings began to appear in *Simplicissimus* only at the very end of the magazine's first thirty years (anthologized here). Of the four pieces that fall within this time limit, one has been omitted here, since it already appears in Dover's Grosz volume entitled *Love Above All, and Other Drawings*. It has been reported that Grosz might have been represented in *Simplicissimus* even earlier, but that the managing editor had first to overcome T. T. Heine's strong objections to including his work.

Grosz, whose real name was Georg Ehrenfried, was born in Berlin on July 26, 1893. He studied art in Dresden, Berlin and Paris from 1909 to 1913. By 1910 he was already contributing to Berlin-based humor magazines: *Ulk, Lustige Blätter* and *Sporthumor*.

His personal style crystallized by 1915; while still in the army, he was sending drawings and poems to liberal and antiwar publications. In 1916 he had his first album of drawings published by the left-wing firm of Malik in Berlin, which continued to handle his work into the Twenties. Grosz himself remarked that his scratchy line (and surely his raw subject matter) was modeled on restroom and billboard graffiti. But he also acknowledged a debt to the art of Bruno Paul and Franz Christophe, and he was a personal friend and disciple of Theodor Kittelsen.

After the war Grosz became a member for Berlin of the international Dada movement, which sponsored anarchism in art and life. From 1919 to 1924 he

edited the incendiary far-left Berlin humor magazine *Die Pleite* (The Bankrupt-
cy), often incurring fines. Through the rest of the Twenties he was widely
published, finally even in the haughty *Simplicissimus*.

In 1932 Grosz visited New York to teach at the Art Students League. In
1933 he moved to America "for the duration." In his new home the bitterness
and passion that had made his drawings famous were decidedly less welcome,
and Grosz turned increasingly to placid landscape oils and watercolors. For a
while he directed an art school of his own. He died in West Berlin on July 6,
1959, only a month after what was to have been a permanent return to the city
of his birth.

**Olaf Gulbransson** (pp. 49–62). Gulbransson was a book illustrator and a
painter. He did stage and costume design. He created masks for the Munich
marionette theater. He supplied drawings for various humor magazines. But
his reputation rests on his work for *Simplicissimus* and, conversely, it was
largely through his contributions that the magazine became what it was.

Gulbransson was born in Oslo (Christiania) on May 26, 1873. He studied art
in Norway between 1885 and 1890, and was first published, in books and
magazines, in 1892. By the turn of the century he was the recognized master of
humorous drawing in Norway and an inspiration for many other Scandinavian
illustrators.

While in exile from Germany in consequence of the Palestine issue of
*Simplicissimus* (see Introduction, p. x ), Albert Langen, the publisher, con-
tinued to hunt for new talent. In 1902 he sent Gulbransson a most tempting
offer to move to Munich and try out as a full-time artist for *der Simpl*.
Gulbransson was to spend two months in Berlin to learn German (he later
claimed that he learned "danke" and "bitte" at that time). In Munich,
Gulbransson soon proved his worth. He became a fixture on *Simplicissimus*,
and largely a Bavarian at heart.

He spent some time in Berlin during World War I, and from 1922 to 1927
was living in Oslo, working for the humor magazine *Tidens Tegn*. During these
years his connection with *Simplicissimus* was not as close as it had been, but
after his return to Munich he was a loyal contributor and staff member until
the end of the magazine in 1944. He died on September 18, 1958, at his estate
on the Tegernsee in Bavaria.

The present selection of his drawings, ranging from 1903 to 1926, shows a general change in his style from dark, heavily shaded pictures, with strong reminiscences of Edvard Munch, to his most celebrated, purely linear, manner. This trend, however, was not irreversible or without exceptions. Gulbransson was especially noted for his caricatures of well-known personalities. His situation cartoons were usually suggested, and the captions written, by others.

**Thomas Theodor Heine** (pp. 4 & 63−81). Heine, a charter member of the *Simplicissimus* family, was the artist most intimately connected with the magazine's fortunes over the years, with a most important say in both its artistic and political decisions. For this reason, several crucial moments in his life (his imprisonment in 1898, the *Simplicissimus* "palace revolution" in 1906, his influence on the decision to continue publishing after the outbreak of World War I) are mentioned separately in the Introduction to this volume.

Heine, who was Jewish, was born in Leipzig on February 28, 1867. His father was a chemist. His mother was an Englishwoman (though he was not sparing in his later attacks on England). He studied in Düsseldorf. In 1889 he moved to Munich, where he painted landscapes, portraits and symbolist figure compositions. From 1892 on, he contributed drawings to *Fliegende Blätter*, among which were picture stories of dogs (especially dachshunds) living out various human situations. His first contribution to *Simplicissimus* (after some drawings in the three-month-older *Jugend*) was just such a dachshund story. (Other influences of *Fliegende Blätter* subject matter are also reflected in his later work.)

Dogs continued to be very important in Heine's art. A fierce bulldog that has broken its chain (this appeared in an early issue of *der Simpl* and clearly represented the social unrest that might topple the old European monarchies) became one of the two permanent symbols of the magazine, and reappeared in many of his situation cartoons. The other symbol, a particularly bestial and low-slung type of devil, was also created by Heine, who used it in posters and cartoons.

Heine is said to have done about 2500 drawings for *Simplicissimus*, writing his own captions. His work appeared on the coveted front page more often than any other artist's. He was praised in the most enthusiastic terms by his contem-

poraries in the fine arts, though he was widely disliked personally for his sourness and sardonic nature (his drawings reveal a decided penchant for the sadistic, and it often seems as if he is exposing cruel practices so that he can portray them in graphic detail).

Aside from this great output for *Simplicissimus* and his administrative duties, Heine also produced important and influential book ornament, posters, ads and brochures, along with sculpture and furniture designs.

He was driven from Germany in 1933, and at the age of 66 entered into a life of wandering and persecution. He lived for varying lengths of time in Prague, Brno and Oslo (where Blix aided him) before settling in neutral Stockholm in 1942. He died there on January 26, 1948.

Our selection of drawings that Heine did for *Simplicissimus* between 1896 and 1925 gives a good idea of his skill and the dazzling array of artistic means at his disposal.

**Theodor Kittelsen** (pp. 82−84). The illustrator Kittelsen is best remembered today for his atmospheric contributions to the 1883−1887 luxury edition of the Norwegian fairy tales of Asbjørnsen and Moe, for which he and Erik Werenskiold supplied much of the art. However, Kittelsen produced many other books devoted to the lore and landscape of his native country, writing his own text for many of them. His handful of contributions to *Simplicissimus* fall within the very earliest years of the magazine.

Kittelsen was born at Kragerø in Norway on April 27, 1857. He studied art at Oslo, then at Munich from 1876 to 1879 (he made another long stay in Munich later on). For part of the Eighties he was in Paris. Norway became his permanent home, and he died at Jeløy ved Moss on January 21, 1914.

At a period when "naturalism" in art and literature was at its peak in Norway, the introspective Kittelsen turned to fantasy and to poetic renderings of nature and rustic life. He never enjoyed substantial personal success, but had an appreciative following that included even George Grosz.

Two of the three pictures reproduced here from *Simplicissimus* had already been published in Norway in Kittelsen's book *Troldskap* (Trolldom; 1887): "The Dying Mountain Troll" (the picture is dated 1887 at the bottom) and "The Sea Specter." The latter drawing illustrated the chapter "Draugen" (in Norwegian folklore, a *draugen* is an apparition, generally a skeletal figure,

sighted at sea, in a small boat, by those about to be stricken by some great misfortune).

The third picture, "The Plague," was an illustration for Kittelsen's book *Svartedauen* (The Black Death). In Scandinavian folklore, the plague was often represented as a grim old woman with a broom who wanders over the countryside, death following wherever she sweeps. The chapter illustrated by this picture is called "Soper hver krok" (She Sweeps Every Corner). Kittelsen began work on *Svartedauen* about 1896, but the book was not published until 1900. Thus, it is possible that the appearance of this drawing in *Simplicissimus* was its first publication.

**Heinrich Kley** (pp. 85–88). Kley was born in Karlsruhe on April 15, 1863. He studied there and in Munich, and by the late Eighties was exhibiting as a painter of genre scenes, interiors, portraits and still lifes. In 1893 he completed a large commission, two murals in the post office at Baden-Baden. Around 1900 he became interested in scenes of heavy industry and views of cities. In 1908 Munich became his home, and a steady flow of drawings appeared in *Simplicissimus* and *Jugend*.

It is these *Simplicissimus* drawings, executed in a brilliant pen technique, satirical and erotic, that brought real success to Kley. (His drawings in *Jugend* are similar, but generally less biting; some have a wash over the pen line.) Kley collected much of his best work, largely from *Simplicissimus*, in albums that are well known and highly prized (several albums have been reprinted by Dover in *The Drawings of Heinrich Kley* and *More Drawings by Heinrich Kley*). The present selection, dating from 1908 to 1919, does not duplicate the material in these albums. When viewed in conjunction with their original publication dates, these drawings reveal a lively awareness of politics and other current events that is not readily apparent in the albums.

Kley also did etchings and book illustrations. The date of his death is disputed, but he probably died in Munich on February 8, 1945.

**Käthe Kollwitz** (pp. 89 & 90). In the first rank of twentieth-century German graphic artists, Käthe Kollwitz is best known for her celebration of simple family life and motherhood.

She was born as Käthe Schmidt in Königsberg, East Prussia, on July 8, 1867. Her art studies were conducted in Königsberg, Berlin and Munich. In 1891 she married the physician Karl Kollwitz, who set up practice in a working-class section of Berlin. It is clear how such an existence confirmed the artist's sympathies and her commitment to social reform and pacifism.

After her marriage, Käthe Kollwitz abandoned oil painting for graphics and sculpture. She developed a remarkable mastery of woodcut, lithography and various specialized printmaking techniques, while her draftsmanship constantly grew in power and monumentality.

In 1933 she was discharged from her teaching post in the Berlin Academy, but chose to remain in Germany. Her studio was bombed in 1944. She died at Schloss Moritzburg near Dresden on April 22, 1945.

Like Barlach, Käthe Kollwitz was not a typical *Simplicissimus* artist, and her contributions were very few. The two reproduced here were the best, and the best-reproduced in the original publication.

**Alfred Kubin** (pp. 91—108). Born in Leitmeritz, Bohemia, on April 10, 1877, Kubin had a most unhappy childhood and youth. His cumulative frustrations, failures and strokes of ill fortune produced the thick atmosphere of anguish that became his only breathable air.

After several false starts in life, Kubin went to Munich in 1898 to study art. Here he got to know and emulate the work of the great fantastic and grotesque artists of the near and distant past: Max Klinger, Ensor, Goya and the rest. After some years spent in travel, he purchased the estate Schloss Zwickledt in Upper Austria in 1906. This was to be his home until he died there, on August 20, 1959, but he was not a complete recluse. He was very fond of Munich, visited the city at least once a year and was a heavy contributor to *Simplicissimus* in the late 1910s and Twenties. Some of his work also appeared in *Jugend*.

In 1908 he wrote the odd autobiographical novel *Die andere Seite* (The Other Side), which serves as a program for all his artistic production. In 1911 he was a founding member, along with Kandinsky and Marc, of the Blauer Reiter group of artists. Despite this association and his acclamation as a precursor by the Surrealists, Kubin always remained a solitary and an independent.

He did some painting before World War I, but his principal life's work was his thousands of drawings (including book illustrations) in an inimitable nervous line. The subject matter is generally tinged with horror; the characters are often misfits and outsiders. If certain art historians are to be credited, it was as if Kubin had experienced within his own body and consciousness the decay and dissolution of the Austro-Hungarian Empire.

A number of Kubin's *Simplicissimus* drawings (not duplicated here) are to be found in the Dover volume *Kubin's Dance of Death and Other Drawings*.

**Pascin** (pp. 109–117). Pascin, whose name was really Julius Pincas, is best known for his drawings and paintings of Parisian prostitutes and for his bohemian existence in the Paris of the Twenties. His work for *Simplicissimus* allows us to look into his earlier life and the remarkable beginnings of his style. This group of drawings, which commences while the artist was still in his teens, reveals a startling precocity in both draftsmanship and sex. They are a veritable hymn to depravity.

Pascin was born in Vidin, Bulgaria, on March 31, 1885, the son of a Jewish merchant of Spanish descent. He grew up in Bucharest, where he became intimate with bordello life at an early age. For a while he studied art in Vienna. It is reported that Gustav Meyrink, the writer of bizarre and mystical stories and a contributor to *Simplicissimus*, recommended him to the magazine.

Pascin was soon living comfortably in Munich, studying a little, traveling a little. He continued to send contributions to *Simplicissimus* for some years after his major move to Paris in 1905, where he studied with Matisse. The drawings included in the present volume range from 1905 to 1909; a few pieces that had appeared in *Simplicissimus* even earlier are reproduced in Dover's volume *Pascin: 110 Drawings*.

In 1914 Pascin went to the United States, where he became a citizen. He traveled in the South and in Cuba, producing many delightful genre scenes, portraits and cityscapes. At the beginning of the Twenties he returned to Paris for what was to be the brilliant final phase of his career, in which he produced drawings of greater simplicity and warmth and those opalescent canvases in which the colors are laid on very thinly. Declining health, marital and extramarital problems, and a feeling of stagnation all contributed to Pascin's suicide in Paris at the age of 45, on June 30, 1930.

**Bruno Paul** (pp. 5—9 & 118—125). Paul was chiefly an architect, interior designer and educator, and his direct association with *Simplicissimus* lasted only a few years, but he was among the most remarkable artists connected with the magazine—possibly among the four or five best it ever had.

Paul was born in Seifhennersdorf in der Lausitz (Silesia) on January 19, 1874. He studied fine and applied art in Dresden from 1886 to 1894, and in Munich from 1894 to 1907. Here he did painting and illustration. He was the co-founder and director of the United Workshops for Art in Manufacture.

Paul's work for *der Simpl* falls mainly within these years in Munich; he first appeared in its pages in March 1897 (he did drawings for *Jugend*, too, but they are a little weak and prettified in comparison). His style was a bold personal exaggeration of Art Nouveau that looks forward to Expressionism. Daring angles and points of view, strong fluid contours and flat color patches: these are some of the features that inspired the young George Grosz and that, according to one historian, served as a visual manifesto for *Simplicissimus* and gave the fledgling magazine its first characteristic style and truly individual artistic merit. Paul's subject matter was varied, but he had a special affection for the proletariat of Munich and the rustics of the surrounding Bavarian countryside.

In 1907 Paul became director of the art school of the Berlin Museum of Applied Art. From Berlin he sent *Simplicissimus* a few drawings that were published under the pseudonym Kellermann. He was later at other Berlin schools. From 1924 to 1932 he directed the United Government Schools for Fine and Applied Art. He resigned his post in 1933 and moved to Düsseldorf. In 1945 he was honored by the new republic. He died in Berlin at the age of 94 on August 17, 1968.

**Ferdinand von Reznicek** (pp. 10 & 126—129). Reznicek was an Austrian baron and cavalry officer who became a gifted illustrator. He was born in Sievering, outside Vienna, on June 16, 1868. Before joining the staff of Simplicissimus he was well known for his work in other Munich magazines: *Radfahr-Humor*, *Fliegende Blätter* and *Jugend*.

One of *der Simpl*'s most popular contributors, Reznicek is said to have done a thousand drawings for the magazine before his untimely death on May 11,

1909. His style was dashing and colorful, though with a fatal tendency toward the insipid. His comfortably spicy subject matter included unfaithful spouses of the upper classes, demimondaines and roués, bathing beauties and Carnival queens.

**Erich Schilling** (pp. 130–132). Schilling was born at Suhl in Thuringia in 1885. His long association with *Simplicissimus* began in 1907. His earliest manner, with its painstaking hatching and minute details, is the most attractive of all. He later turned to a style imitative of fifteenth- and sixteenth-century woodcuts, but his work of this type was crude without possessing real strength. After his startling political conversion to Nazism (he had lampooned Hitler in the Twenties), his drawings became rather distressing examples of "National Socialist Realism." Schilling killed himself in 1945 amid the debacle of the Third Reich.

**Max Slevogt** (pp. 133–138). An outstanding exponent of German Impressionism in painting, and perhaps the foremost German book illustrator of modern times, Slevogt was involved only briefly with *Simplicissimus*—but in its first, formative years.

Born in Landshut, Bavaria, on October 8, 1868, Slevogt grew up in Würzburg and later in Munich, where he studied at the Academy. He visited Paris in 1889 and Italy in 1889/90. From the inception of *Jugend* and *Simplicissimus* in 1896, he contributed to both magazines. Our selection runs from 1896 to 1900, and includes poetically erotic compositions in lithographic style, as well as playful pen vignettes that prefigure the work of Kley in both technique and subject matter.

In 1901 Slevogt made a decisive move to Berlin. From then on, he disappears from *der Simpl* and his career belongs to the history of painting and illustration. He did both canvases and frescoes, and was active in stage design. Despite gradual stylistic development, in each aspect of his production he remained loyal to his love for air, light and color. Slevogt died in Neukastel (in the Palatinate) on September 20, 1932.

**Théophile-Alexandre Steinlen** (pp. 139—142). Steinlen's work, like that of other Frenchmen (Chéret, Willette) was occasionally featured in *Simplicissimus* in the years before World War I, when the magazine's policy toward France was still very amicable.

Steinlen was born at Lausanne, in the French-speaking part of Switzerland, on November 10, 1859. He moved permanently to Paris in 1882 and became a French citizen in 1901. An extremely talented draftsman and printmaker, he was a regular contributor to numerous Parisian humor magazines and was responsible for some of the best *fin-de-siècle* book illustration. He began producing highly successful commercial posters in the Nineties, and collectors prize the patriotic posters he did during the First World War. He also executed murals in the Taverne de Paris.

Especially associated in his art with the underprivileged (and criminal) elements of Montmartre, so in his Munich reportage and drawings for *Simplicissimus* Steinlen seems to have been most interested in the amusements and other doings of the common people.

**Eduard Thöny** (pp. 11—15 & 143—163). One of the pillars of *Simplicissimus*, the draftsman, book illustrator and painter Eduard Thöny was with the magazine during its entire run and did almost 4,000 drawings for it out of a lifetime total of about 5,000.

Thöny was born at Brixen in the Austrian Tyrol (now Bressanone in the Italian Tyrol) on February 9, 1866. He was in Munich by 1873, and studied art there. In the late Eighties he was a contributor to *Radfahr-Humor*, along with Engl and Reznicek. In the early Nineties he spent some time in Paris, where he not only studied with the revered military painter Edouard Detaille, but also soaked up Montmartre atmosphere. Both these aspects of his training influenced his later production.

In 1896 he was back in Munich; his first drawing in the young *Simplicissimus* appeared in the October 24 issue in that year. Coming to the magazine in full control of his considerable powers, Thöny very soon became a fixture. His army officers and cavalry horses received a never-flagging acclamation from a public that apparently consisted largely of military men—who either did not see or did not mind his spoofing of their circumscribed *Weltanschauung*. Other steadily recurring subjects are streetwalkers, beer-hall devotees, and the big

spenders and their parasites in expensive restaurants and night spots. Thöny did not write his own captions, but his drawings were not suggested by given captions: the editors added a text to the pictures he supplied.

The present selection of outstanding Thöny drawings from 1897 to 1926 could easily have been tripled without loss of quality. His sense of composition is always astounding, while his style moves slowly (World War I seems to be a dividing line) from an academically correct (but never fussy or petty) depiction of contours and masses to a looser line and a more allusive rendering of form by means of color accents.

Thöny, with *Simplicissimus* to the bitter end in 1944, lost a son (one author says two sons) in the Second World War. He died at his home in Holzhausen on the Ammersee, in Bavaria, on July 26, 1950.

**Rudolf Wilke** (pp. 16 & 164—167). During his brief life, Wilke was considered by T. T. Heine and other severe judges as possibly the most talented draftsman working for *Simplicissimus*. His exciting style was unlike any one else's and clearly pointed toward Expressionism.

Wilke was born in Braunschweig on October 27, 1873, and died there on November 4, 1908. He studied in Munich and at the Académie Julian in Paris (1894/5). Back in Munich, he was among the earliest contributors to *Jugend*, and later became most closely associated with *Simplicissimus*.

**Adolphe Willette** (p. 168). The drawing reproduced here is the only one by Willette published in *Simplicissimus*. From an early issue (September 19, 1896), it is an *hommage* to one of the great figures of humorous illustration in Paris. Besides contributing to numerous magazines, Willette did outstanding posters, book illustrations and cabaret murals. Juicy girls were generally featured.

Willette was born in Châlons-sur-Marne, about 55 miles east of Paris, on July 31, 1857, and died in Paris on February 4, 1926.

**Heinrich Zille** (pp. 169—172). Living and working among the poorest classes in Berlin, Zille celebrated their primitive and promiscuous joys and woes with in-

finite amusement and tenderness. Streetwalkers, pimps, abortionists, sleazy cabaret girls, grimy kids old before their time in the ways of the world and conspiring to find a moment's pleasure in the bleakest and most populous of wildernesses—all these are viewed without moralizing or mawkishness, but with just the right touch of romance and wonder to win our affection and help us forget the artist's technical limitations.

Zille was born in Radeburg, Saxony, on January 10, 1858. He arrived in Berlin in 1867. In 1873 he took evening art classes with Theodor Hosemann, the well-known nineteenth-century illustrator of popular Berlin scenes. From 1876 to 1907 Zille drudged as a lithographer in a large printing shop, only gradually making a name for himself by contributions to magazines. Around the turn of the century he was published in *Lustige Blätter* and *Jugend*. It was not until he left his job and set up as an independent artist that his real career and fame commenced.

By 1909 he was contributing—though not with great regularity—to *Simplicissimus*. The first of his several popular albums of cartoons did not appear until 1915. His drawings inspired various shows, films, balls and songs, but he made no subsidiary profits and continued to live frugally. In 1924 he was appointed to the Berlin Art Academy. He died in Berlin on August 9, 1929.

# the illustrations

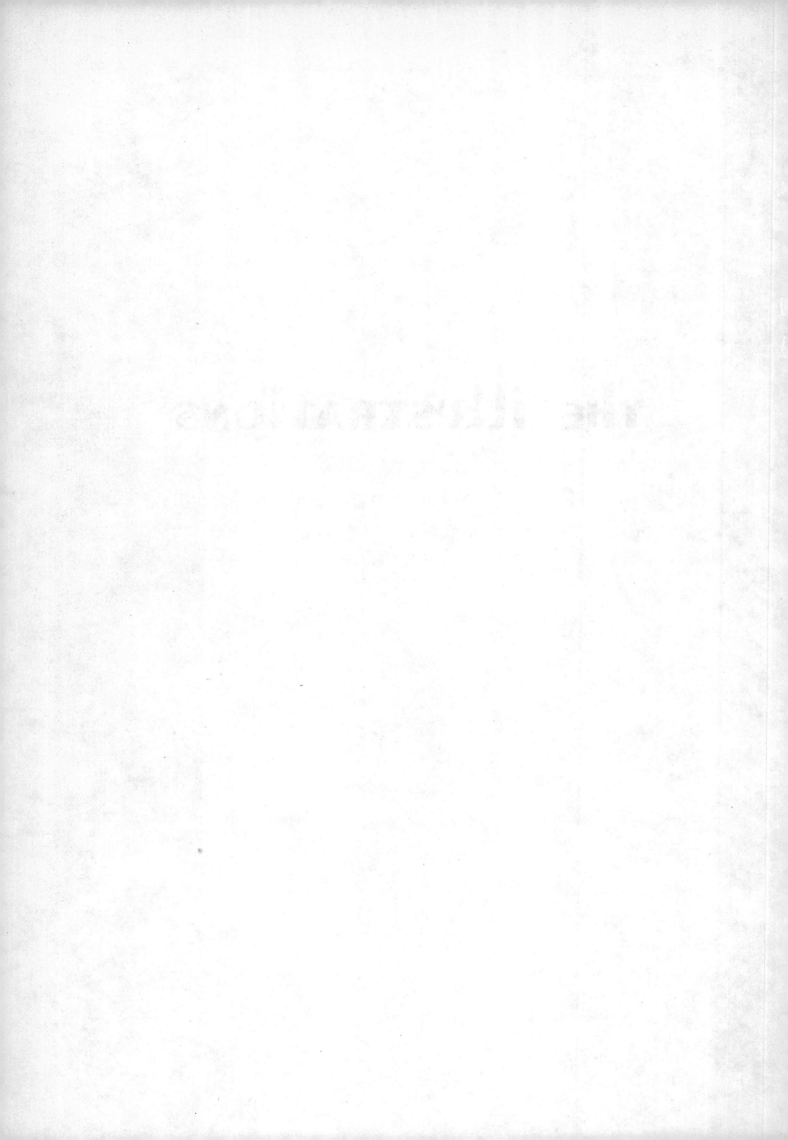

# Die Toten von Dortmund

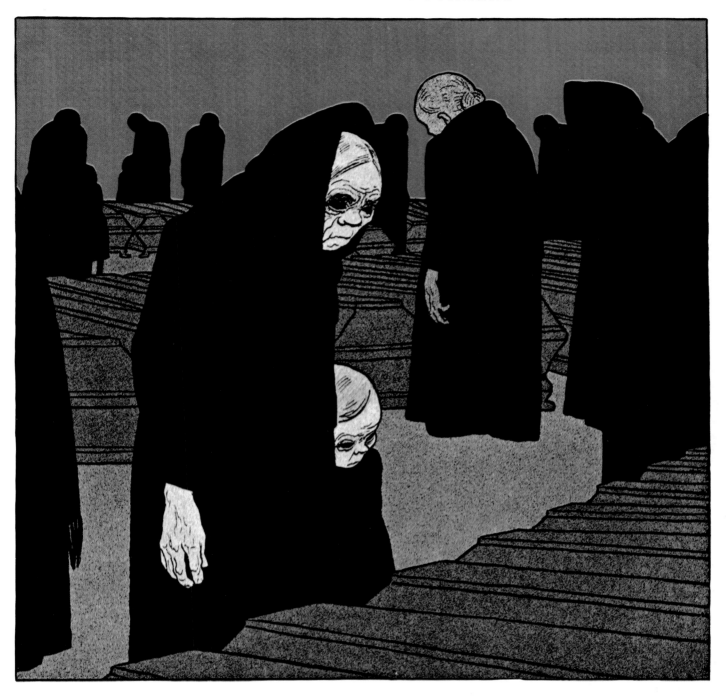

„Und warum mußten sie vor den Richter treten — ?!"

**The Dead of Dortmund.** "And why did *they* have to face their judge?" [The Rhineland city of Dortmund suffered greatly in the early Twenties from Communist and Spartacist uprisings and the brutality of the French occupying troops.] [Mar. 2, 1925.]

KARL ARNOLD

1

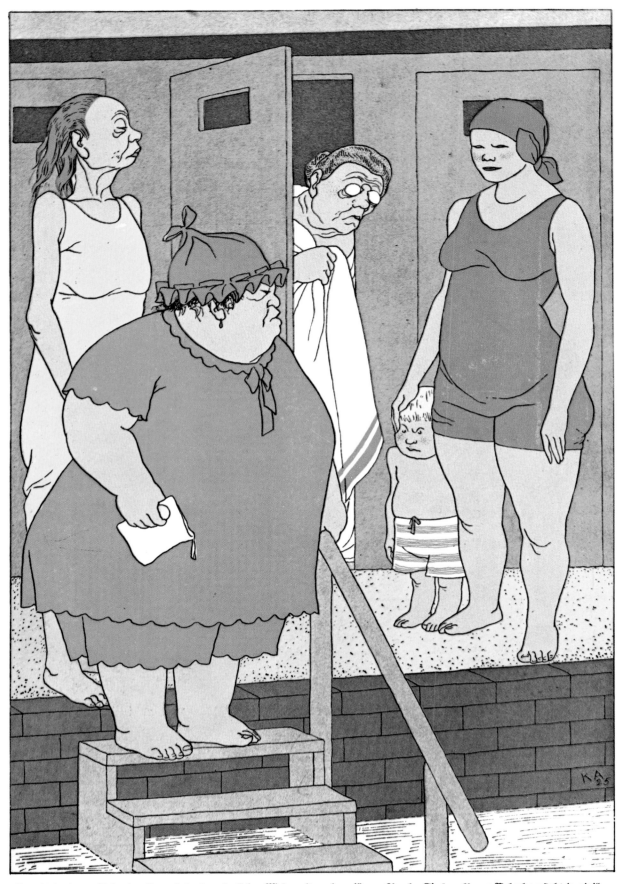

„Das ist doch ungehörig, ins Damenbad ein männliches Weſen mitzunehmen!“ — „A gehn S', ſo a kloans Buberl verſteht ja nix!“ — „Ja, aber der Burſche merkt ſich das!“

KARL ARNOLD

2

**In the Battle Against Immorality.** "It's really improper to bring a male into the ladies' bath!" "Oh, come now, a little kid like this doesn't understand anything!" "Yes, but the boy will remember it!" [Jul. 27, 1925.]

# Wie bleibe ich jung und schön?

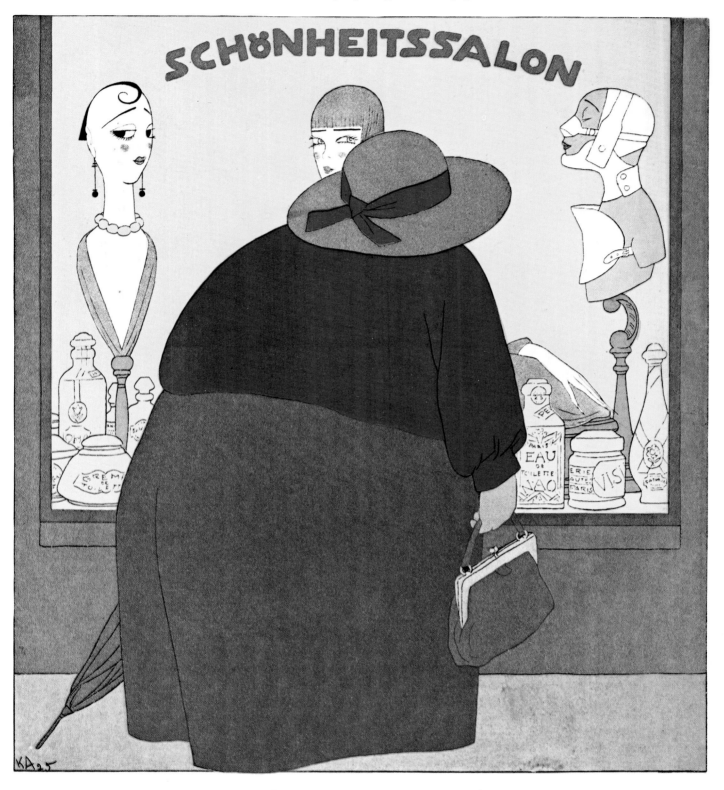

„Uns Damen bleibt doch nichts erspart!"

**How Can I Stay Young and Beautiful?** "We women are spared nothing!" [*Schönheitssalon* = beauty parlor.] [Oct. 5, 1925.]

KARL ARNOLD

# Arbeiterfürsorge

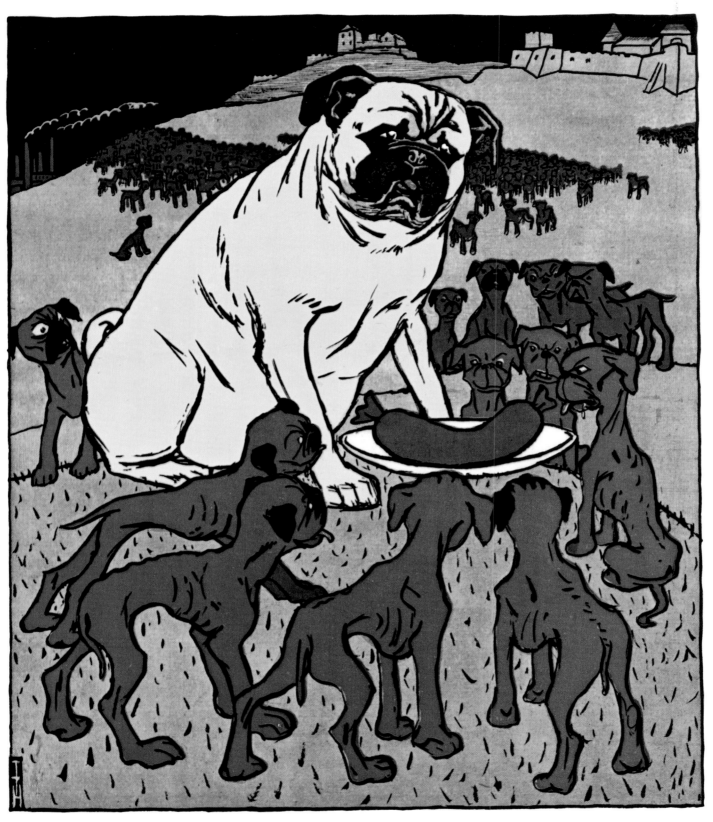

„Seht, liebe Kinder, ich freſſe jetzt dieſe Wurſt. Wenn ihr mir ein Stück davon wegfreſſen wollt und dafür eure Keile von mir kriegt, ſo iſt das die Revolutions-Theorie. Wenn ihr aber geduldig zuſeht, bis ich die Wurſt allein aufgefreſſen habe, ſo iſt das die Evolutions-Theorie."

THOMAS THEODOR HEINE
4

**Social Welfare for Workers.** "You see, my dear children, I now eat this sausage. If you try to snatch a piece away from me and I give you a licking, that is called revolutionary theory. But if you watch patiently while I eat up the whole sausage by myself, that is called evolutionary theory." [Vol. VIII (1903/4), No. 26.]

# Der schöne Mensch

„Willst du nicht eine kleine Porträtskizze von mir machen? Mein neues Buch ‚Der schöne Mensch‘ soll mit dem Bildnis des Verfassers geschmückt werden.“

**The Beautiful Person.** "Won't you do a little portrait sketch of me? My new book, *The Beautiful Person*, is to be illustrated with a picture of the author." [Vol. II (1897/8), No. 27.]

BRUNO PAUL

# Die Zahnbürſte

„Zum Donnerwetter, Herr, was machen Sie denn da mit meiner Zahnbürſte?!"
„Ach, entſchuldigen Se giedigſt, ich gloobte, ſe gehärte zum Schiff."

The Toothbrush. "In heaven's name, Sir, what are you doing with my toothbrush?"
"Oh, please excuse me, I thought it belonged to the ship." [Vol. II (1897/8), No. 40.]

# Allerdings

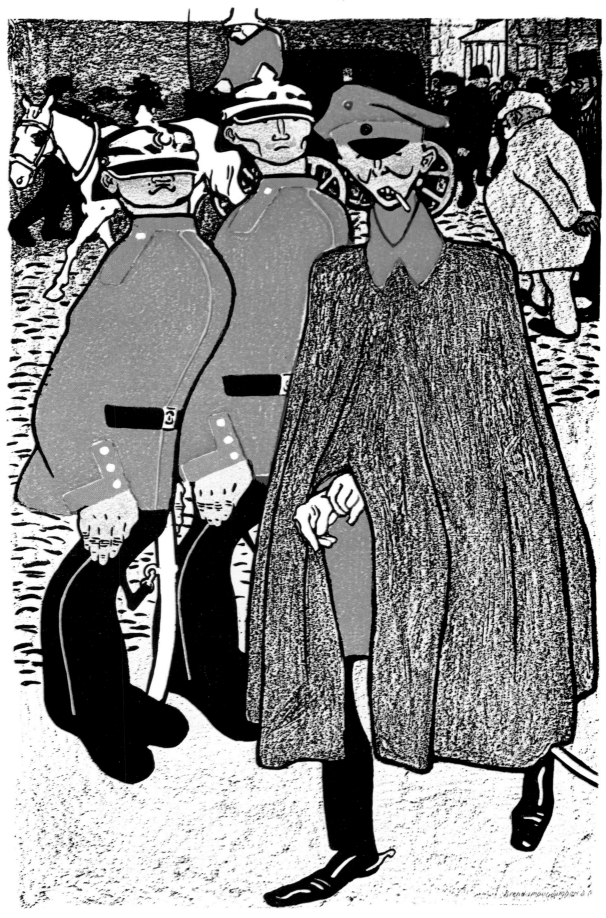

„Ich habe immer das ekelhafte Gefühl, daß sich die Lümmels was unanständiges denken, wenn man vorbei is."

**Of Course.** "I always have the sickening feeling that those roughnecks think indecent thoughts when officers are around." [Vol. V (1900/1), No. 5.]

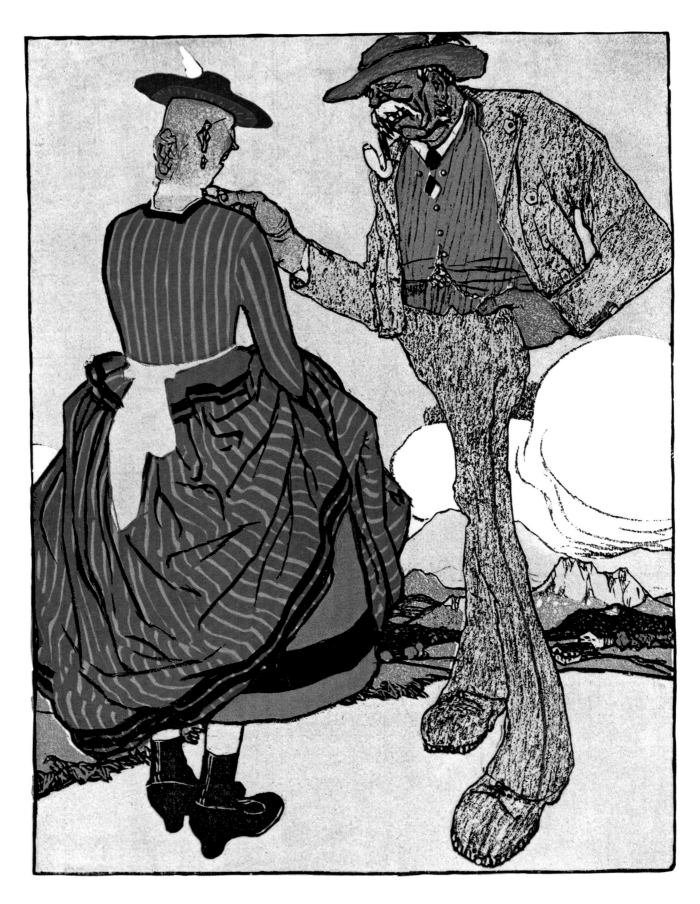

„Du, Stasi, gestern hon i den Aepfibaam vor dein Kammerfenster a bissei g'schüttelt. Do is glei oaner obag'fallen.“ — „Wos, an Aepfi um de Zeit?“ — „Na, a Summerfrischla.“

BRUNO PAUL
8

**Falling Fruit.** "Say, Stasi, yesterday I gave a little shake to that apple tree outside your bedroom window, and one fell right down." "What, a ripe apple?" "No, a vacationer." [Vol. VII (1902/3), No. 16.]

# Erkennungszeichen

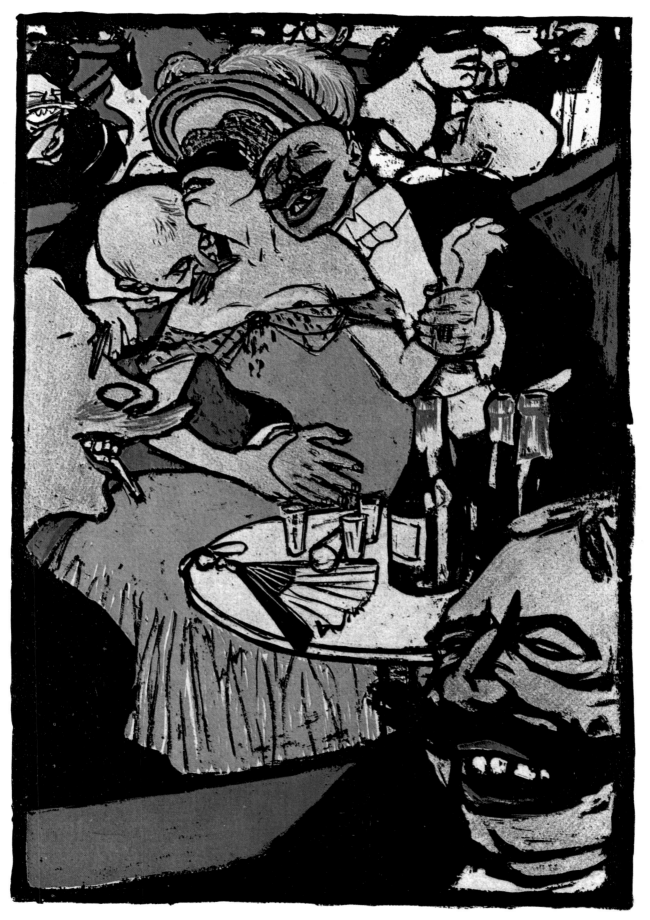

„Zu dumm, daß man nur im Frack kommen darf, man unterscheidet sich gar nicht von den Kellnern."     „Doch, die benehmen sich anständig."

**Distinctive Mark.** "It's ridiculous that we have to wear dinner clothes here, you can't tell us apart from the waiters." "Oh, yes, you can, they behave decently." [Vol. VII (1902/3), No. 46.]

# Die Mutter der Naiven

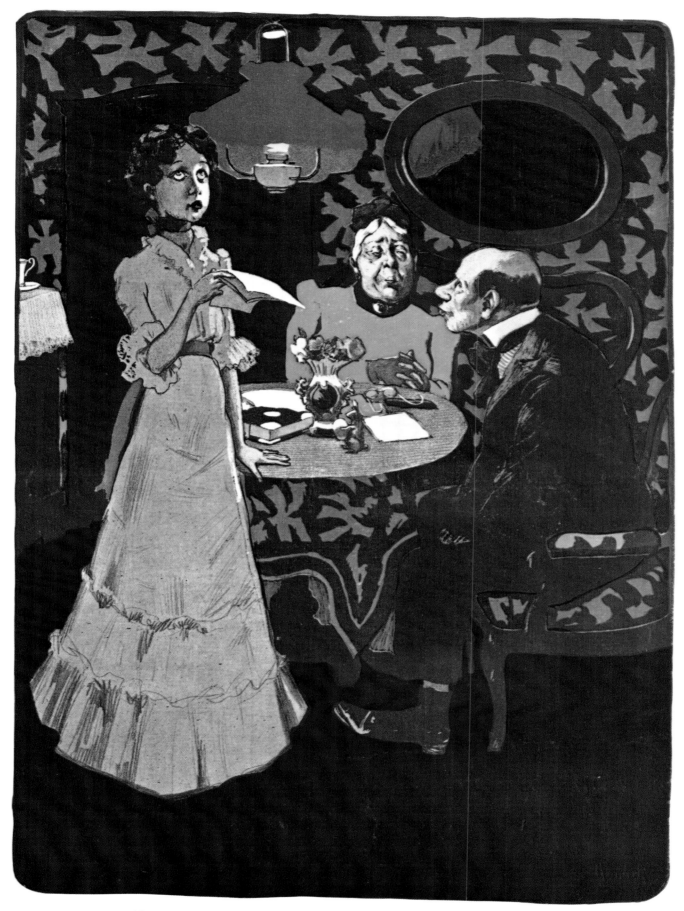

„Ach Gott, ich weiß schon, Herr Regisseur, meine Tochter würde viel größere Rollen bekommen, wenn sie nur mehr Busen hätte."

FERDINAND VON REZNICEK

**The Mother of the Ingenue.** [To the director:] "Goodness! I know my daughter would get much bigger roles if she only had more bosom." [Vol. IV (1899/1900), No. 27.]

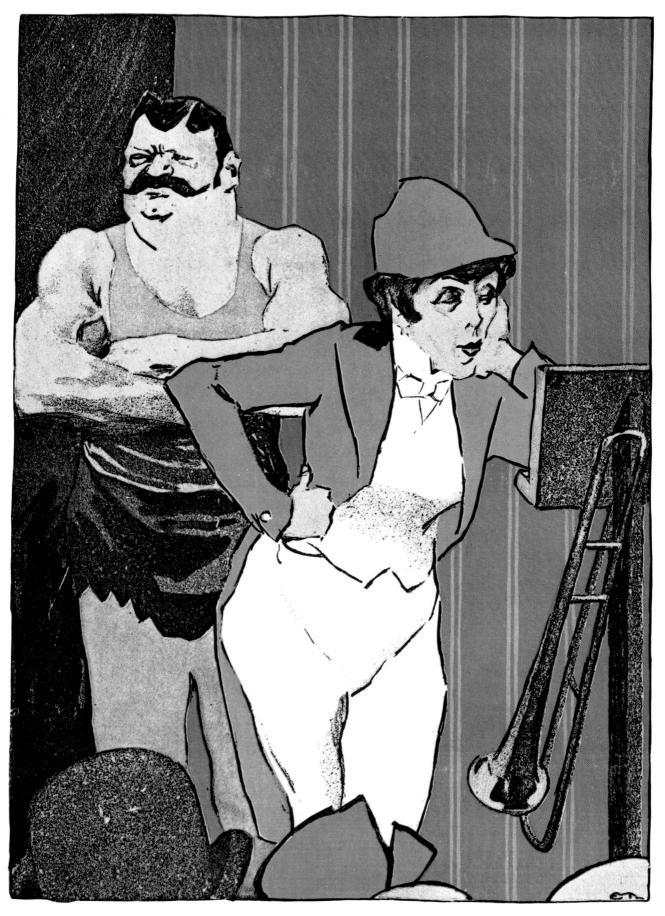

„Schöner Reinfall! Jetzt darf unfer dummer Auguft nicht mehr auftreten. Die Polizei hielt ihn für eine politifche Anfpielung."

**Circus.** "A fine how-de-do! Now our clown can't go on any more. The police considered him to be a political allusion." [Vol. VII (1902/3), No. 21.]

EDUARD THÖNY

„Ach — — Grete, du — — küßt — — so — — ſü — füß, daß man die Männer gar nicht vermißt."

EDUARD THÖNY
12

**Women Artists' Ball.** "Oh . . . Greta . . . you . . . kiss . . . so . . . sweetly—that there's no need for men." [Vol. VII (1902/3), No. 46.]

# Schnapsbarone

„Herr Paſtor, ich liebe es nicht, wenn Sie gegen das Trinken predigen; die Leute ſaufen **meinen** Schnaps, verſtanden?!"

**Whiskey Barons.** "Pastor, I don't like it when you preach against drinking. The people swill *my* whiskey, get it?" [Jul. 12, 1909.]

EDUARD THÖNY

# Die Riffabylen

„Allah will es — und England hat nichts dagegen."

The Riffs. "Allah is willing—and England has no objection." [In 1925 the Riffs rebelled against French rule in Morocco.] [Jun. 1, 1925.]

# Nacktkultur!

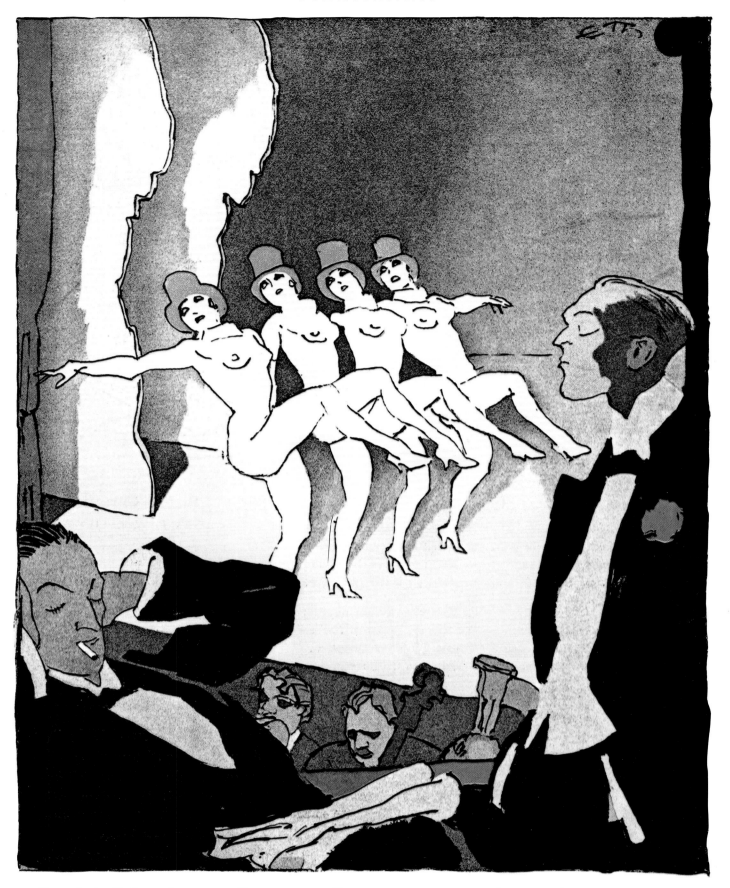

„Das einzig Aufregende an der Revue ist das Publikum — da sind die Damen nicht ganz ausgezogen."

**Nudism!** "The only stimulating thing about this revue is the audience—there the women aren't completely undressed." [Mar. 22, 1926.]

EDUARD THÖNY

15

# Gemütsmenſchen

Bild Nr. 7

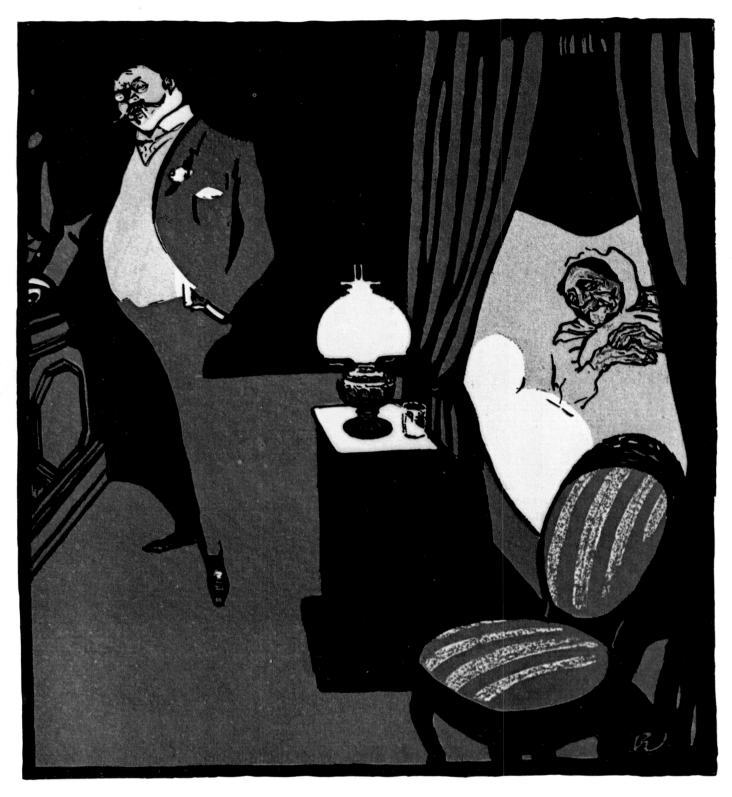

„Alſo, liebe Mama, ich geh' jetzt — wichtige Verabredung im Club — falls du ſtirbſt, vergiß nicht, vorher die Lampe auszulöſchen." —
„Der gute Junge, er denkt doch an alles!"

**Sentimental People, No. 7.** "So, Mother dear, I'm going now—important appointment at the club—in case you die, don't forget to turn off the lamp first." "The good boy, he thinks of everything." [Vol. IV (1899/1900), No. 35.]

# Höhenmenschen

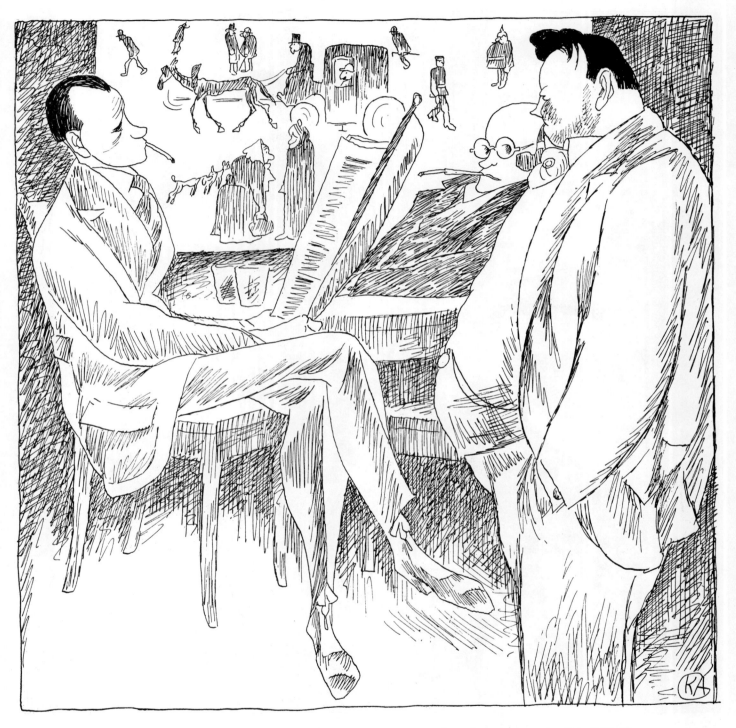

„Sehen Sie, wie recht ich hatte — ich habe mich niemals von der Begeisterung mitreißen lassen!"

**On a Loftier Plane.** "You see how right I was—I never let myself get carried away by enthusiasm." [German intellectuals two weeks before the Armistice.] [Oct. 29, 1918.]

# Bei Kriegsgewinnlers

„Die Bedingungen wären Papa ja gleich — wenn nur der Frieden nicht wäre."

KARL ARNOLD
18

**In the Home of War Profiteers.** "Papa wouldn't care about the terms—as long as there was no peace." [Nov. 19, 1918.]

# Unſre ſchweren Jungen

„Wenn wa ooch noch die Einbruchswerkzeuge an die Angtang abliefern müſſ'n, ſin wa bankrott.“

**Our Tough Guys.** "If we have to surrender our burglary tools to the Entente too, we're bankrupt." [Feb. 11, 1919.]

# Armut die große Mode

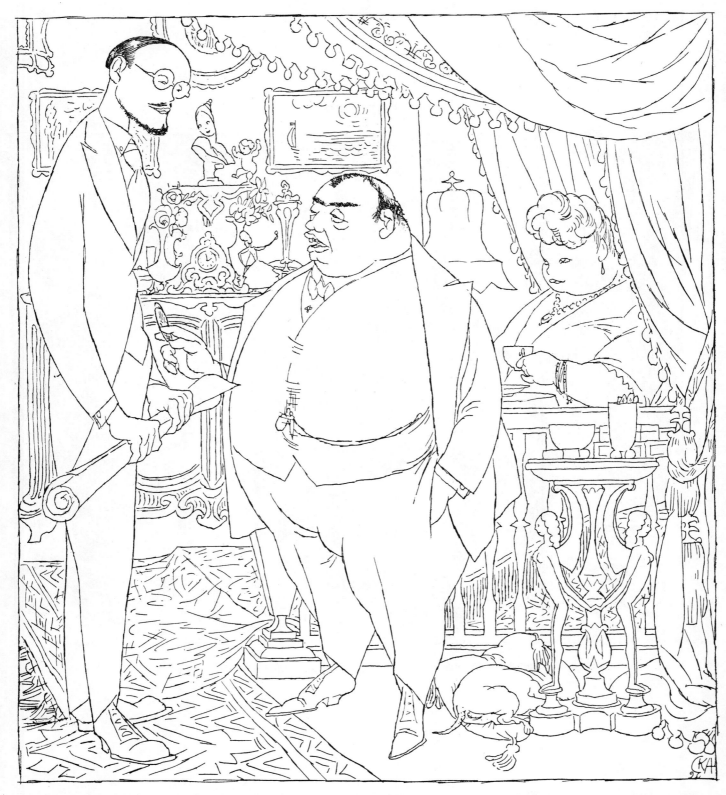

„Entwerfen Sie uns eine ganz bescheidene Hauseinrichtung, Herr Professor. So einfach wie möglich — es kann kosten, was es will."

KARL ARNOLD
20

**Poverty Is Fashionable.** "Design very modest furnishings for us, please. As simple as can be—it doesn't matter how much it costs." [Jun. 23, 1920.]

**Dance Epidemic.** [Dec. 15, 1920.]

KARL ARNOLD

21

# Berliner Bilder

### I.
### Nepp

Acht gegen Einen.

**Berlin Scenes, No. 1: Clip Joint.** Eight against one. [May 18, 1921.]

# Berliner Bilder
## IV.
### Jazz-Orchester und Shimmy-Tanz

Portokasse und Schreibmaschine beim Fünfuhr-Mokka.

**Berlin Scenes, No. 4: Jazz Band and Shimmy.** Post office clerks and typists at a five-o'clock dance. [Jun. 8, 1921.]

KARL ARNOLD

23

# Berliner Bilder

## V.
### Die Friedrichstraße

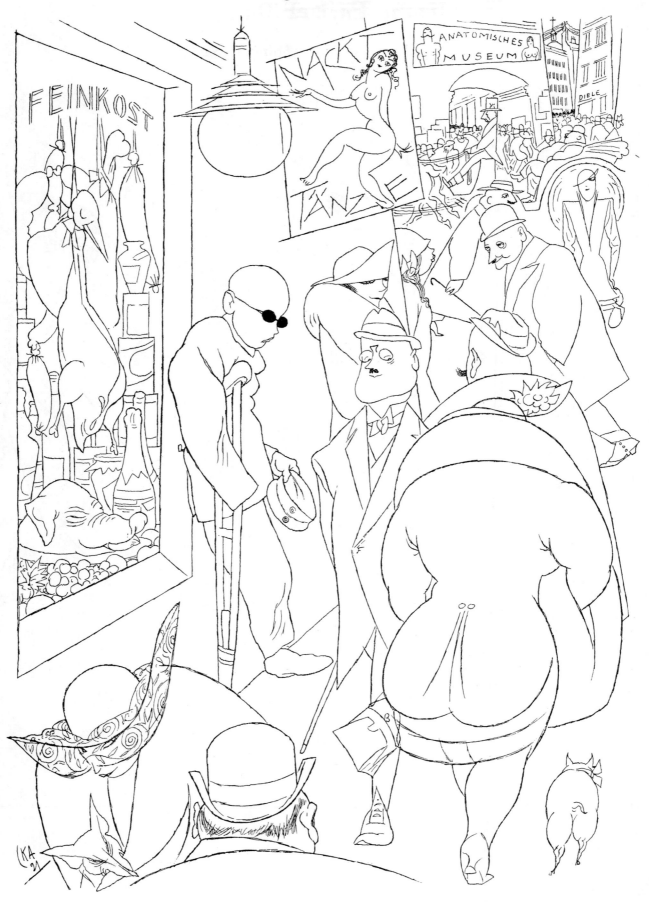

KARL ARNOLD
24

**Berlin Scenes, No. 5: Friedrichstrasse.** [Before World War II, the Friedrichstrasse was one of the most animated downtown streets. After the war, it became a no-man's land, bisected by the Berlin Wall. *Feinkost* = gourmet foods; *Nackttänze* = nude dances; *Diele* = lounge.] [Jun. 22, 1921.]

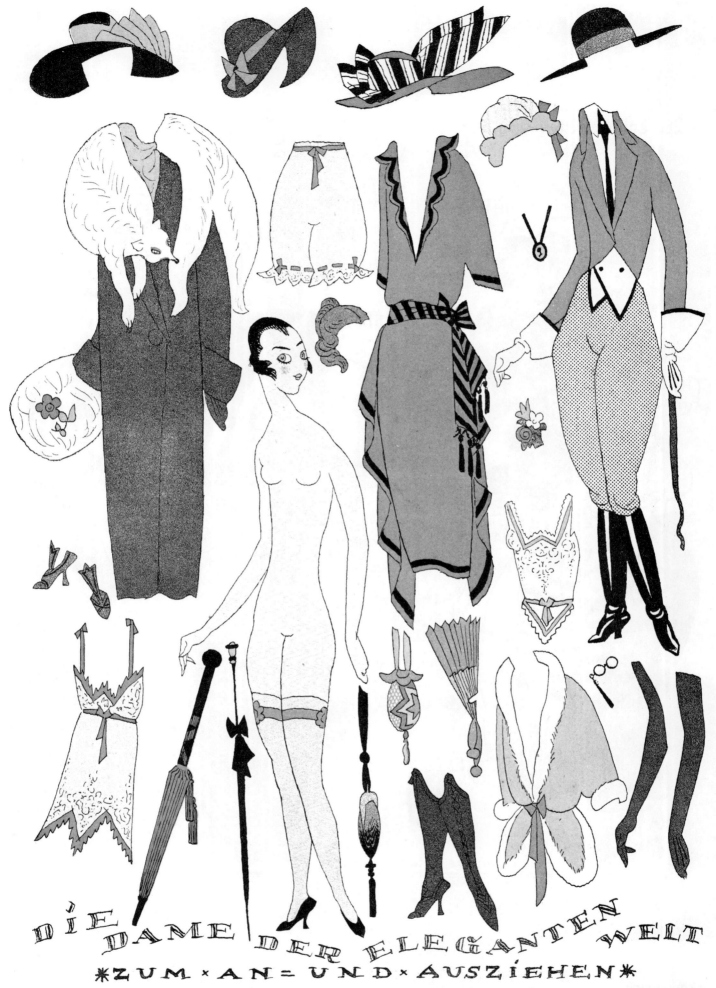

**The Elegant Woman.** For dressing and undressing. [Nov. 9, 1921.]

KARL ARNOLD

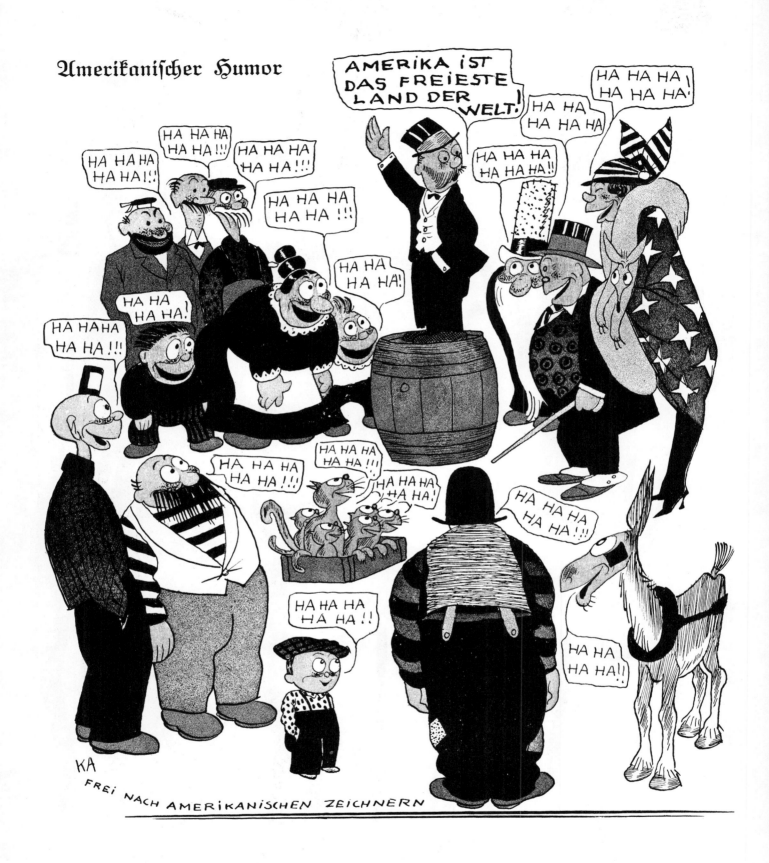

KARL ARNOLD
26

**American Humor.** "America is the freest country in the world." Freely redrawn from American illustrators. [Among the characters shown are Bud Fisher's Mutt and Jeff, George McManus' Jiggs and Maggie, Rudolph Dirks's and Harold Knerr's Captain and the Kids (with Mama and the Inspector), Frederick Burr Opper's Happy Hooligan and Maud the mule, and James Swinnerton's Little Jimmy.] [Sept. 20, 1922.]

# Schreckliche Drohung

„Du Lausbub, wenn du nicht folgst, laff' ich dich studieren!"

**Fearful Threat.** "You scamp, if you're not obedient, I'll send you to school." [Oct. 25, 1922.]

KARL ARNOLD

27

# Berliner Bilder

## XIX.
### Im Schlemmerlokal am Neppski-Prospekt

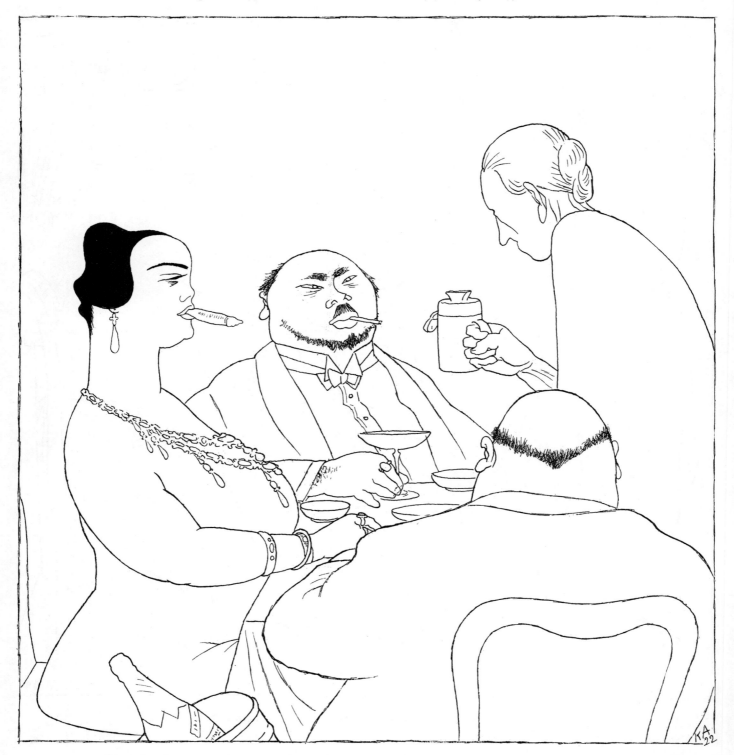

„Bitte eine Kleinigkeit für die hungernden Kinder in Rußland!" — „Danke, wir sind selbst Russen."

**Berlin Scenes, No. 19: In the Gourmands' Night Spot on the Neppski Prospekt.**
"Please, a small donation for the starving children in Russia." "No, thanks, we're Russians ourselves." [Neppski Prospekt: pun on the slang term *Nepp* (clip joint) and the Leningrad thoroughfare Nevski Prospekt.] [Nov. 22, 1922.]

„Solang die Juden am Rhein stehn, sag' i, gibt's koa Ruh' im Land!" — „Geh, hör' auf, dös san do die Franzosen." — „Sooo — da geh amal in a Hitler-Versammlung, der sagt dir's nacha scho', wer die san!"

**National Politics.** "I say that as long as the Jews are occupying the Rhine, we'll have no peace and quiet." "Oh, get off it, it's the French that are there." "Yeah? Just go to one of Hitler's meetings—he'll tell you who they are." [Jan. 3, 1923.]

KARL ARNOLD

## Wie sag' ich's meinem Kinde

„Du bist nun in dem Alter, Paula, wo man mit den Männern ———" — „Laß' das, Mutter — ich bin pervers."

KARL ARNOLD
30

**How Can I Tell My Child?** "Paula, you've reached the age when men . . ." "Drop it, Mother, I'm a lesbian." [Sept. 20, 1924.]

# Hunger

„Da reden sie von Lebensmittelverbilligung — und uns verteuern sie das Kokain."

**Hunger.** "They talk about lowering the cost of living—and they raise the price of our cocaine!" [Oct. 12, 1925.]

KARL ARNOLD

31

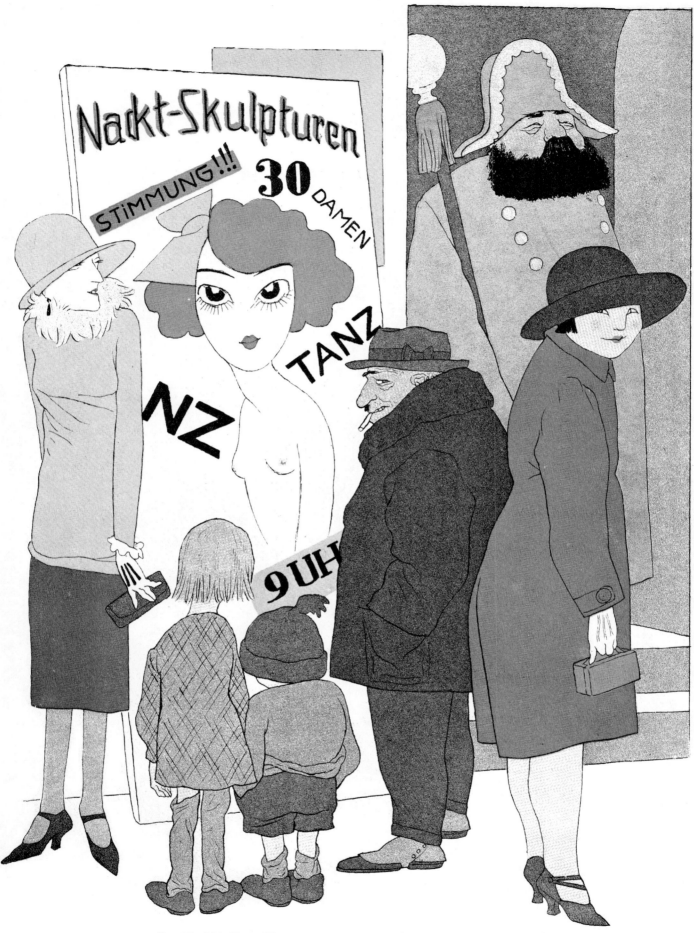

„Quatsch nich! Deine Mutta is ja viel zu dick — die kann nich als Nutte jehn."

KARL ARNOLD
32

**The Metropolis.** "Don't hand me that. Your mother is much too fat. She can't be a streetwalker." [On the sign: "Nude statues. Atmosphere!!! 30 women. Dancing. 9 o'clock."] [Jan. 11, 1926.]

# Konsequent

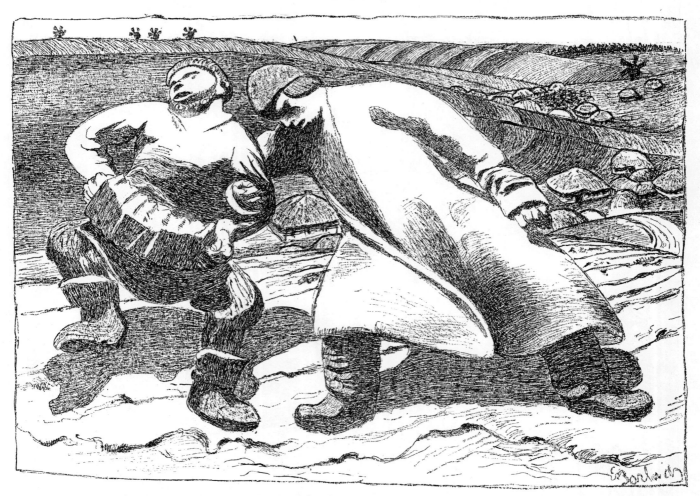

„Jetzt saufen wir aus Schmerz, Brüderchen, weil sie unsere Duma aufgelöst haben. Aber wenn wir eine neue Duma haben, Brüderchen, dann saufen wir aus Freude."

**Logical.** "Now we drink for sorrow, little brother, because they've dissolved our Duma. But when we have a new Duma, little brother, we'll drink for joy." [Jul. 29, 1907.]

ERNST BARLACH

33

# Kindliche Bitte

„Wenn de heite een Vatter mitbringst, denn aber keenen wo schnarcht."

RAGNVALD BLIX
34

**Filial Request.** "If you bring home a father today—please, not one that snores!" [Jun. 21, 1909.]

# Sein Verhängnis

„Mein Gott, ich hätte auch ein großer Künstler werden können! Aber meine Spezialität ist die Herbstlandschaft — und Schaffensdrang verspüre ich nur im Frühling.“

**His Destiny.** "Lord! I could have been a great artist, too! But my specialty is autumn landscapes—and I feel the urge to create only in the spring." [Jan. 29, 1912.]

RAGNVALD BLIX

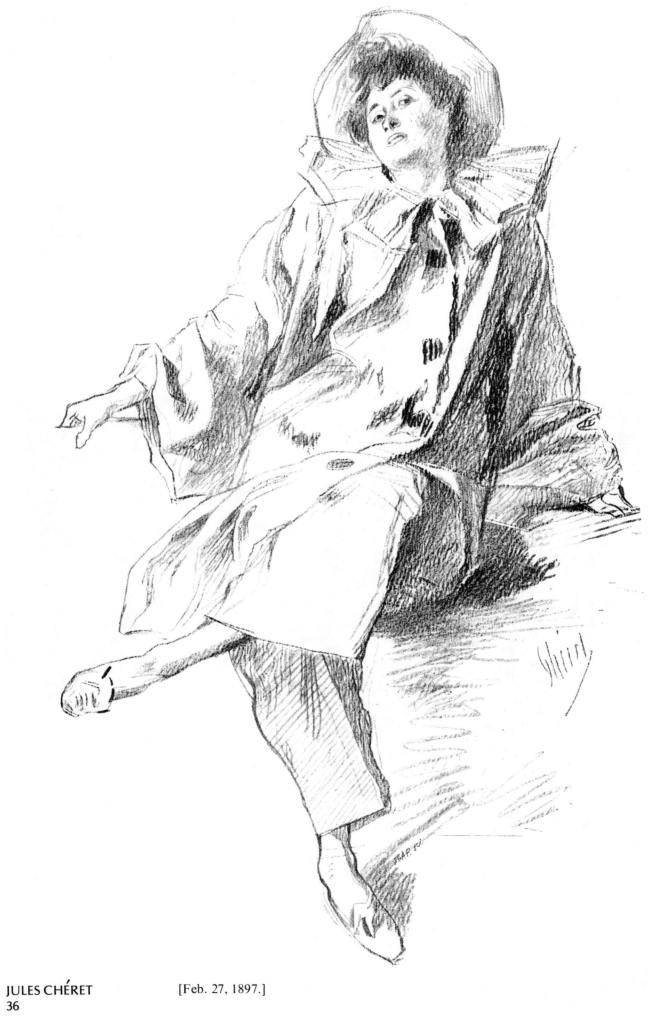

JULES CHÉRET     [Feb. 27, 1897.]
36

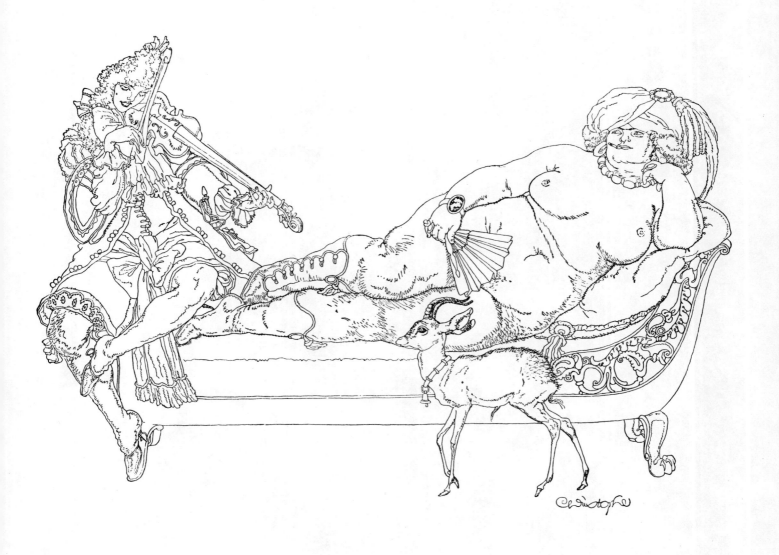

# Der Waldläufer von M. Schwann

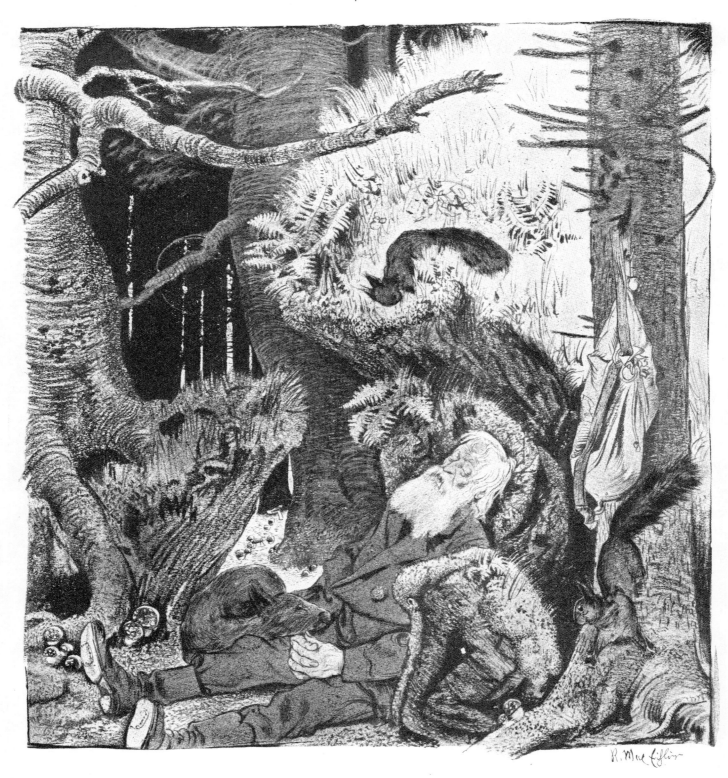

**The Forest Ranger.** [Illustration for a story by M. Schwann.] [Aug. 1, 1896.]

**The Morning Visit.** [Illustration for a poem by M. F. Verdier.] [Oct. 24, 1896.]

REINHOLD MAX
EICHLER
39

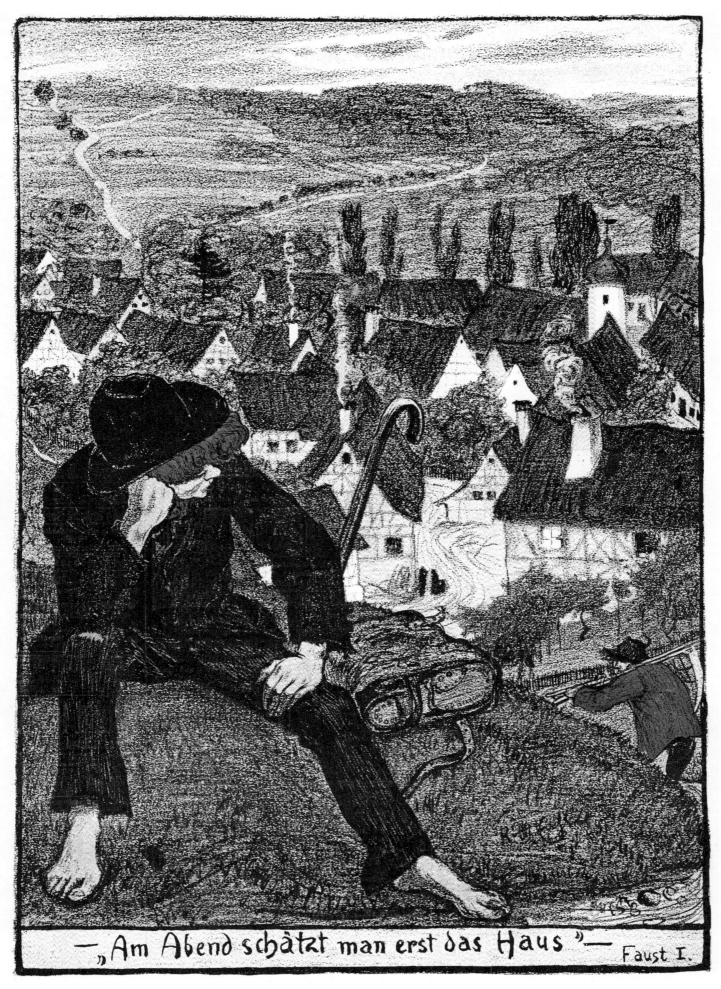

„Am Abend schätzt man erst das Haus"— Faust I.

REINHOLD MAX
EICHLER
40

"At evening one begins to appreciate a home": *Faust*, Part I. [Vol. II (1897/8),
No. 11.]

# Die Malefiz!

„Jessas Maria, bin i wieder d'rschrock'n. Die Malefiz! — Oan so z' d'rschreck'n, die Malefiz oallweil' — die Malefiz, die Malefiz!"

**Damn!** "Jesus Mary, was I scared! Damn! To scare somebody like that! Damn, I say! Damn! Damn!" [Vol. II (1897/8), No. 38.]

# Der Sieger von Sadowa

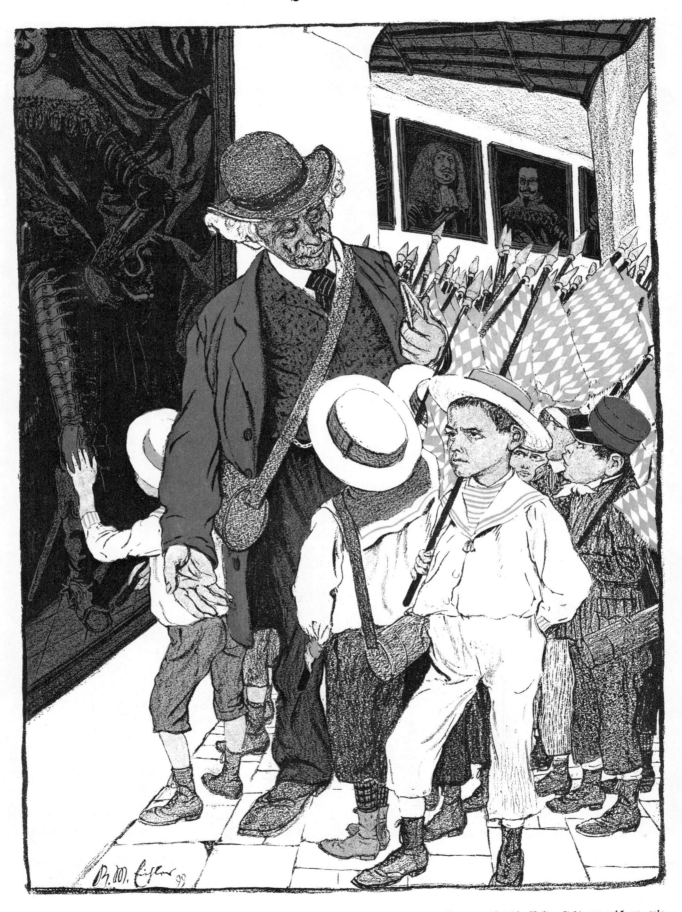

„Ja, liebe Schüler, hohe Herkunft macht es nicht allein, den Fleißigen und Strebsamen gehört die Welt. Seht nur mich an, wie weit es der Mensch durch Fleiß und Strebsamkeit bringen kann!"

REINHOLD MAX
EICHLER

42

**The Victor of Sadowa.** "Yes, my dear pupils, high birth is not everything. The world belongs to the industrious and ambitious. Just look at me and see how far man can go through industry and ambition!" [On Sadowa, see page xviii .] [Vol. IV (1899/1900), No. 14.]

# Ein Pessimist

,,Na, Burſch, du wirſt dich auch mal verdammt wundern, was das Leben iſt.   Das Blumenpflücken hört dann bald auf."

**A Pessimist.** "Yes, Sonny, some day you too will wonder what the hell life is all about. Then you'll quit picking flowers." [Vol. **IV** (1899/1900), No. 30.]

# Würdigung

BREND'AMOUR, SIMHART & C?.

*„Herrgott, muß dös fad sein, wenn ma so vornehm is!"*

REINHOLD MAX
EICHLER
44

**Appreciation.** "Lord, it must be dull to be that aristocratic!" [Vol. V (1900/1), No. 22.]

## Der Predigtamtskandidat

„Ach, Herr Kandidat, laffen Sie mich; ich muß jetzt wieder in die Küche, sonst brennt mir meine Gans an!" — „Josephine, sei unbesorgt; so lange du bei mir bist, steht deine Gans in Gottes Hand!"

**The Candidate for Holy Orders.** "Please let me go, Your Reverence. I must get back to the kitchen, or my goose will burn!" "Don't worry, Josephine. As long as you're with me, your goose is in God's hands!" [Vol. IV (1899/1900), No. 7.]

# Au weh!

„So 'n Reinfall — jetz' is der Knabe doch 'n Mä'chen!"

**Ouch!** "What a washout! The boy turned out to be a real girl!" [Feb. 8, 1926.]

Nach der Orgie

„Rülps' mal, Theo, det Elend verreißt
mir 's Herz!"

**After the Orgy.** "Give a belch, Ted, poverty tears my heart out!" [Mar. 1, 1926.]

GEORGE GROSZ

# Der Lenz ist da

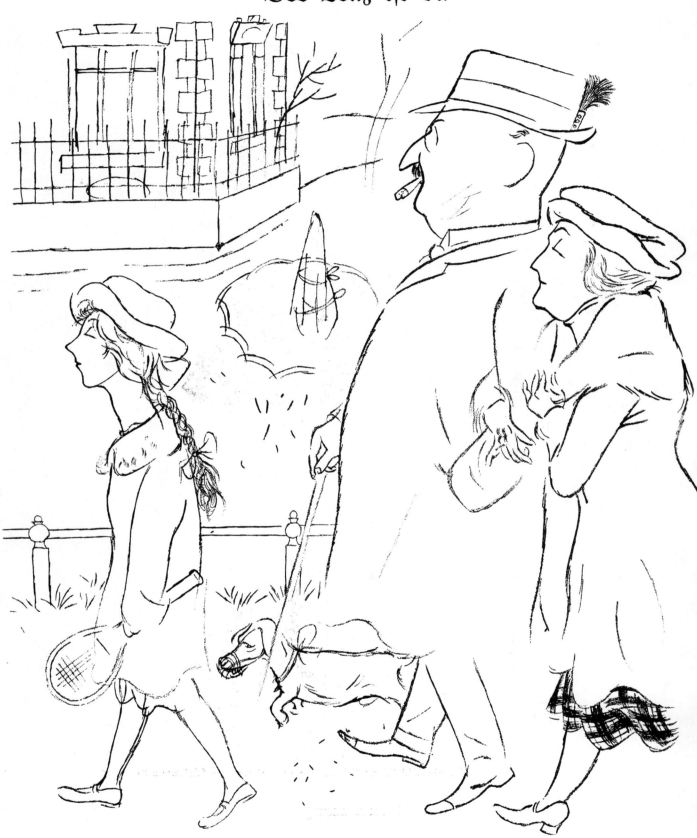

„Nee, nee, Emilje, mich bringste nich mehr in 'n Zoo — da gommste uff falsche Gedanken."

**Spring Is Here.** "No, no, Emily, you won't get *me* to the zoo again—you're barking up the wrong tree." [Mar. 29, 1926.]

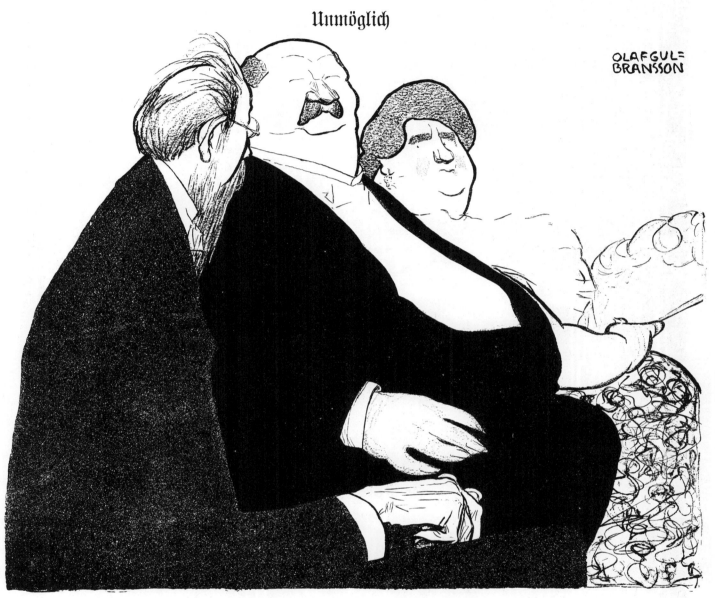

Unmöglich

OLAFGUL=
BRANSSON

„Kinder haben Sie nicht, Herr Guschelbauer?" — „Nein, wir sind doch keine Akrobaten."

**Impossible.** "You have no children, Mr. Guschelbauer?" "No, we aren't acrobats, you know." [Vol. VII (1902/3), No. 47.]

OLAF GULBRANSSON

# Im Nachtcafé

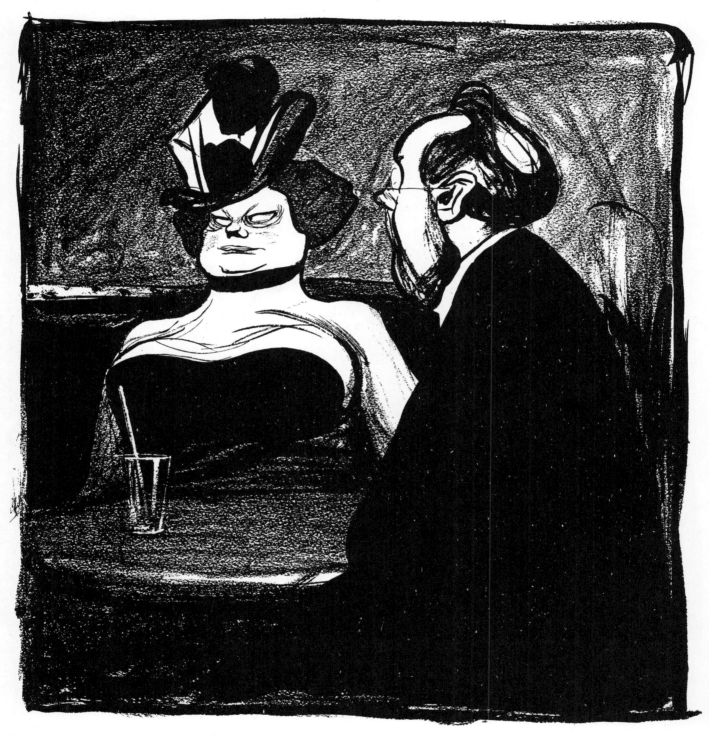

„Fräulein, haben Sie in Ihrem Charakter auch etwas, wogegen Sie fortwährend ankämpfen müssen?"

**In the Night Spot.** "Miss, do you too have something in your character that you constantly have to fight against?" [Vol. VIII (1903/4), No. 5.]

# Ein Vorschlag zur Güte

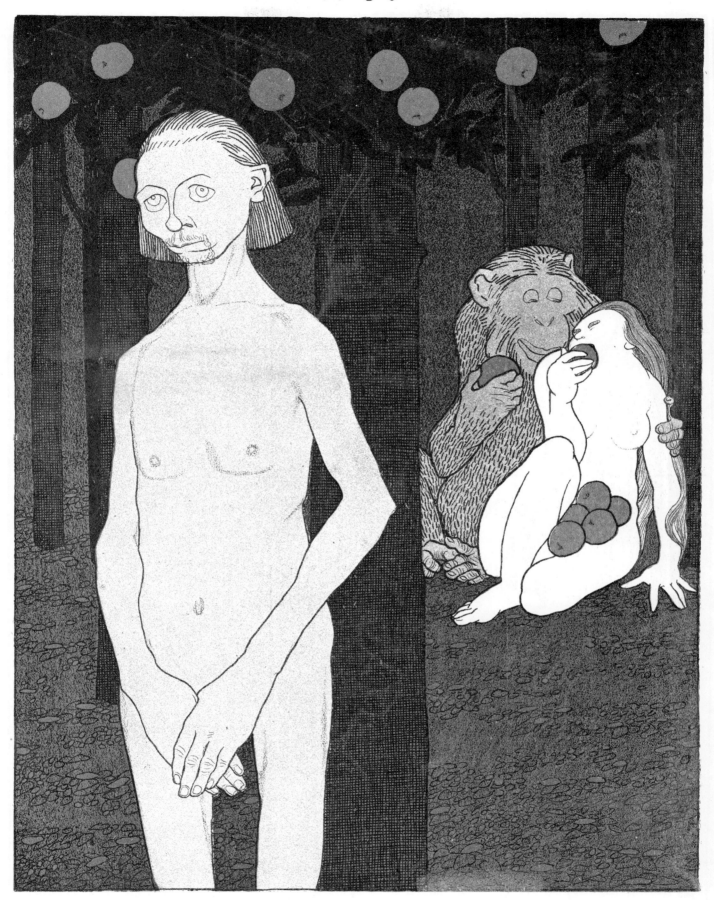

Wir können die biblischen Ueberlieferungen sehr wohl mit der Naturwissenschaft in Einklang bringen. Nach den neuesten Forschungen hat Adam von Eva den Apfel nicht angenommen; unsere Stammutter gab ihn deshalb einem Gorilla. Und so ist die darwinistische Lehre bewiesen.

**A Friendly Suggestion.** We can now bring the stories in the Bible into agreement with the natural sciences. According to the latest research, Adam did not accept the apple from Eve; our first mother therefore gave it to a gorilla. And thus Darwin's theory is proved. [Vol. VIII (1903/4), No. 31.]

OLAF GULBRANSSON

51

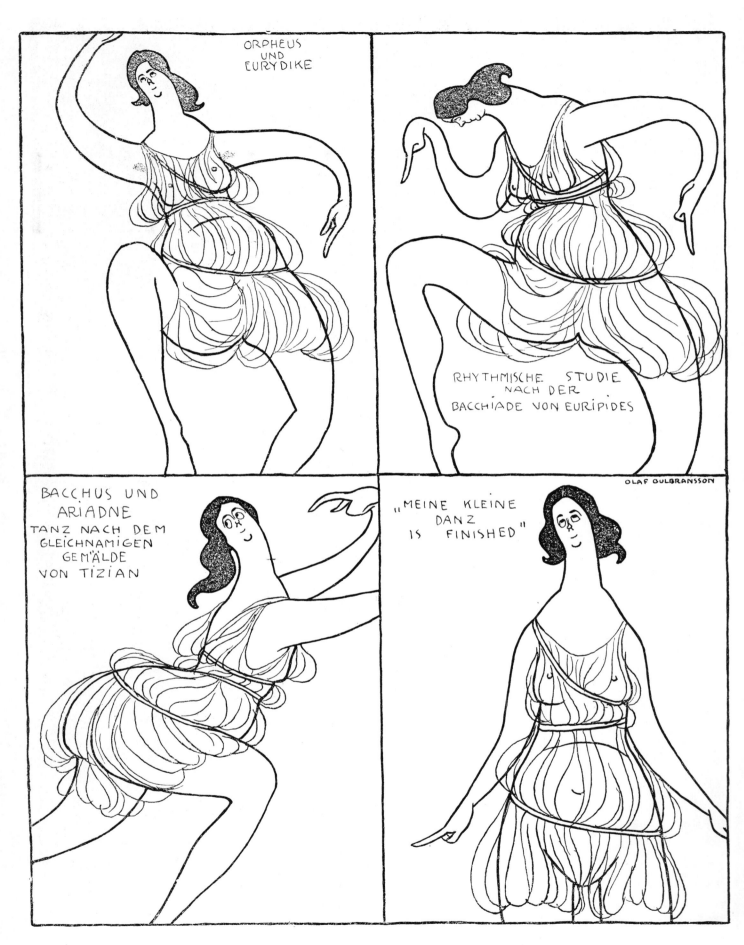

ORPHEUS
UND
EURYDIKE

RHYTHMISCHE STUDIE
NACH DER
BACCHIADE VON EURIPIDES

BACCHUS UND
ARIADNE
TANZ NACH DEM
GLEICHNAMIGEN
GEMÄLDE
VON TIZIAN

„MEINE KLEINE
DANZ
IS FINISHED"

OLAF GULBRANSSON

OLAF GULBRANSSON
52

**Isadora Duncan.** Orpheus and Eurydice. Rhythmic study based on Euripides'
*Bacchae.* Bacchus and Ariadne, a dance based on Titian's painting of that name.
"Meine kleine Danz is finished." [Vol. VIII (1903/4), No. 47.]

# Tivoli

„Ich wollte, Minchen, du könntest auch so empfinden wie ich, der ich die Erfinder der herrlichen Satzform ‚facere non possum ut non oder quin‘ leibhaftig zwischen diesen Trümmern einherwandeln sehe.“

**Tivoli.** "Min, I wish you could have the same sensation that I do of seeing the inventors of that splendid grammatical construction *facere non possum ut non* or *quin* walking about amongst these ruins in the flesh." [This is the town of Tivoli outside of Rome, the ancient Tibur. The Latin construction admired by the pedantic *Gymnasium* professor means "I cannot help (doing something)."] [May 11, 1908.]

OLAF GULBRANSSON

53

# Ein Schwächeanfall

*„Schau, schau!"*

– – – –

– – – –

*„Gelt, Alterchen, jetzt muß ich dir wieder auf die Beine helfen?"*

**OLAF GULBRANSSON**
**54**

**A Fit of Debility.** "Look at that!" . . . "Eh, old man, now I've got to help you up again?" [May 17, 1909.]

# Die große Mode

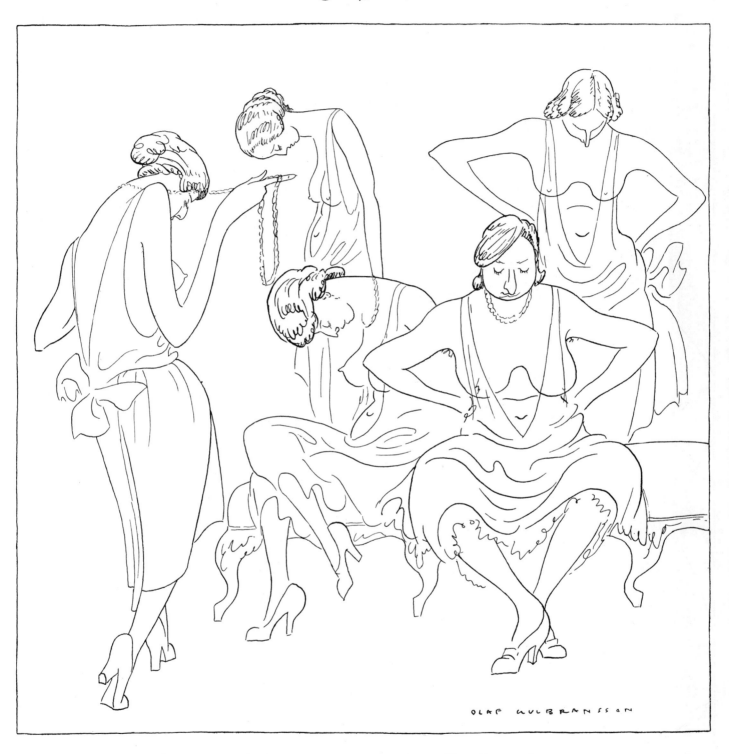

Angeregt durch Rabindranath Tagore übt sich Berlin W. in Nabelbeschauung.

**The Height of Fashion.** Inspired by Rabindranath Tagore, fashionable Berlin practices contemplation of the navel. [May 18, 1921.]

OLAF GULBRANSSON

# Amiesemang

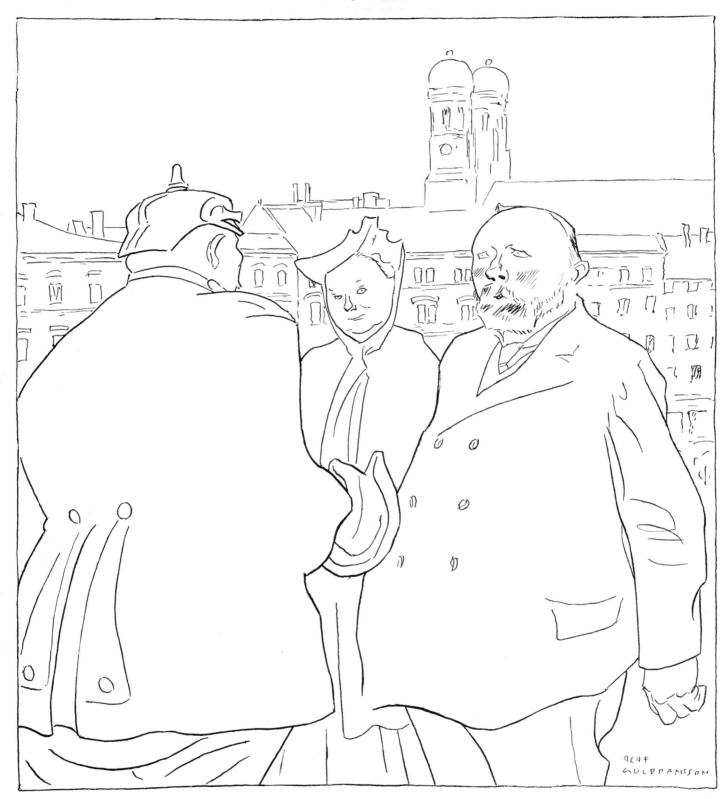

„Entschuldjen Se gietigst, ham Se hier nich e bißchen was Lasterhaftes? Awwr nich zu schtark, daß m'r ooch seine Frau mitnähm' gann!"

OLAF GULBRANSSON
56

**Entertainment.** "Excuse me, please, don't you have anything depraved here? But not too bad, so a man can take his wife along." [The towers of the Frauenkirche show that these tourists are in Munich. Their dialect is from quite a different part of Germany.] [Jul. 12, 1922.]

„Sie sind reizend, Fred! Ich bewundere Ihre geschmackvoll zusammengestellte Individualität."

**Calm Sea.** "You have such charm, Fred! I admire your tastefully composed personality." [Jul. 26, 1922.]

OLAF GULBRANSSON

# Abschied

„Und bring' mir ein Feigenblatt aus Italien mit. Einen Anzug kann ich mir doch nicht mehr kaufen."

OLAF GULBRANSSON
58

**Departure.** "And bring me back a fig leaf from Italy. I can't afford a suit any more."
[Oct. 18, 1922.]

# Der letzte Halt

„Ich glaube nicht mehr an Gott, ich glaube nicht mehr an die Menschen — und jetzt wollen Sie mir auch noch die Karten verekeln!"

**The Last Foothold.** "I don't believe in God any more, I don't believe in people any more—and now you want to make me sick of cards, too!" [Jan 21, 1923.]

# Nach Tisch

„Natürlich, du mußt immer den großen Bengel auf dem Schoß haben!" — „Laß mich doch. Du brauchst deine Zeitung zur Verdauung — ich meine Mutterliebe."

OLAF GULBRANSSON
60

**After Dinner.** "Of course, you still have to hold that big gawky boy on your lap!" "Let me alone. You need your paper for your digestion, I need my motherly love." [Jan. 28, 1924.]

# Baedeker

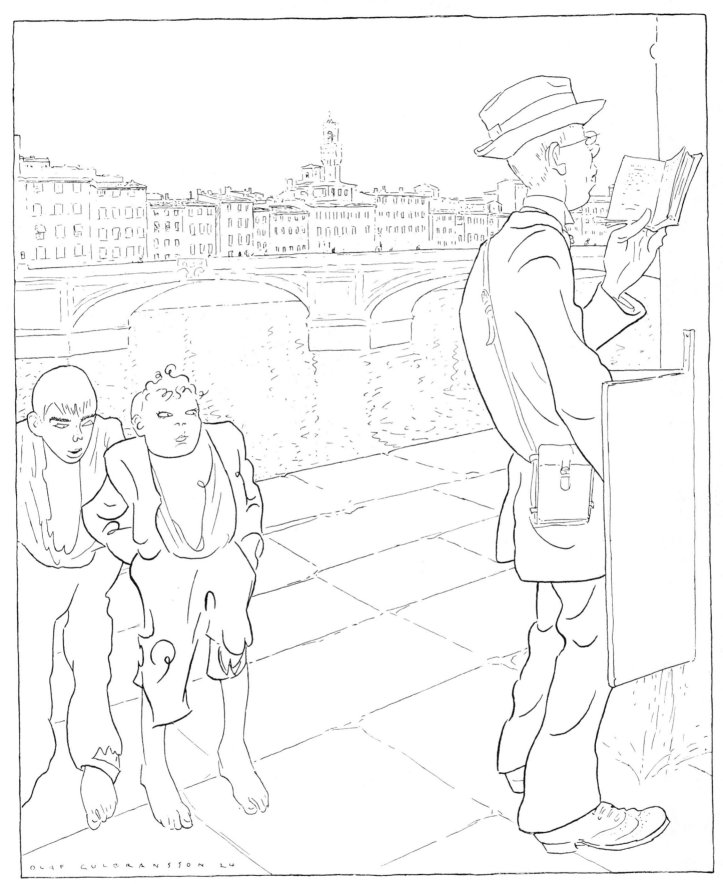

„Nicht mal das kann er auswendig, der Tedesco!"

**Baedeker.** "The *tedesco* can't even do *that* without his book!" [The scene is Florence.]
[Oct. 27, 1924.]

OLAF GULBRANSSON

# Macht der Töne

„Wenn ich sie spielen höre, lieb' ich sie beide; nach dem Konzert ist mir ein Boxer lieber."

OLAF GULBRANSSON
62

**The Power of Music.** "When I hear them play, I love them both. After the concert I prefer a prizefighter." [Mar. 8, 1926.]

# Ein Wiederfehen

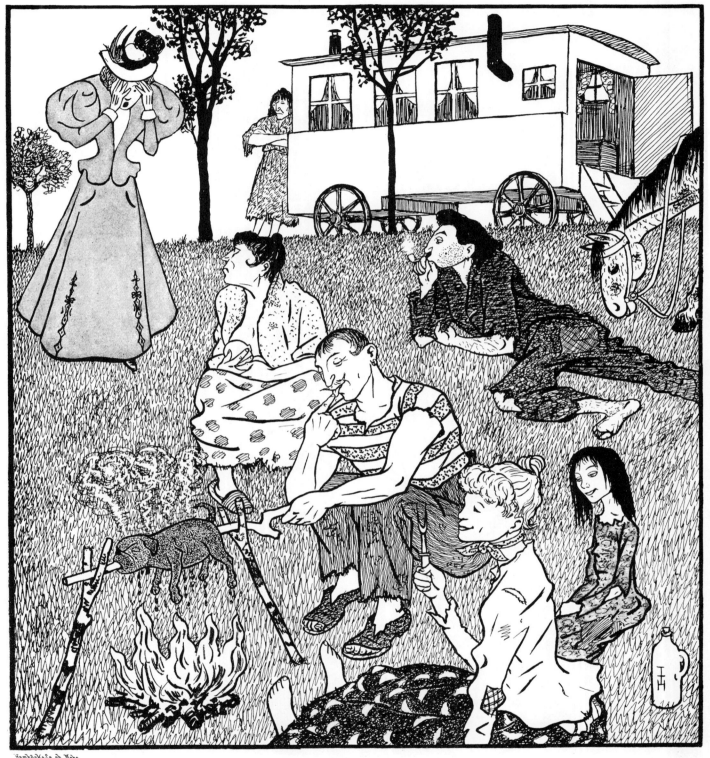

„O Puzzi, muß ich so dich wiederfinden!"

**They Meet Again.** "Oh, Puzzi, is this how I find you?'' [Nov. 21, 1896.]

# Bilder aus dem Familienleben Nr. 2

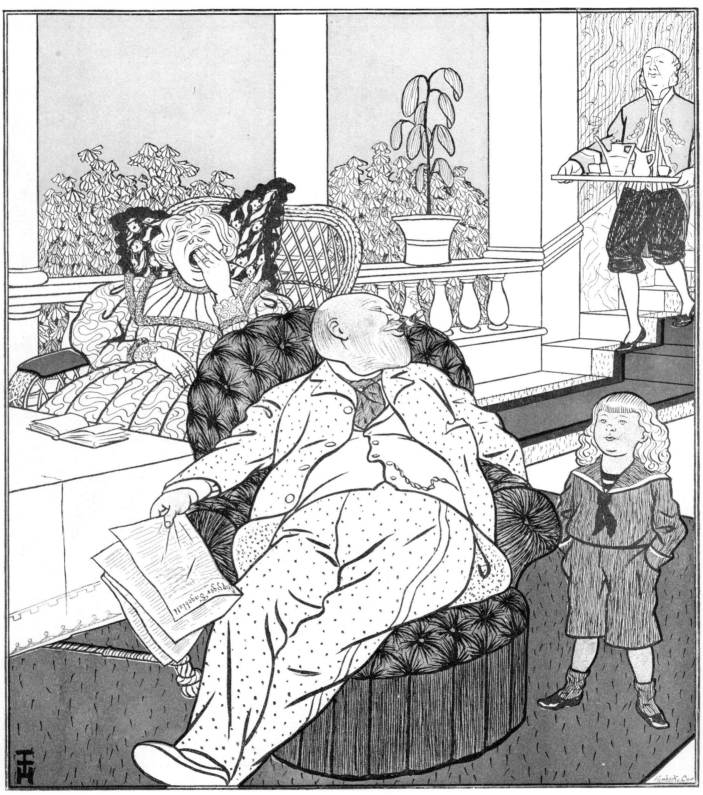

„Papa, was willst du eigentlich 'mal werden?"

Scenes of Family Life, No. 2. "Papa, what do you want to be when you grow up?"
[Dec. 5, 1896.]

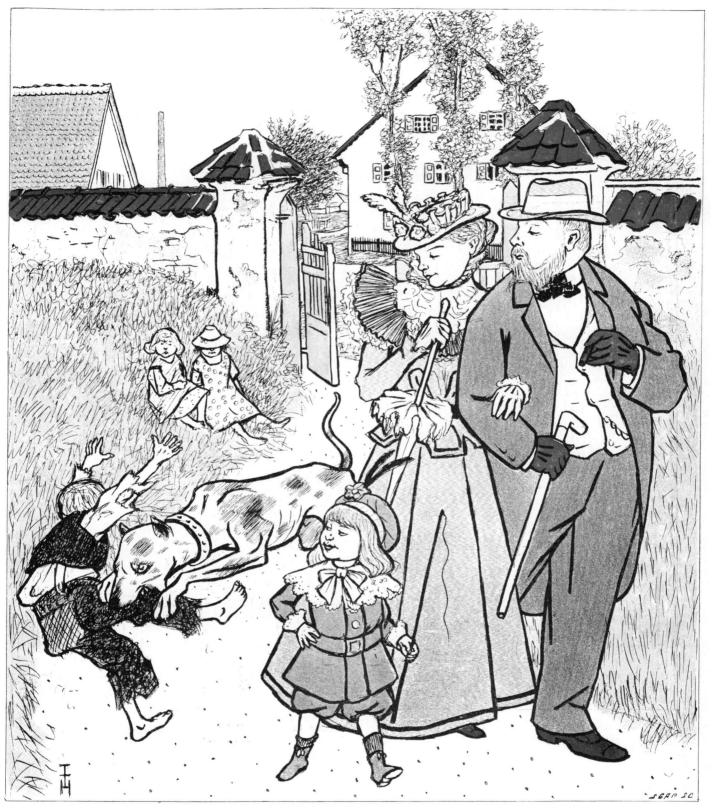

„Pfui, Cäſar, ſchämſt du dich nicht, ſo eine ſchmutzige Hoſe in den Mund zu nehmen!"

**Cultivation of the Finer Feelings.** "Tut, tut, Caesar, aren't you ashamed to take such dirty trousers in your mouth?" [Vol. II (1897/8), No. 11.]

THOMAS THEODOR
HEINE

Des Gymnasiasten erste Liebe

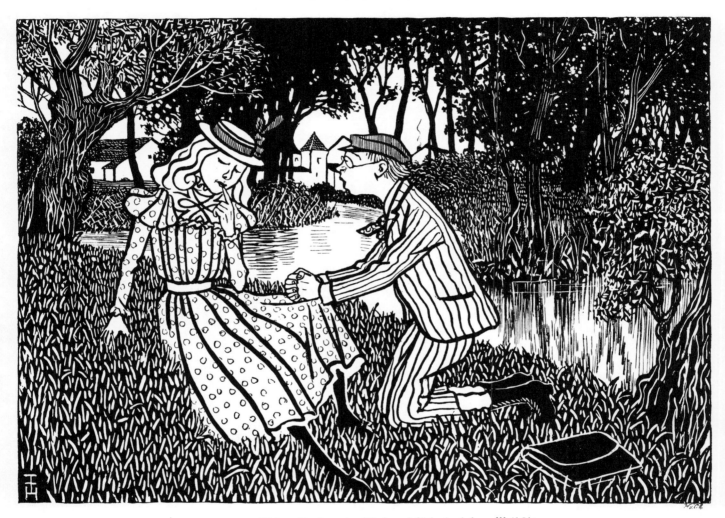

„Elvira, schwöre mir, bist du wirklich ein hehres Weib?!"

THOMAS THEODOR
HEINE
66

**The High-School Boy's First Love.** "Elvira, swear it to me, are you truly an exalted woman?" [Vol. II (1897/8), No. 21.]

## Streikbrechers Töchterlein

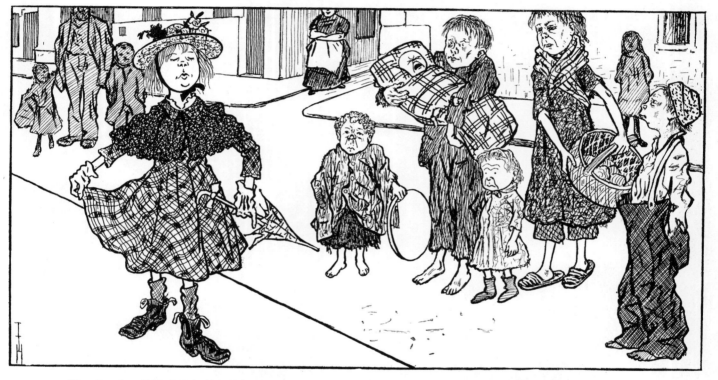

„Schaugt's, wia nobi die Huberin ihra Lisl z'ammricht', weil der Huber wieder in d' Arbeit geht. Wia a Herrschaftskind kummt's daher."

**The Strikebreaker's Little Girl.** "Look how fancy Mrs. Huber gets up her Lizzie, 'cause Huber is working again. She goes down the street like a rich kid." [Vol. II (1897/8), No. 34.]

THOMAS THEODOR
HEINE
67

# England in China

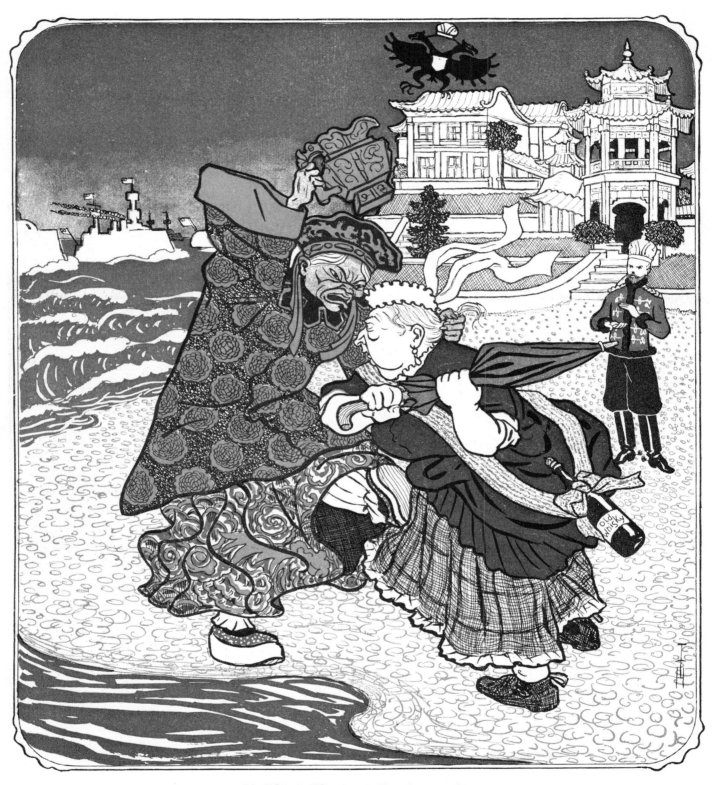

Die Mütter! Mütter! — 's klingt so wunderlich!

(Faust II.)

THOMAS THEODOR HEINE

68

**England in China.** "The Mothers! Mothers! It sounds so odd!" (*Faust*, Part II). [The "Mothers" are earth goddesses visited by Faust in Goethe's poem. Depicted are Queen Victoria and the Dowager Empress Tzu Hsi, with Czar Nicholas II looking on.] [Vol. III (1898/9), No. 29.]

# Martinique

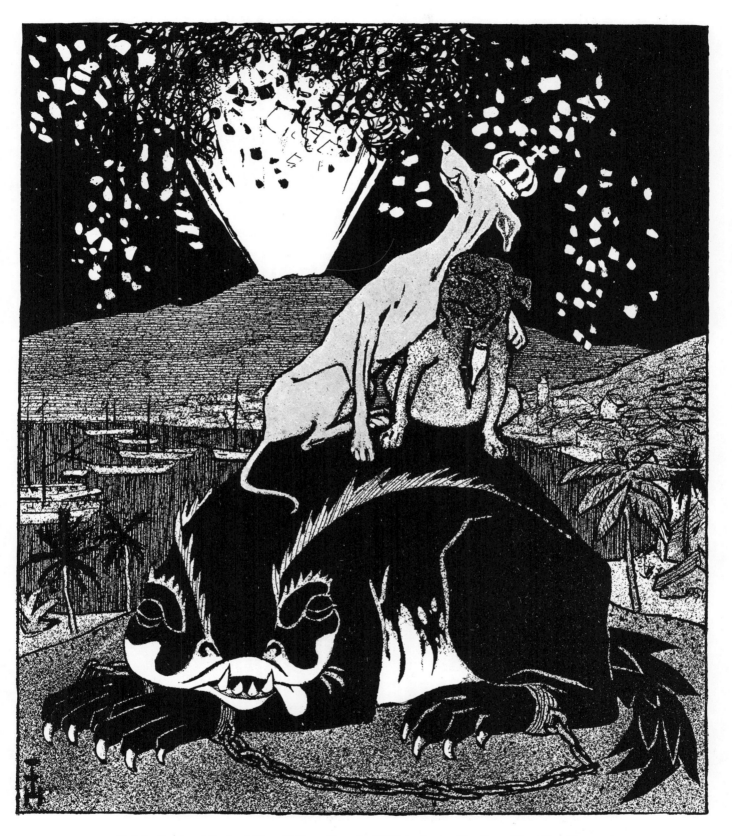

Auch in Europa giebt es erloschene Vulkane, die uns plötzlich durch neue Eruptionen überraschen können.

**Martinique.** Europe, too, has dormant volcanoes that may suddenly surprise us with new eruptions. [The most catastrophic eruption of Mont Pelé in Martinique occurred on May 8, 1902.] [Vol. VII (1902/3), No. 11.]

# Kolonialmächte

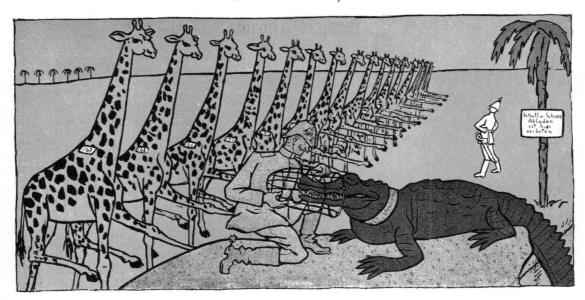

So kolonisiert der Deutsche,

So kolonisiert der Engländer,

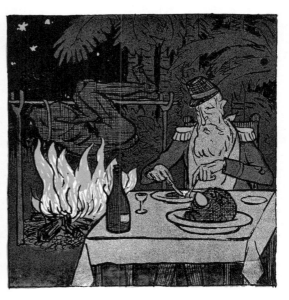

So der Franzose                    und so der Belgier.

**Colonial Powers.** This is how the German colonizes. [The sign reads: "Dumping refuse or snow here is prohibited."] This is how the Englishman colonizes. And the Frenchman. And the Belgian. [Vol. IX (1904/5), No. 6.]

# Bilber aus dem deutschen Pastorenleben

I.

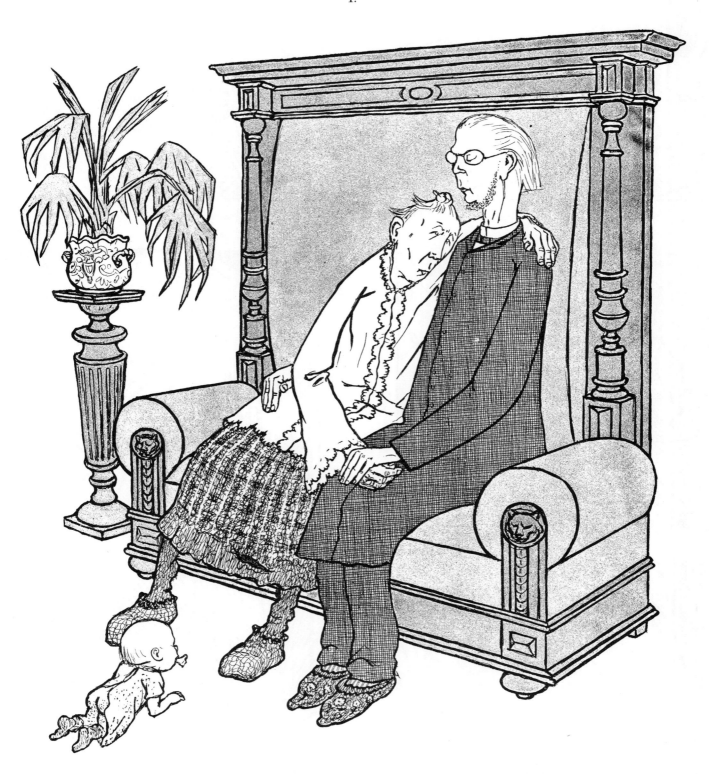

„Sage mir, Gotthold, ist unsere irdische Liebe nicht doch sündhaft?" — „O nein, Mathilde, sündhaft ist nur das Vergnügen."

**Scenes from the Life of German Pastors, No. 1.** "Tell me, Gotthold, isn't our earthly love sinful?" "Oh, no, Mathilde, only pleasure is sinful." [Vol. IX (1904/5), No. 35.]

THOMAS THEODOR
HEINE

# Die Nationen bei einem Eisenbahnunglück

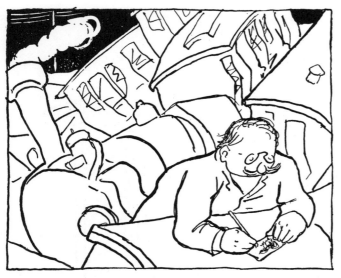

Der Deutsche schreibt eine Ansichtskarte.

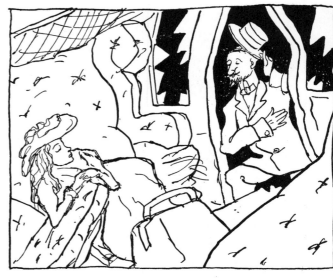

Der Franzose macht eine Damenbekanntschaft.

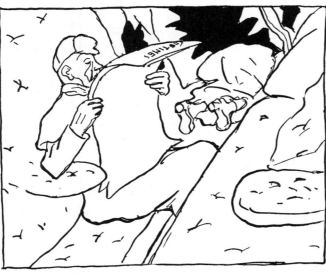

Der Engländer läßt sich in seiner Lektüre nicht stören.

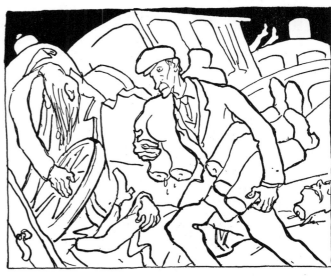

Der Amerikaner sammelt Leichenteile für die Wurstfabriken von Chicago.

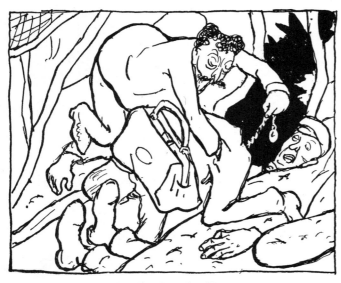

Der Süd-Europäer stiehlt.

Der Russe explodiert, weil er zufällig eine Bombe in der Tasche hat.

THOMAS THEODOR HEINE
72

**Various Nationalities in a Railroad Accident.** The German writes a picture postcard. The Frenchman scrapes acquaintance with a lady. The Englishman reads on undisturbed. The American gathers parts of bodies for the Chicago sausage factories. The South European steals. The Russian explodes because he happens to have a bomb in his pocket. [Jul. 9, 1906.]

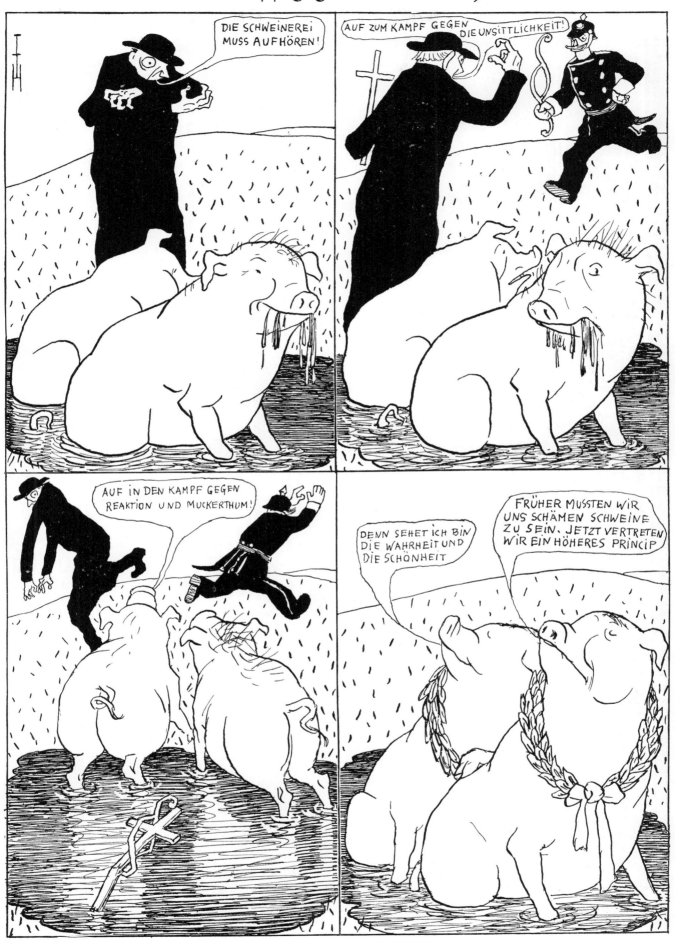

**The Battle Against Morality.** (1) "This swinish filth must cease!" (2) "Onward to the battle against immorality!" (3) "Onward to the battle against reaction and hypocrisy!" (4) "For see, I am truth and beauty." "In the past we had to be ashamed to be pigs. Now we represent a higher principle." [Aug. 20, 1906.]

THOMAS THEODOR
HEINE
73

# Frühlingssonne

„Zieh die Vorhänge zu, die Sammetmöbel verschießen sonst!"

THOMAS THEODOR
HEINE
74

**Scenes of Family Life, No. 44: Spring Sunshine.** "Close the curtains or the velvet
furniture will fade!" [May 13, 1907.]

# Die Wirkung auf das Ausland

„Jetzt verstehe ich, warum sich die Homosexualität in Deutschland so verbreitet!"

**The Effect on Foreign Countries.** "Now I understand why homosexuality is spreading like that in Germany!" [May 25, 1908.]

THOMAS THEODOR
HEINE

75

# Deutsche Künstler

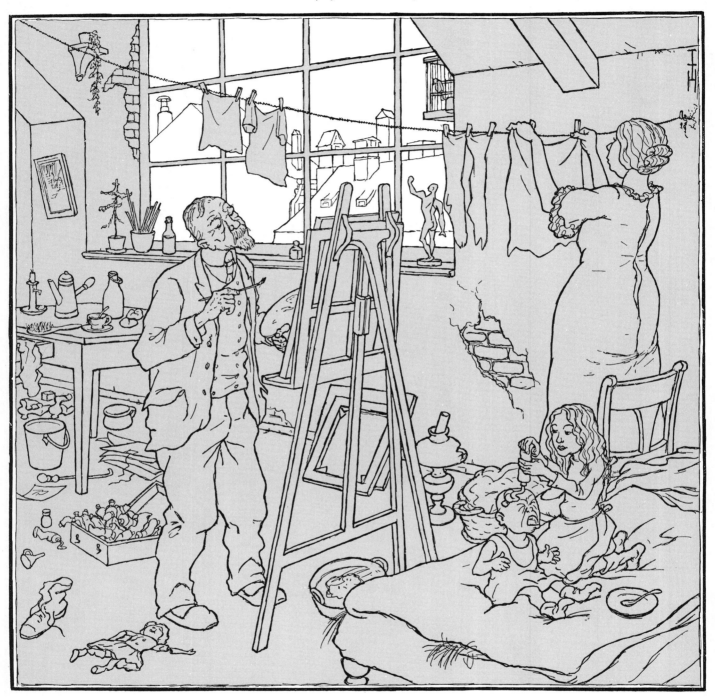

„Eigentlich müßte man Franzose sein oder tot oder pervers, am besten ein toter perverser Franzose — dann könnte man leben!"

THOMAS THEODOR
HEINE
76

**German Artists.** "Actually, if one were a Frenchman, or dead, or a pervert—best of all: a dead perverted Frenchman—then one could live!" [Oct. 21, 1910.]

# Die neuen Steuern

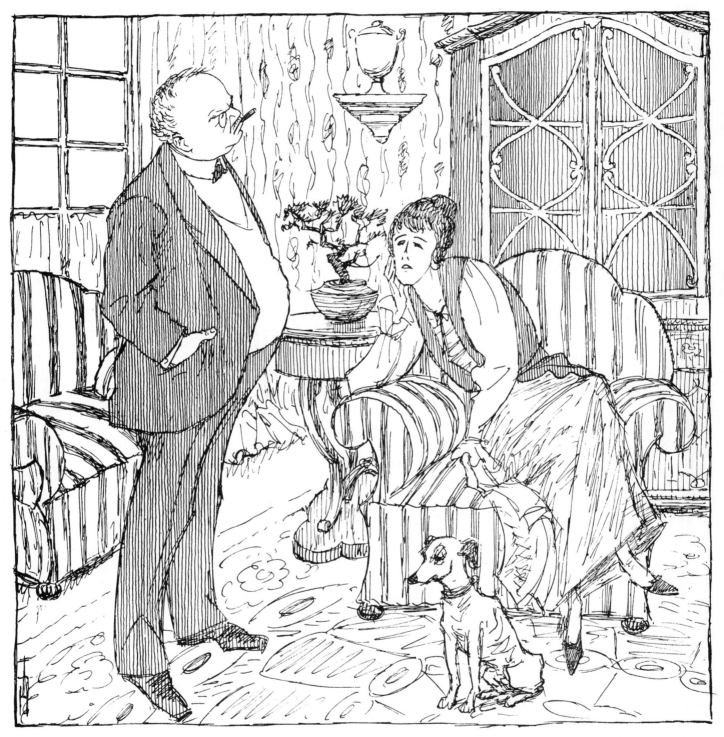

„Unfer Geld können fie uns nehmen, aber unfere Bildung können fie uns nicht nehmen." — „Ja, wenn man wenigftens die Wahl hätte."

**The New Taxes.** "They can take our money away from us, but they can't take away our education." "If we only had the choice!" [Aug. 8, 1919.]

THOMAS THEODOR
HEINE

# Realismus

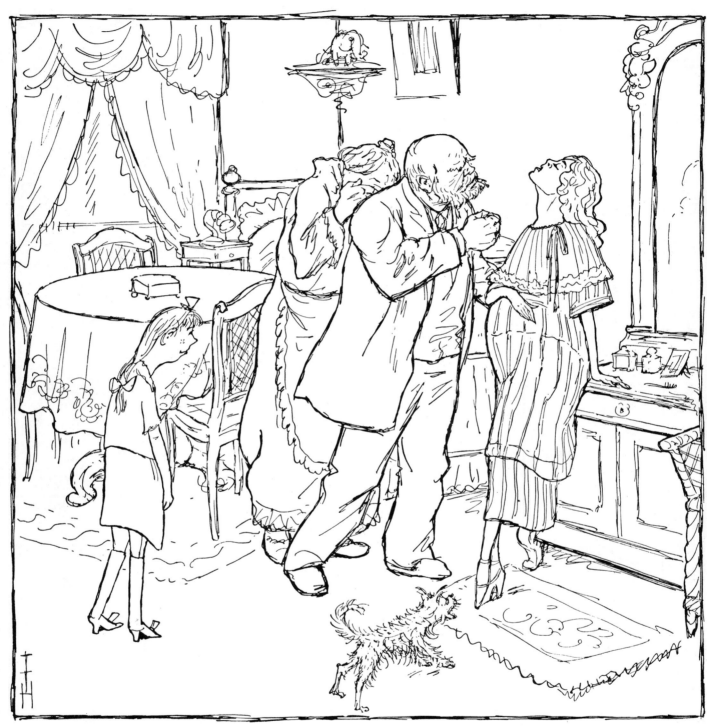

„Ihr müßt mir verzeihen, liebe Eltern! Es ist mir bei einer Kinoaufnahme für einen Aufklärungsfilm passiert!"

THOMAS THEODOR
HEINE

**Realism.** "You must forgive me, my dear parents! It happened while we were shooting an educational film!" [Sept. 2, 1919.]

# Die Enthaltsamen

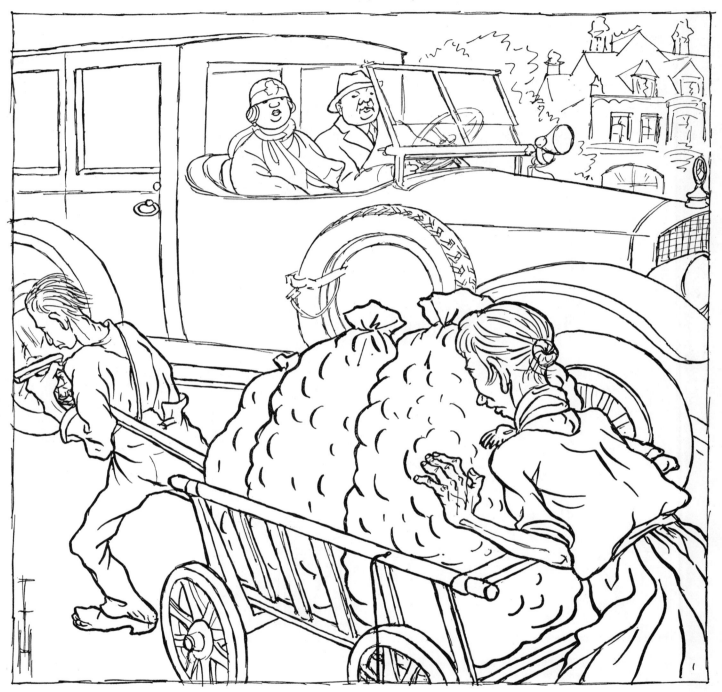

„Wieviel Kartoffeln die Leute brauchen! Wir essen zu Mittag nicht mehr als zwei, drei Kartoffeln — —"

**The Abstemious.** "So many potatoes those people need! We don't eat more than two or three potatoes at lunchtime." [Oct. 13, 1924.]

THOMAS THEODOR
HEINE
79

# Münchner Mäzene

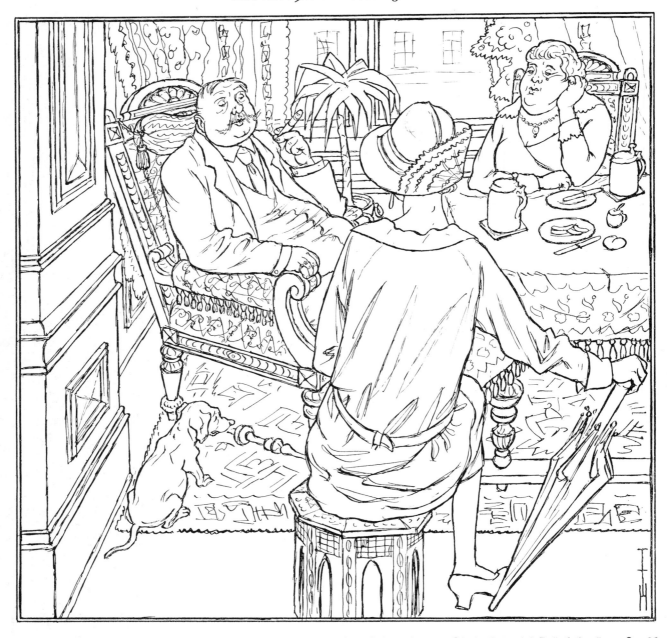

„Ich wundere mich, daß Sie nie etwas für die Kunst getan haben, Herr Schormeier, wo Sie doch so viel Geld haben." — „Ja, schaun S', nacha hätt' i halt nimmer so vui Geld."

THOMAS THEODOR
HEINE

80

**A Patron of the Arts in Munich.** "I'm surprised, Mr. Schormeier, that you've never done anything for the arts, with all your money." "Well, look, then I wouldn't have this much money." [May 25, 1925.]

# Entfettung

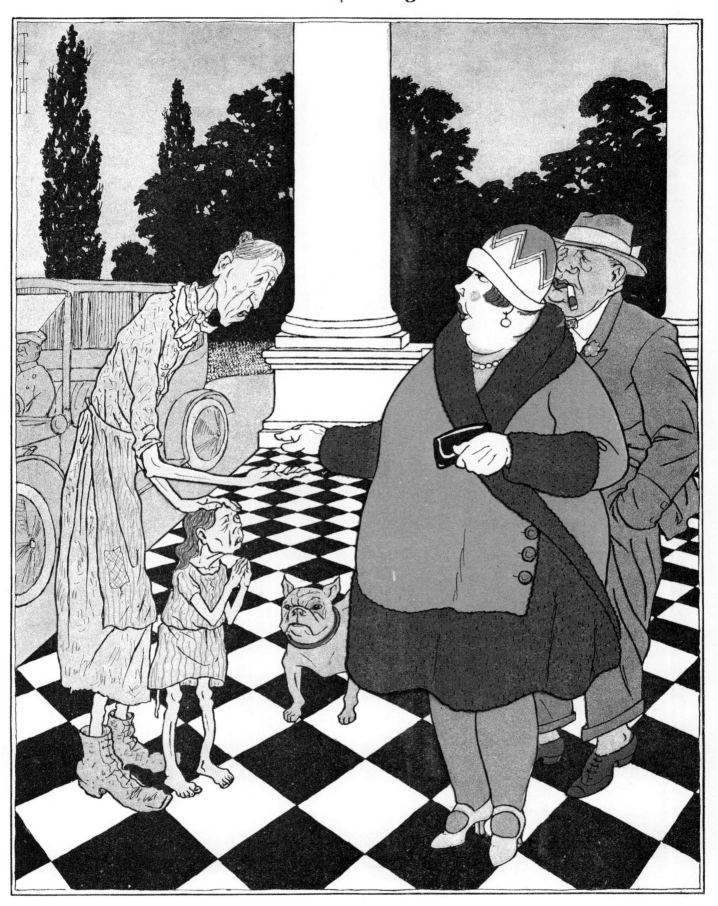

*„Hier haben Sie eine Mark — und nun verraten Sie mir aber auch, wie Sie es angefangen haben, so schlank zu werden!"*

**Reducing Diet.** "Here is a mark for you—and now tell me your secret. How did you go about getting that slim?" [Aug. 24, 1925.]

THOMAS THEODOR
HEINE

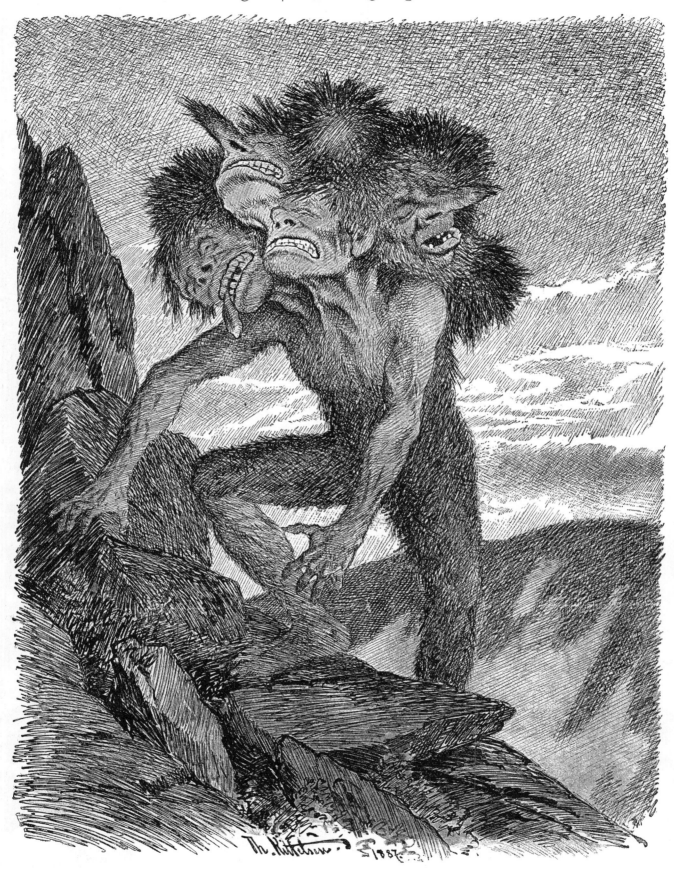

**THEODOR KITTELSEN**     **The Dying Mountain Troll.** [Vol. II (1897/8), No. 31.]

## Das Seegespenst von Th. Kittelsen

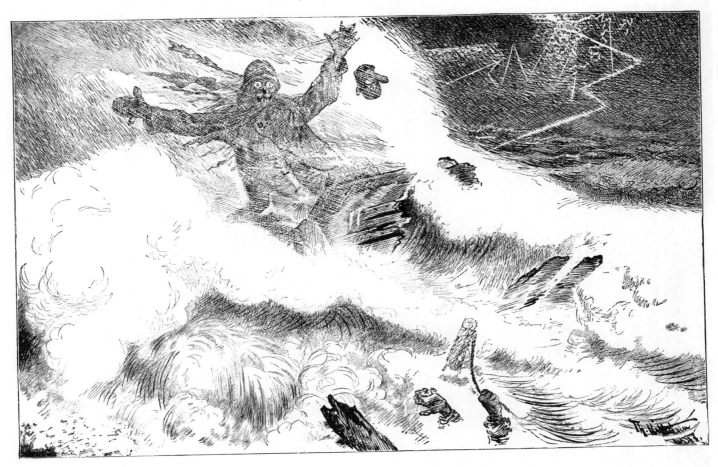

**The Sea Specter.** [Vol. II (1897/8), No. 40.]

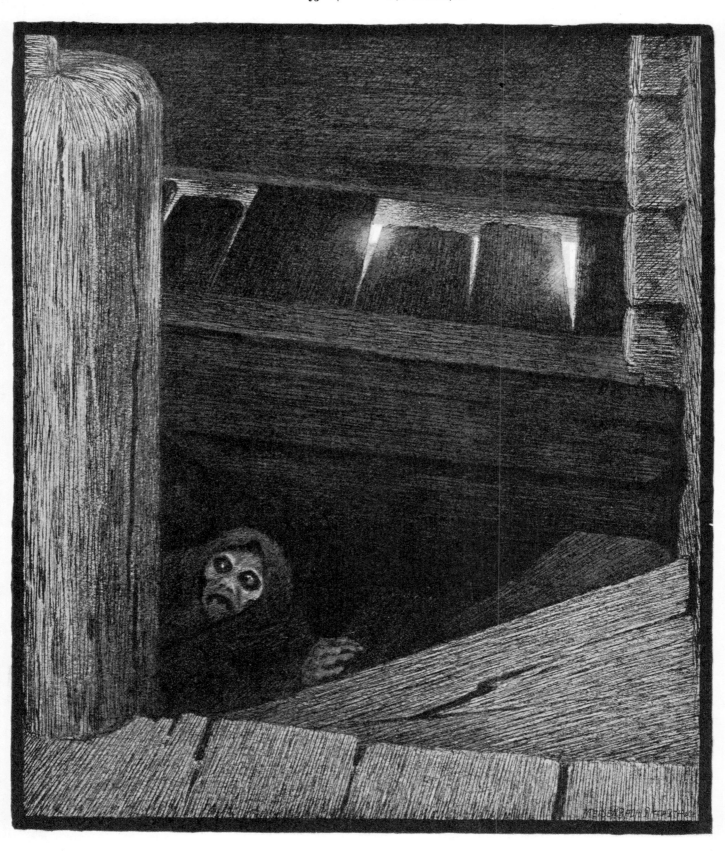

THEODOR KITTELSEN    **The Plague.** [Vol. III (1898/9), No. 2.]
84

## Aus unferes Herrgotts Marionettentheater

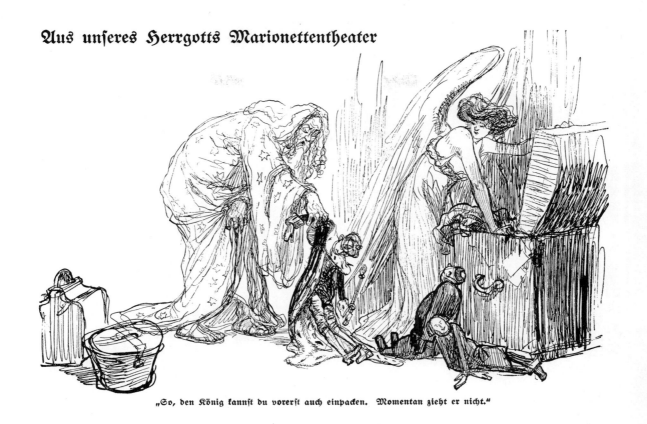

*„So, den König kannst du vorerst auch einpacken. Momentan zieht er nicht."*

## Reisesaison

Above: **From God's Marionette Theater.** "All right, you can pack away the king, too, for the time being. At the moment he isn't bringing in any customers." [Nov. 30, 1908.] Below: **Tourist Season.** [Jul. 14, 1913.]

# Tango

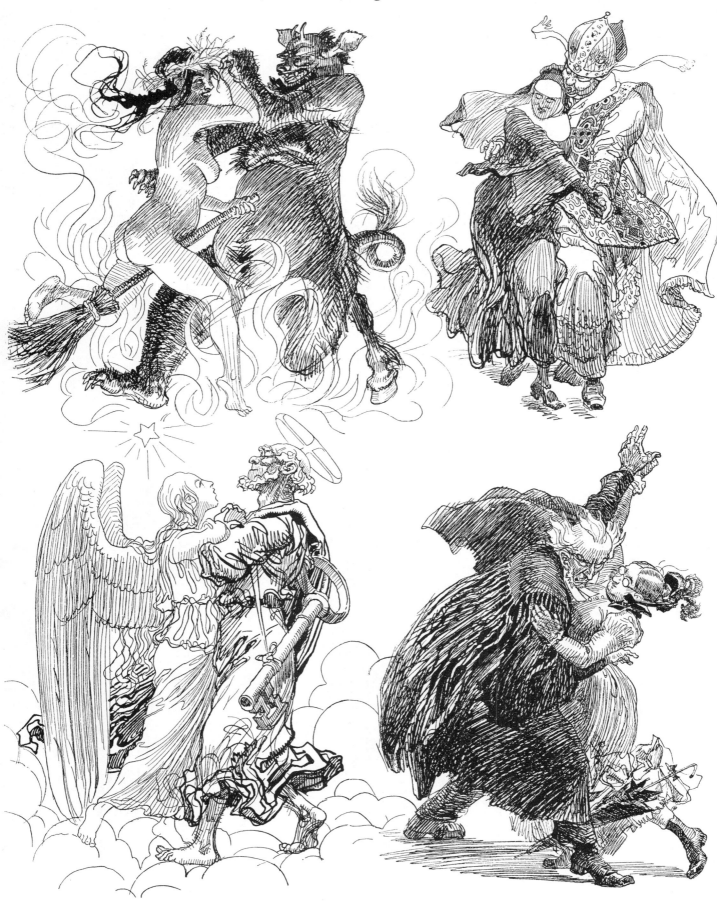

HEINRICH KLEY       **Tango.** [Feb. 23, 1914.]

## Bringt das Gold zur Reichsbank!

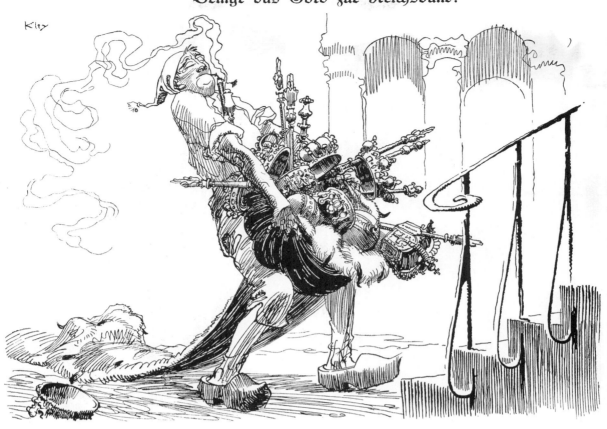

## Trödelmarkt

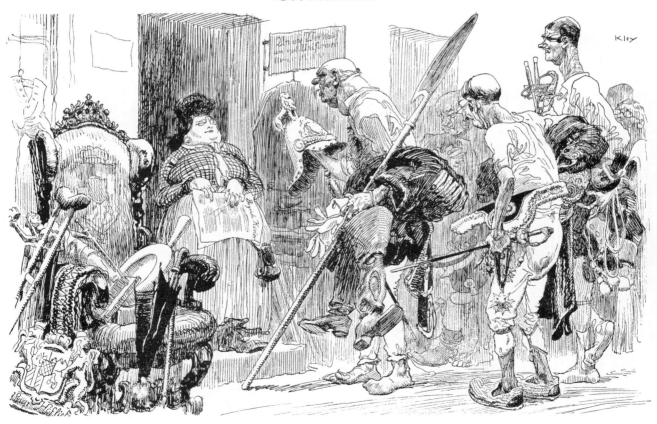

Above: **Turn in Your Gold to the National Bank!** [Michel, the German John Q. Public, is answering the call with the many crowns and scepters that have become useless.] [Dec. 3, 1918.] Below: **Secondhand Shop.** [Military and courtly goods are being disposed of cheaply.] [Dec. 10, 1918.]

HEINRICH KLEY

87

# Am Grenzzaun

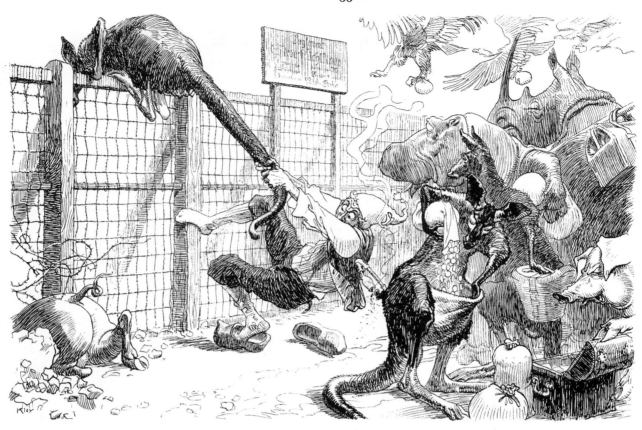

# Der Tanzboden

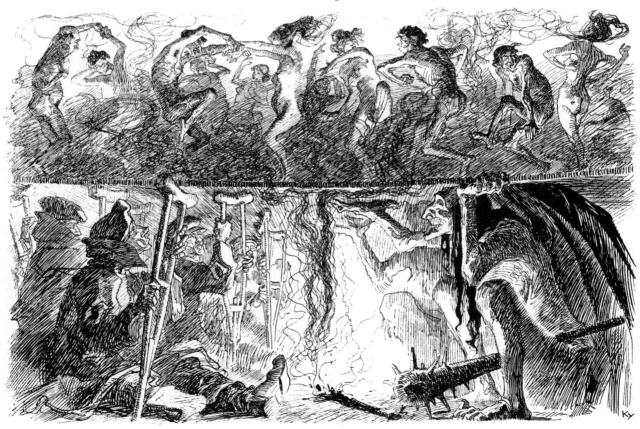

HEINRICH KLEY
88

Above: **At the Border.** [Michel attempts to curb the flight of capital from Germany.]
[Jan. 14, 1919.] Below: **The Dance Floor.** [Feb. 18, 1919.]

# Eine deutsche Mutter

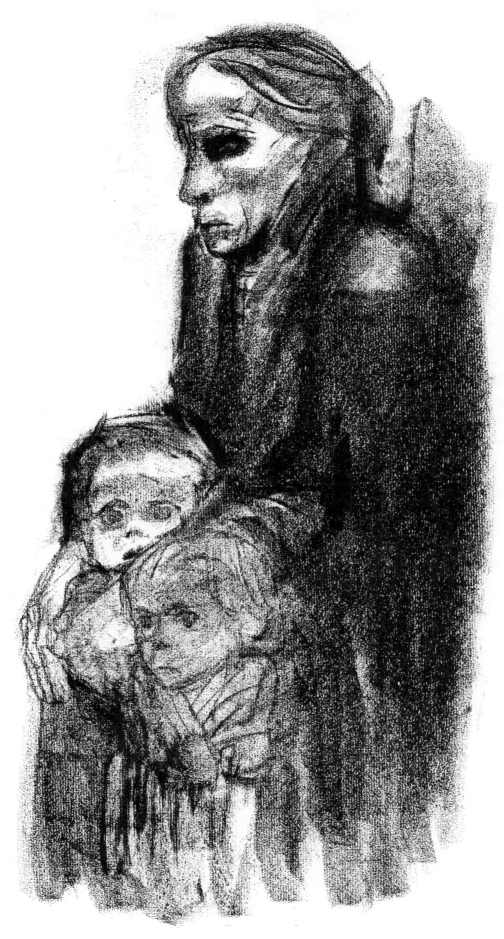

**A German Mother.** [Jan. 21, 1924.]

KÄTHE KOLLWITZ

**Krieg und Frieden**

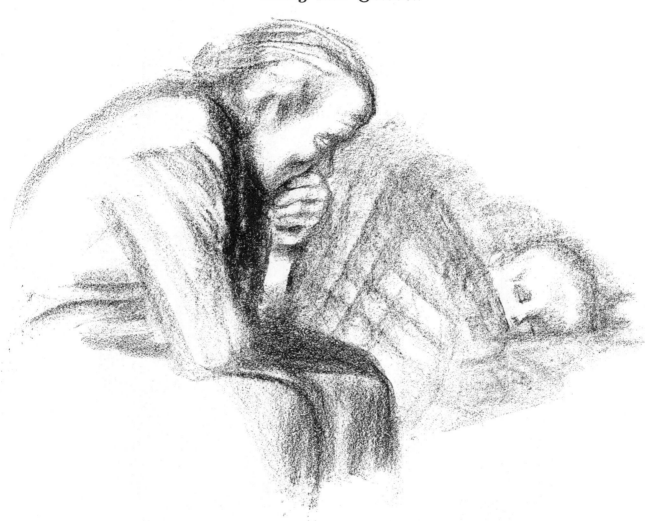

„Wie mein Mann in Frankreich gefallen is, hatt' ich wenigstens nich die Sorge ums Begräbnis!"

**War and Peace.** "Since my husband was killed in France, at least I didn't have to worry about the funeral!" [Feb. 4, 1924.]

# Gewitterregen

**Rainstorm.** [Jun. 18, 1923.]

# Straßenhändler

ALFRED KUBIN
92

**Street Vendor.** [Jul. 2, 1923.]

# Verbummelter Zauberer kehrt wieder heim zu seinem alten Drachen

**Ne'er-Do-Well Sorcerer Comes Back Home to His Old Dragon.** [Aug. 20, 1923.]

ALFRED KUBIN

ALFRED KUBIN
**The Disinherited Man.** [Oct. 1, 1923.]

# Die Poesie der Landstraße

**The Poetry of the Road.** [Jan. 1, 1924.]

# Der Lebenswecker

ALFRED KUBIN
96

**The Awakener of Life.** [Mar. 24, 1924.]

Abſchied des Gerichteten von ſeiner Wohnung

**The Executed Man Takes Leave of His Dwelling.** [Aug. 11, 1924.]

ALFRED KUBIN

# Das Frühstück

ALFRED KUBIN
98

**Breakfast.** [Jan. 12, 1925.]

# Hausmusik

**Music in the Home.** [Apr. 13, 1925.]

## Das ahnende Kalb

**The Apprehensive Calf.** [Apr. 20, 1925.]

# Die Pechschmelze

**The Pitchboilers' Shed.** [May 11, 1925.]

# Die Heilquelle

ALFRED KUBIN
102

**The Mineral Spring.** [May 25, 1925.]

# Juli

**July.** [Jul. 13, 1925.]

# Die ungleichen Brüder

**The Dissimilar Brothers.** [Aug. 17, 1925.]

# Rasputins Ermordung

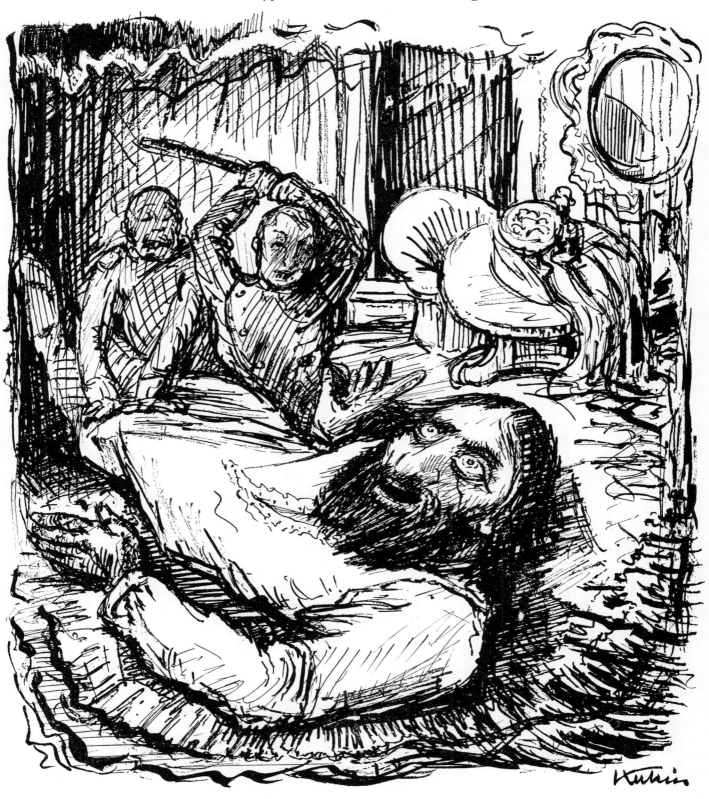

**The Assassination of Rasputin.** [Aug. 24, 1925.]

# Ein unerwünschter Gaft

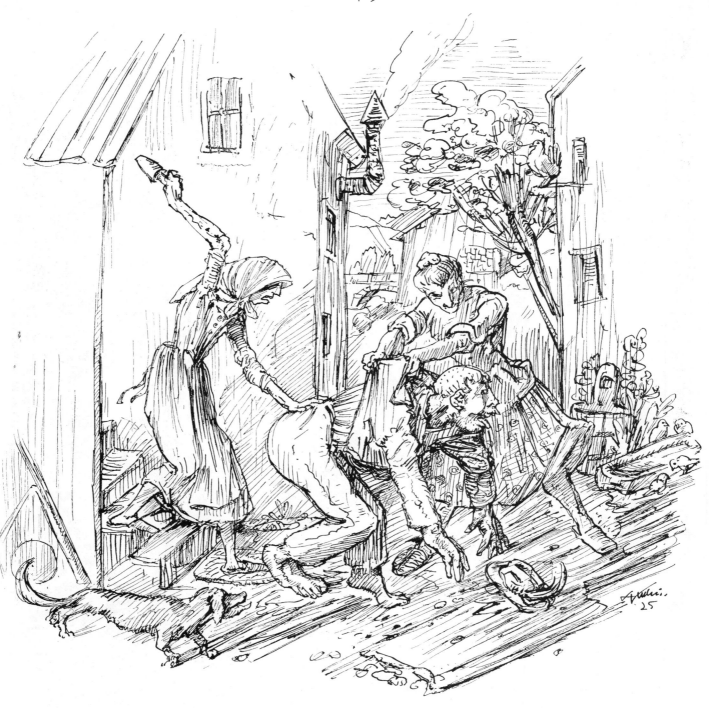

ALFRED KUBIN
106

**An Unwanted Guest.** [Sept. 21, 1925.]

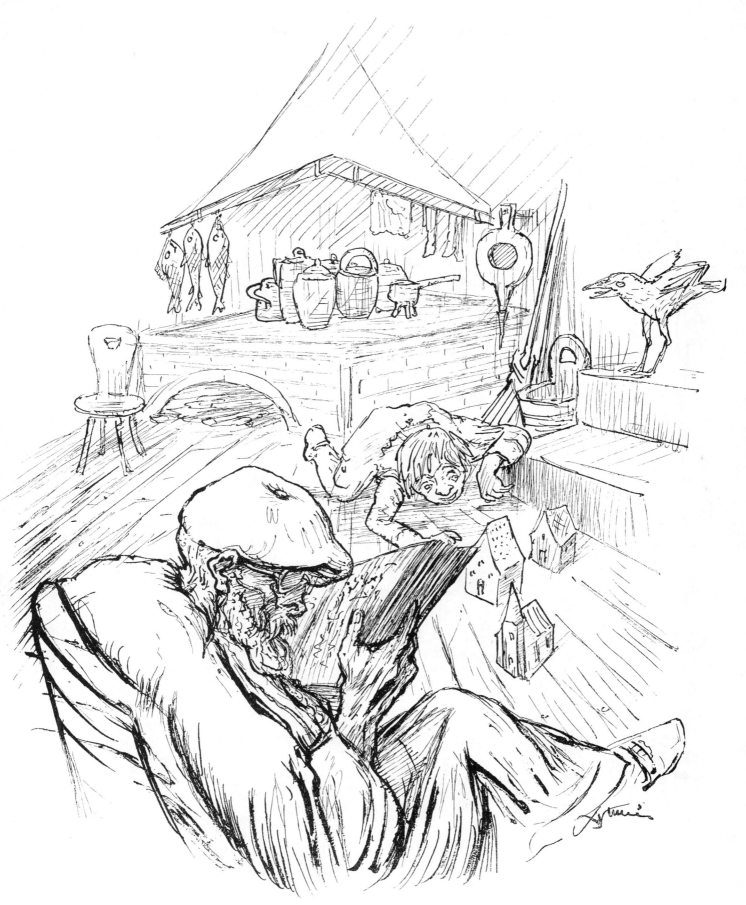

Simplicius bei dem Einsiedler.

**Simplicius Living with the Hermit.** [Based very freely on characters and incidents in Grimmelshausen's novel *Der abenteuerliche Simplicissimus teutsch*.] [Oct. 19, 1925.]

# Festbesoldet

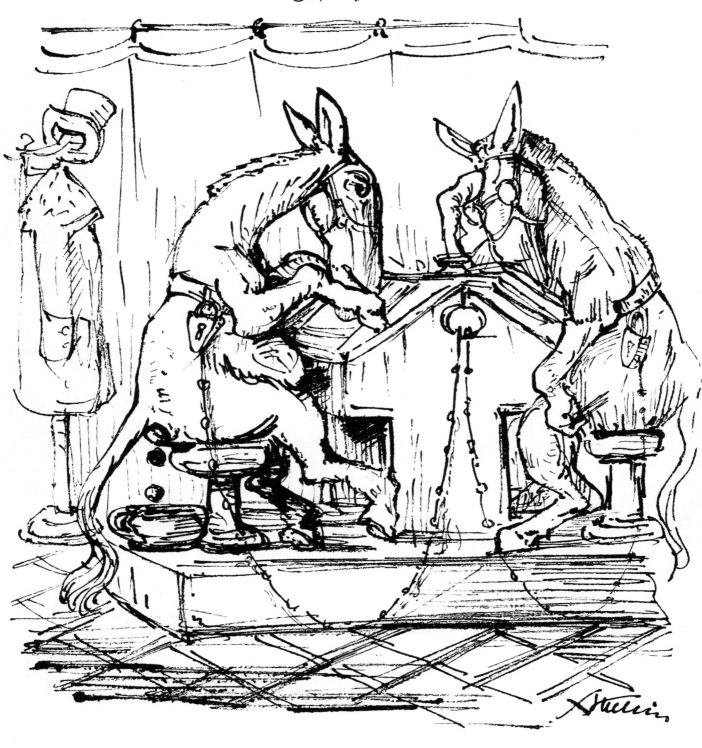

ALFRED KUBIN
108

**Bureaucracy.** [Mar. 22, 1926.]

## Rumänisches Volkslied

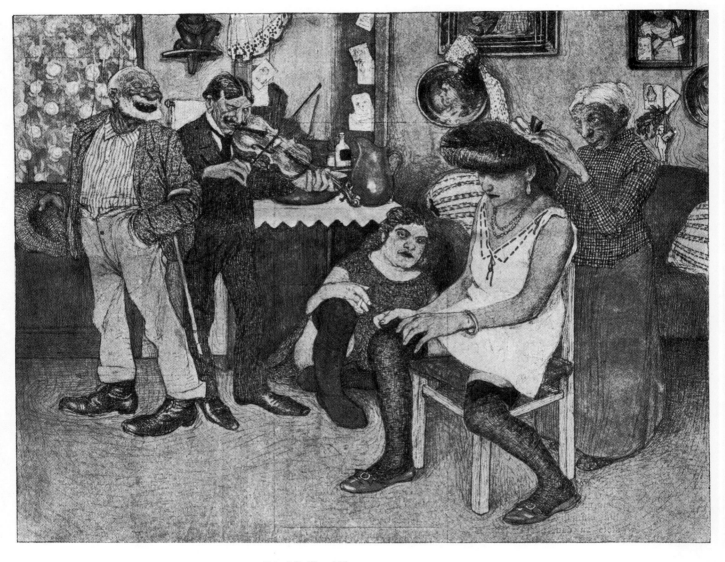

„Schmückt Maruschka,
Schmückt das Täubchen,
Schmückt das Kind für den Mädchenhändler!"

**Rumanian Folk Song.** "Adorn Marushka, adorn the dove, adorn the child for the pander." [Vol. X (1905/6), No. 5.]

# Die Zote

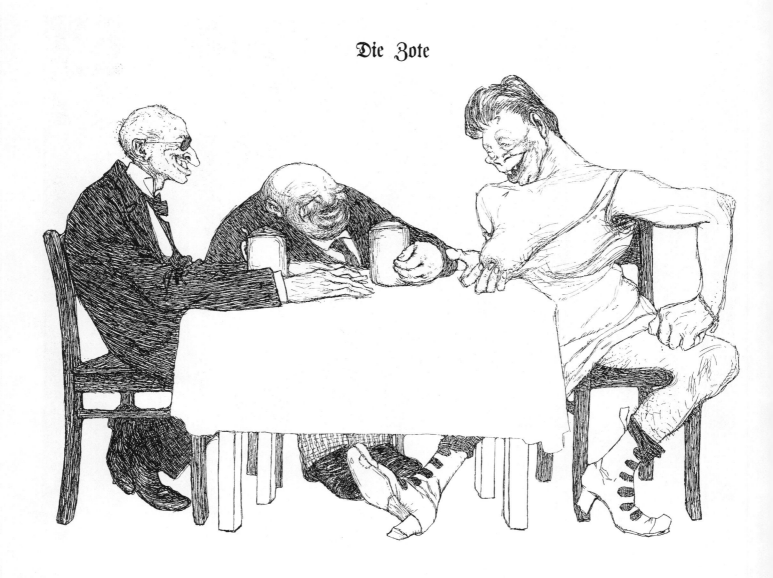

**The Dirty Story.** [Vol. X (1905/6), No. 25.]

# Eine Familie

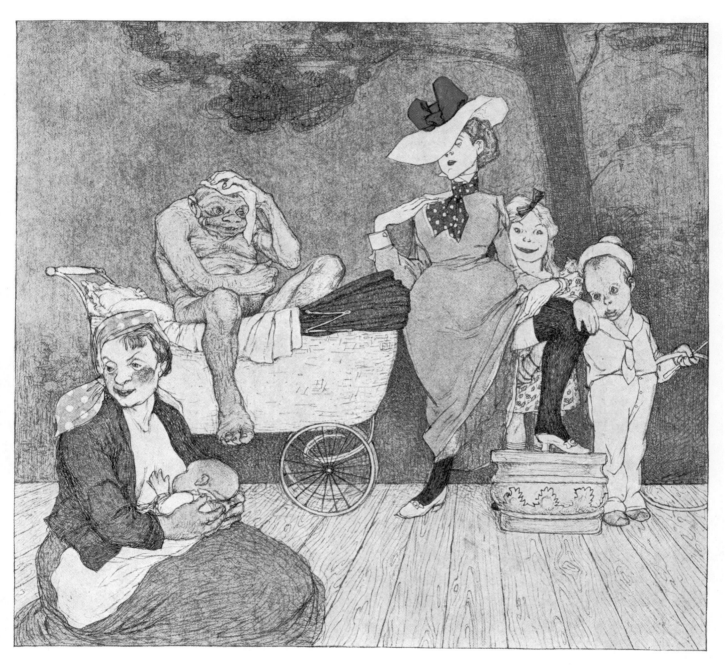

*„Wenn Herr Hagenbeck unfern Papa zurückweist, find wir ruiniert.“*

**A Family.** "If Mr. Hagenbeck turns down our Papa, we're wiped out." [Carl Hagenbeck, the famous wild animal trainer and circus and zoo director.] [Vol. X (1905/6), No. 28.]

# Gewissensbisse

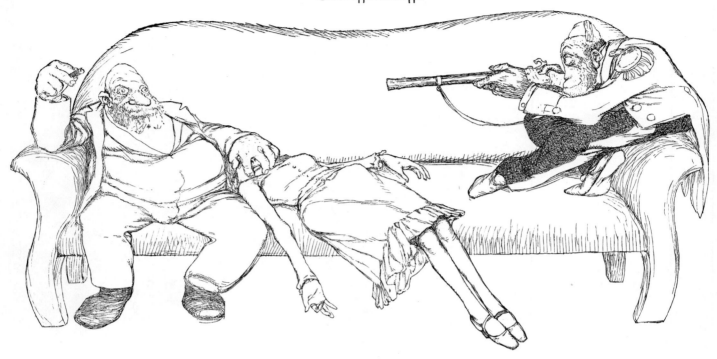

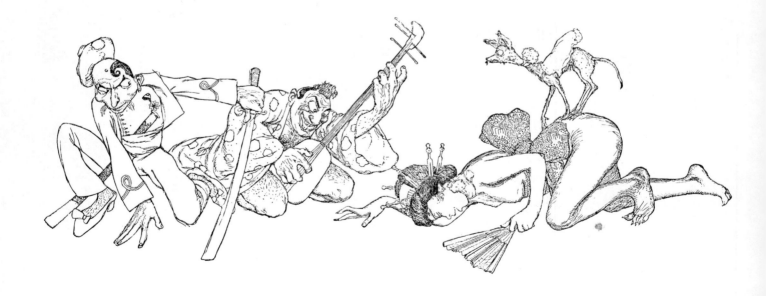

Above: **Pangs of Conscience.** [Vol. X (1905/6), No. 43.] Below: [Vol. X (1905/6), No. 47.]

# Die Stütze der Familie

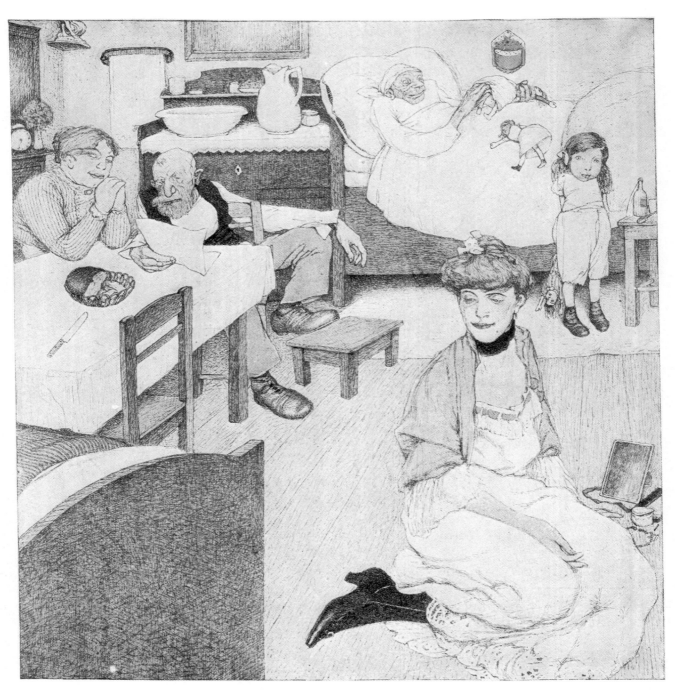

„Na, Mieze, wat sagste nu? Nu ham se deinen Emil jlücklich fürn Jährchen injespunnt wejen Zuhälterei." — „Jott sei Dank, en Esser wenijer!"

**The Family Breadwinner.** "Well, Mitzi, what do you say now? They've gone and locked up your Emil for a year for pimping." "Thank God, one less mouth to feed!" [Oct. 15, 1906.]

# Referenzen

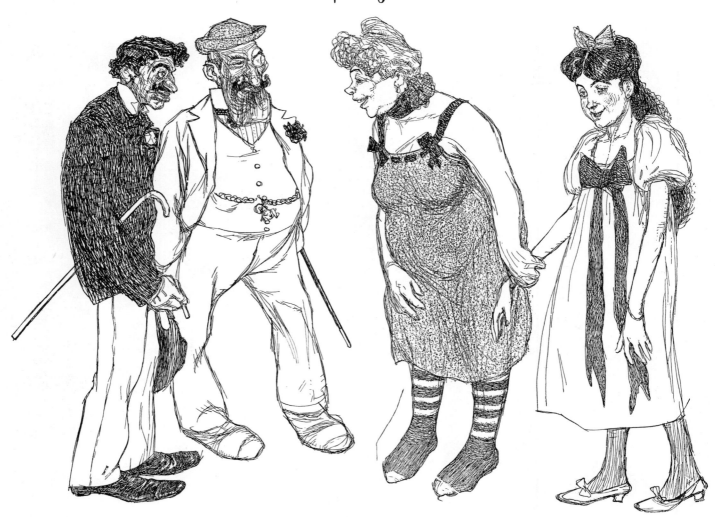

„Und wann S' woll'n, meine Herren, zeig i Ihna noch das Belobigungszeugnis vom Herrn Polizeirat. Alles hat er so sauber und nett bei uns g'funden, steht drinnen."

**References.** "And if you like, gentlemen, I'll even show you the letter of recommendation from the police commissioner. He writes how clean and nice everything was at our place." [Dec. 3, 1906.]

# Unter Kollegen

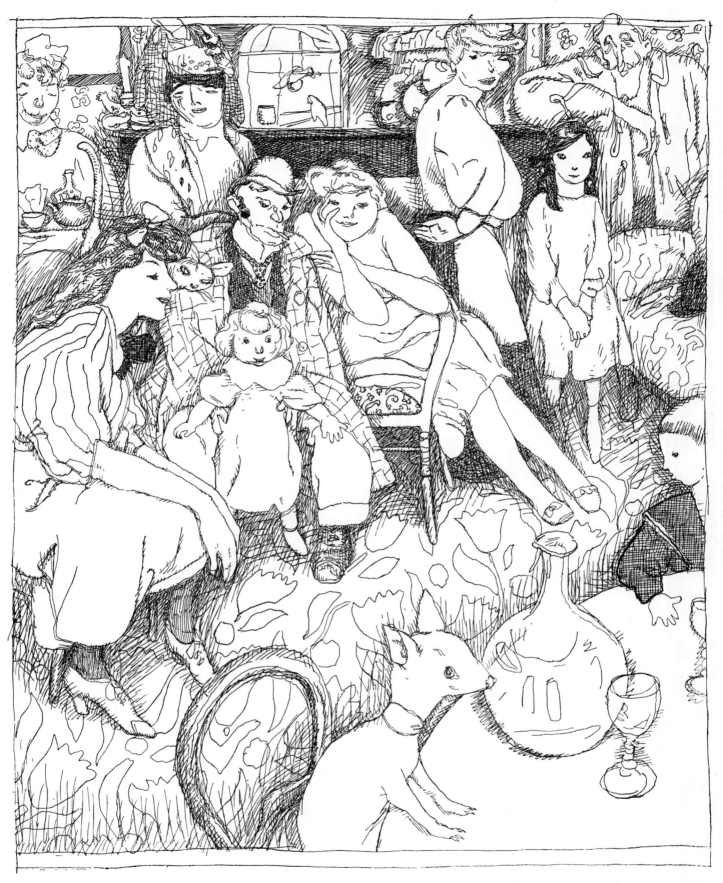

„Na, Mädchens, habt ihr gehört, der Albert von Monaco soll gleich gar en Denkmal kriegen? Das ist der erste von unserer Branche."

**Among Colleagues.** "Well, girls, have you heard that Albert of Monaco is going to be honored with a monument? He's the first among our customers." [May 27, 1907.]

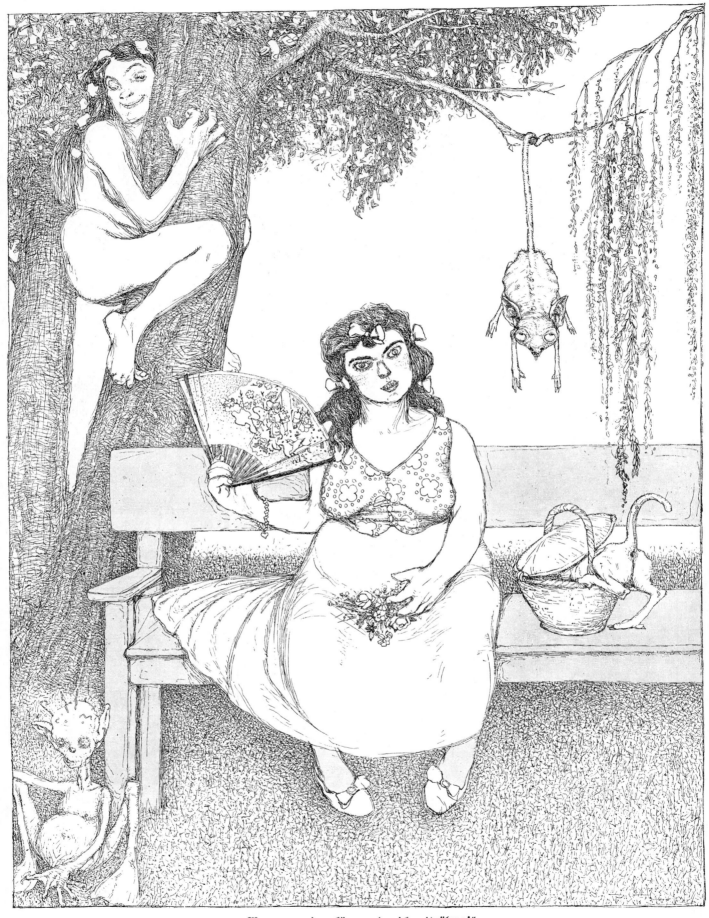

*„Wenn nur einer käme und mich mitnähme!"*

**In the Month of May.** "If only someone would come along and take me away with him!" [Jun. 15, 1908.]

# Ein Schwärmer

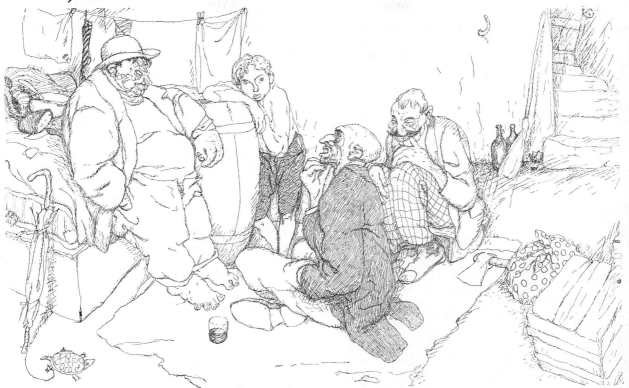

„Ich sag' euch, Augen hat das Mädchen so schwarz wie meine Füß'!"

# Schrittmacher

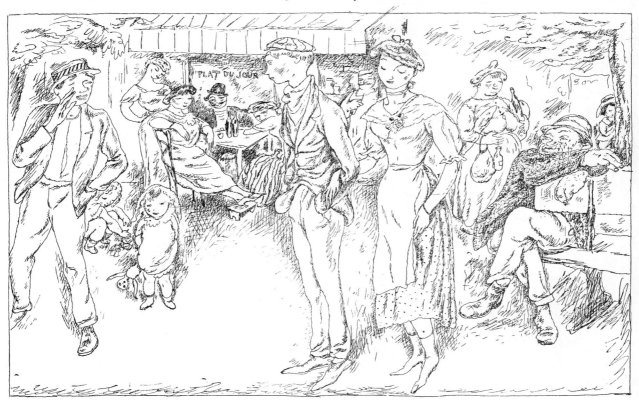

„Laß sie laufen! Wenn sie erst die Boulevards kennt, kennt sie uns nicht mehr."

Above: **A Dreamer.** "I tell you, the girl has eyes as black as my feet!" [Apr. 26, 1909.] Below: **Pacemaker.** "Forget her! When she gets to know the boulevards, she won't know us any more." [Dec. 6, 1909.]

# Schlechte Kapitalsanlage

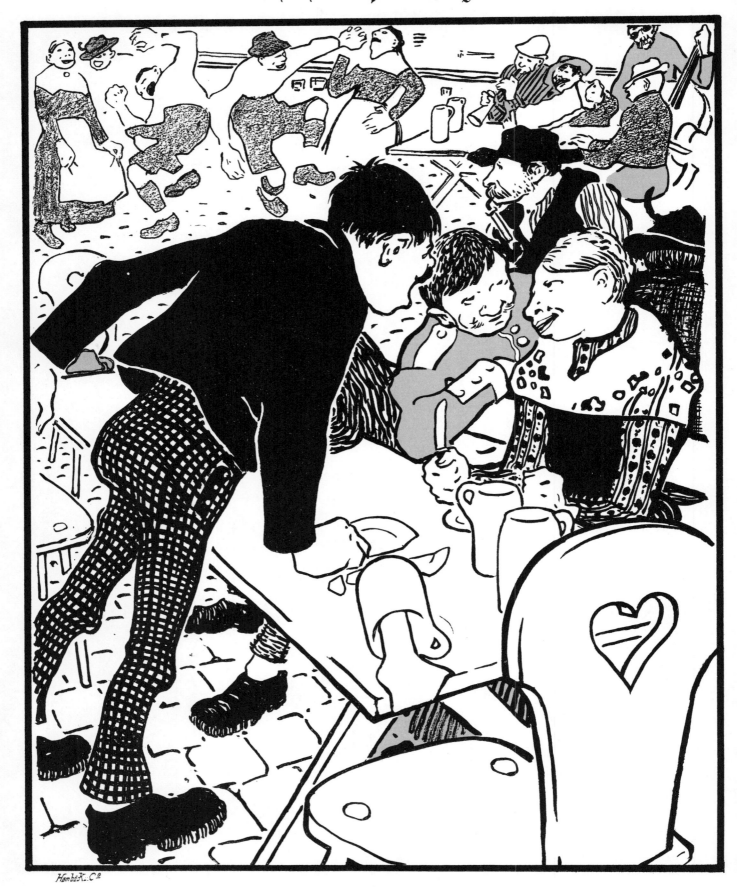

„Refi! Z' mir schaugst her! Wer hat den Kas zohlt, der Schorschl oder i?!"

**Bad Investment.** "Tessie, look here! Who paid for the eats, Georgie or me?" [Vol. II (1897/8), No. 16.]

# Der neue Vater

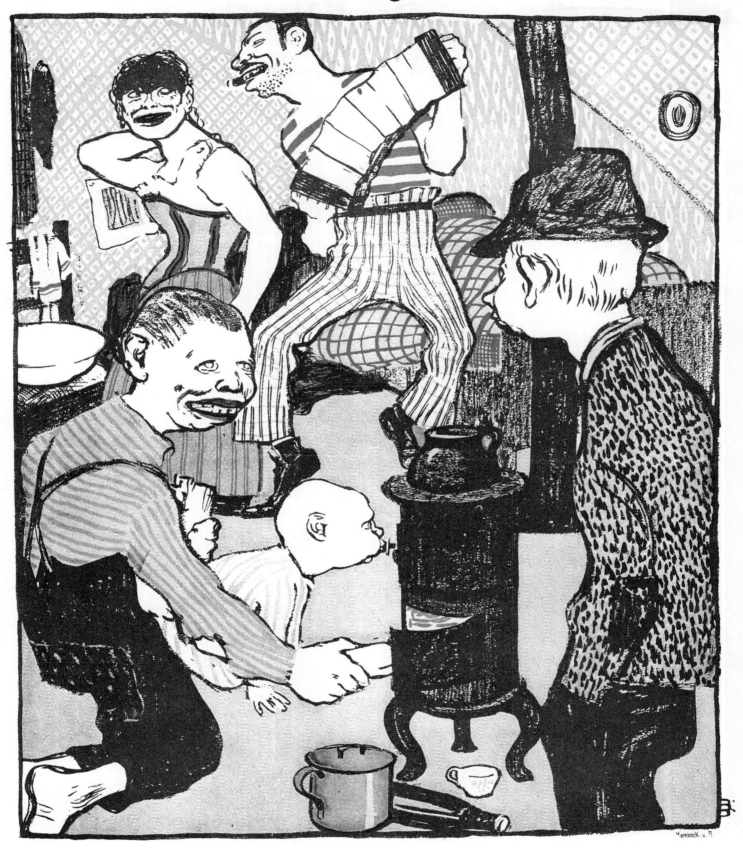

„Du, Schorſchl, mir hab'n iaßt an neia Vattern. Der is anderſcht fidel!"

**The New Father.** ''Hey, Georgie, we have a new father now. And is he a cut-up!'' [Vol. II (1897/8), No. 34.]

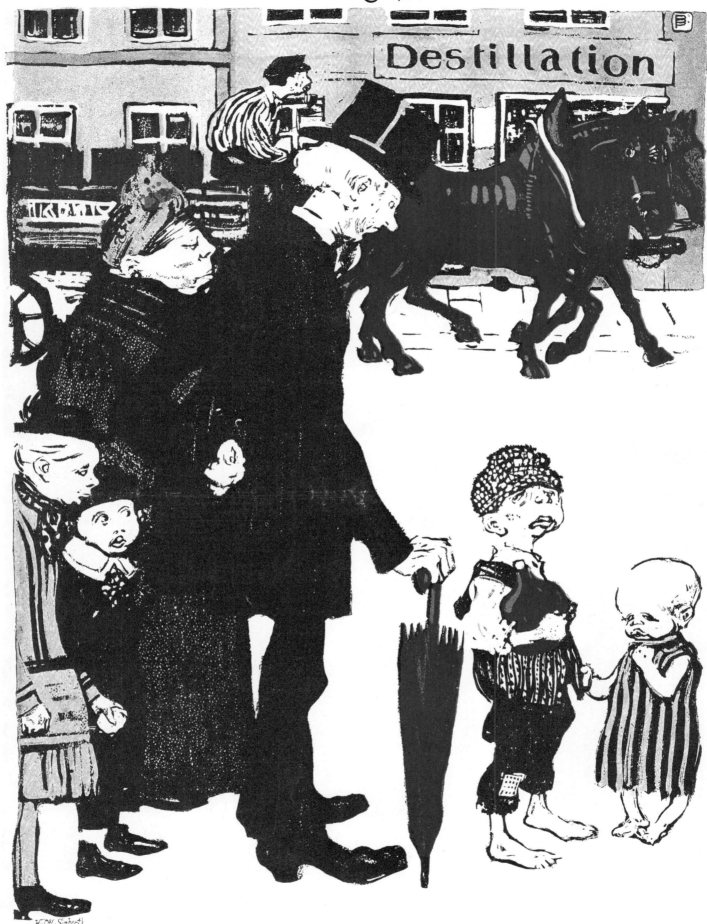

„Sage deinen Eltern, sie sollten sich schämen, so kleine Kinder nach Schnaps zu schicken." — „Der Schnaps is for geene Eltern nich, der geheert meine."

BRUNO PAUL
120

**In the Suburban Slum.** "Tell your parents they should be ashamed to send such small children for whiskey." "The whiskey ain't for no parents, it's mine." [*Destillation* =saloon.] [Vol. II (1897/8), No. 46.]

# Gemütsmenschen

Bild Nr. 8

„Ach Gott, Herr Baron! Erst verführen Sie meine Tochter und nun schmeißen Sie uns zum Haus 'naus — —" — „Was geht das mich an? Sie hätten sie besser erziehen sollen."

**Sentimental People, No. 8.** "Oh, God, Baron! First you seduce my daughter and now you're throwing us out of our home!" "What's that to me? You should have brought her up better." [Vol. V (1900/1), No. 12.]

# Bei den Ringkämpfern

„Edgar, warum haft du nicht folche Musteln?" — „Meine Liebe, in unferen Kreifen legt man mehr Wert auf die geiftige Ausbildung."

BRUNO PAUL
122

**At the Wrestling Match.** "Edgar, why haven't you got muscles like that?" "My dear, in our sphere people place more value on intellectual development." [Vol. VI (1901/2), No. 7.]

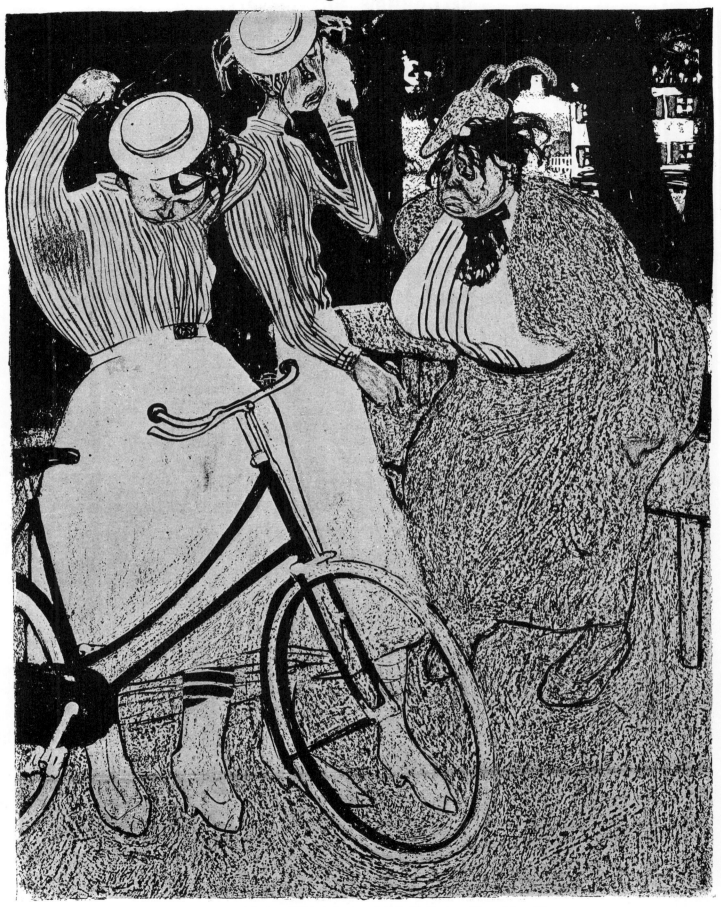

„Mama, glaubft du wirklich, daß wir auf diese Weise einen Mann kriegen?"

**A Doubt.** "Mama, do you really think we'll get a husband this way?" [Vol. VI
(1901/2), No. 17.]

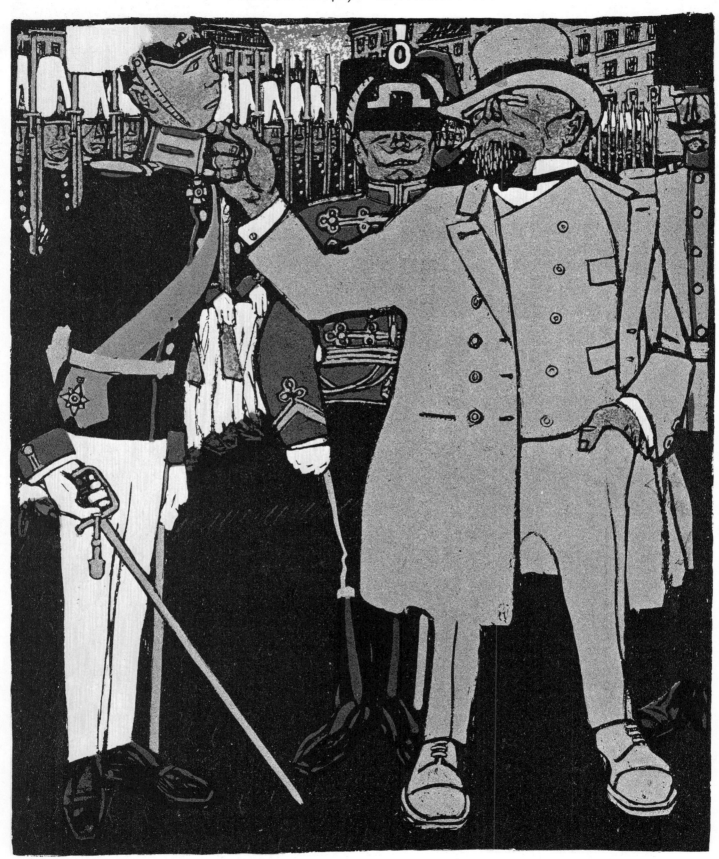

„Also Sie sind der junge Mann, der hier einmal König wird?"

BRUNO PAUL
124

**American Multimillionaires.** "So you're the youngster who'll be king here some day?"
[Vol. VIII (1903/4), No. 23.]

# Das letzte Wort

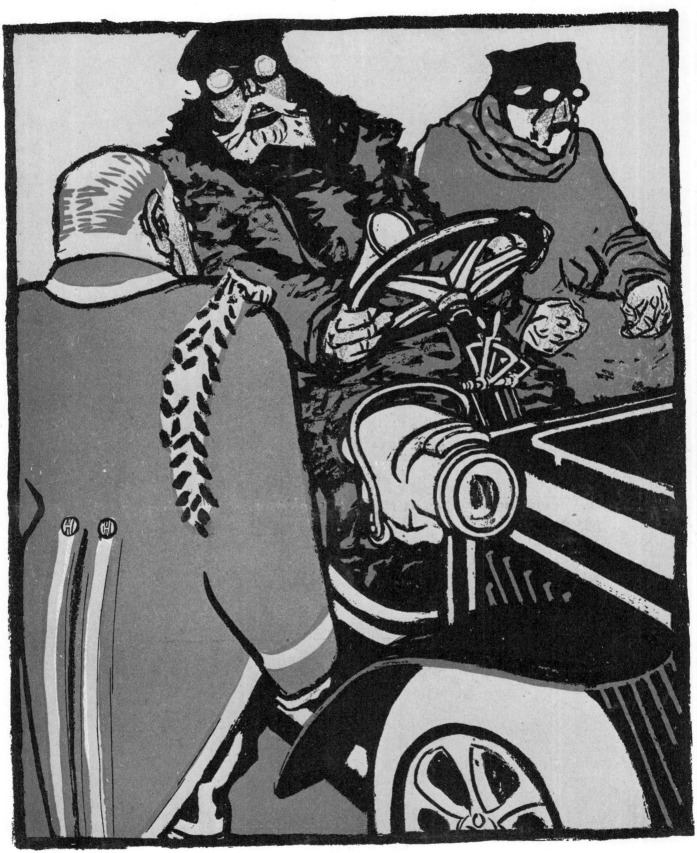

"Johann, richten Sie für alle Fälle die Familiengruft her."

**The Last Word.** "John, just in case—get ready the family vault." [Vol. IX (1904/5), No. 23.]

# Das Wunder

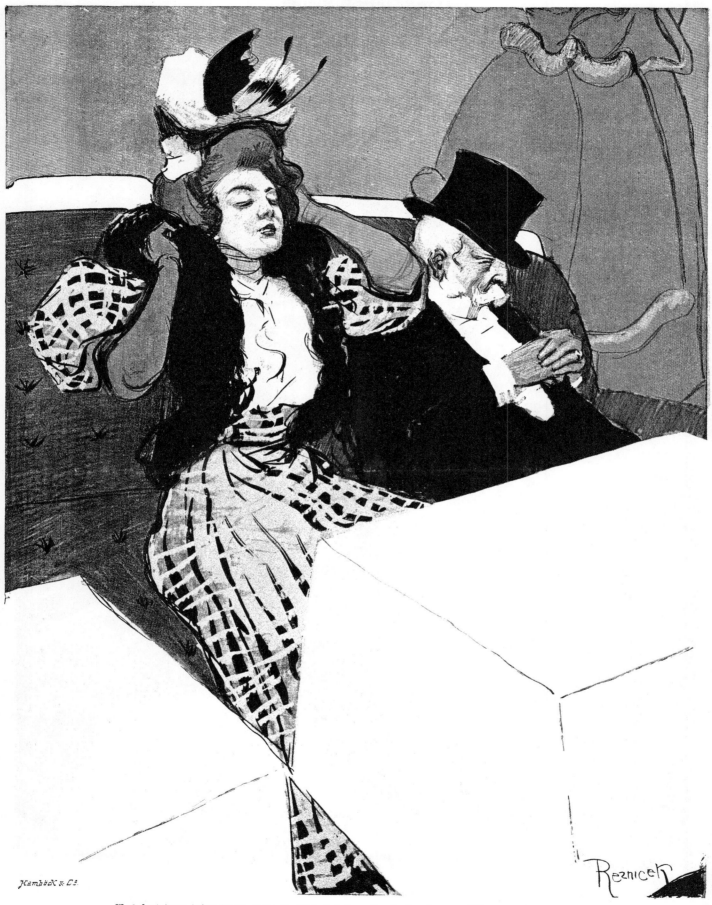

*„Was sagt denn deine Frau, wenn sie hört, daß du mit mir soupieren gehst?" — „Die wundert sich."*

FERDINAND VON
REZNICEK
126

**Amazement.** "What does your wife say when she hears that you take me out to supper?" "She's amazed." [Vol. III (1898/9), No. 10.]

# Die Sittlichkeitskommission

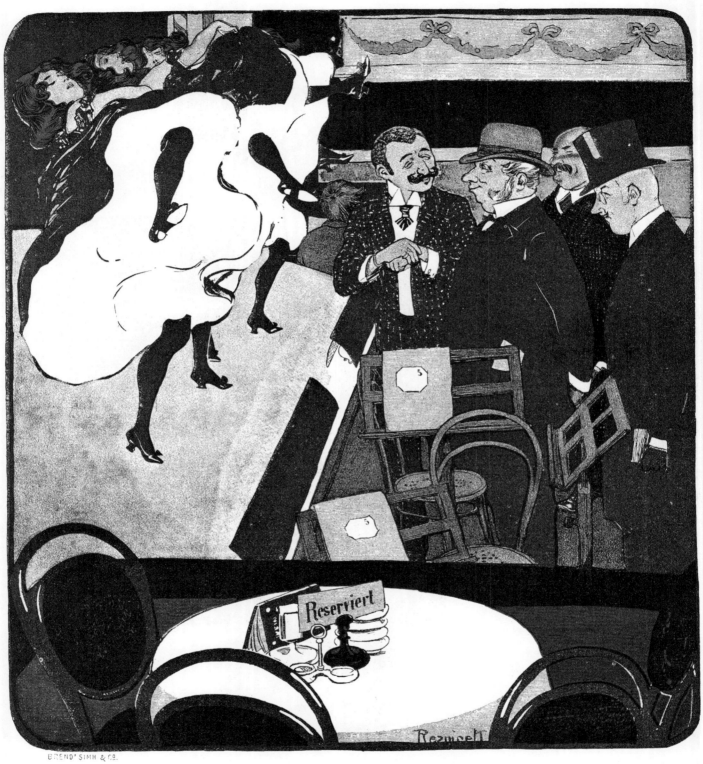

„Ihre Produktionen scheinen vom Standpunkt der Sittlichkeit sehr verwerflich. Bitte wollen Sie dieselben wiederholen."

**The Morals Committee.** "Your show appears to be quite objectionable from the standpoint of morality. Please run through it for us." [Vol. IV (1899/1900), No. 24.]

# Aschermittwoch

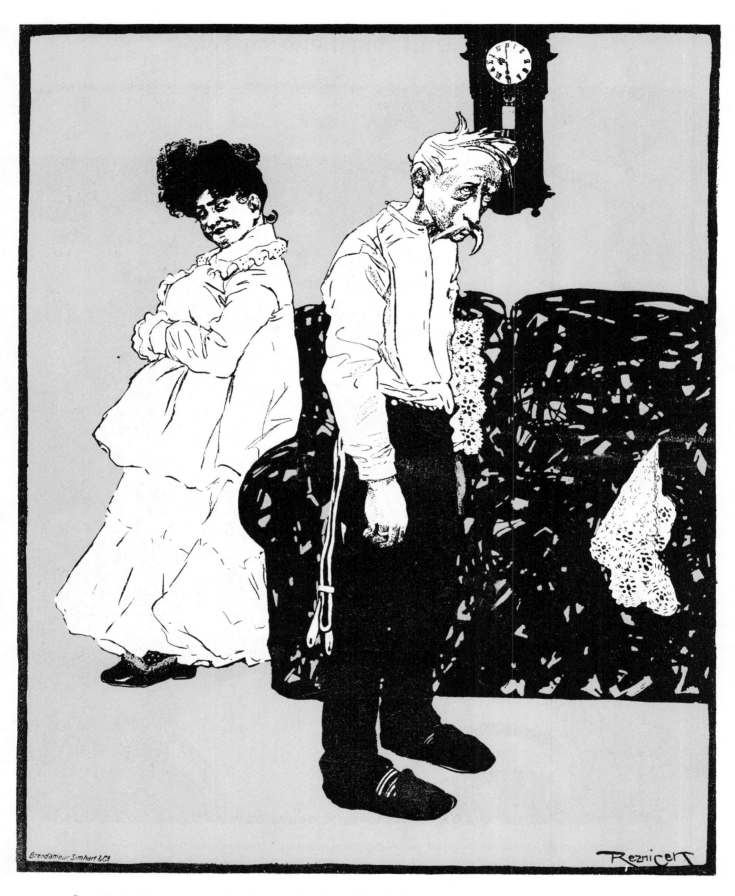

„So, bist du jetzt wieder zu haben für deine Familie? Sechs Wochen lang haben dich deine Kinder nicht zu Gesicht bekommen." „Richtig — Kinder habe ich auch."

FERDINAND VON
REZNICEK
128

**Ash Wednesday.** "So you're available to your family again. For six weeks your children haven't seen your face." "That's right—I have children, too!" [He has been on a Carnival (*Fasching*) spree.] [Vol. V (1900/1), No. 49.]

# Die Frau Oberst

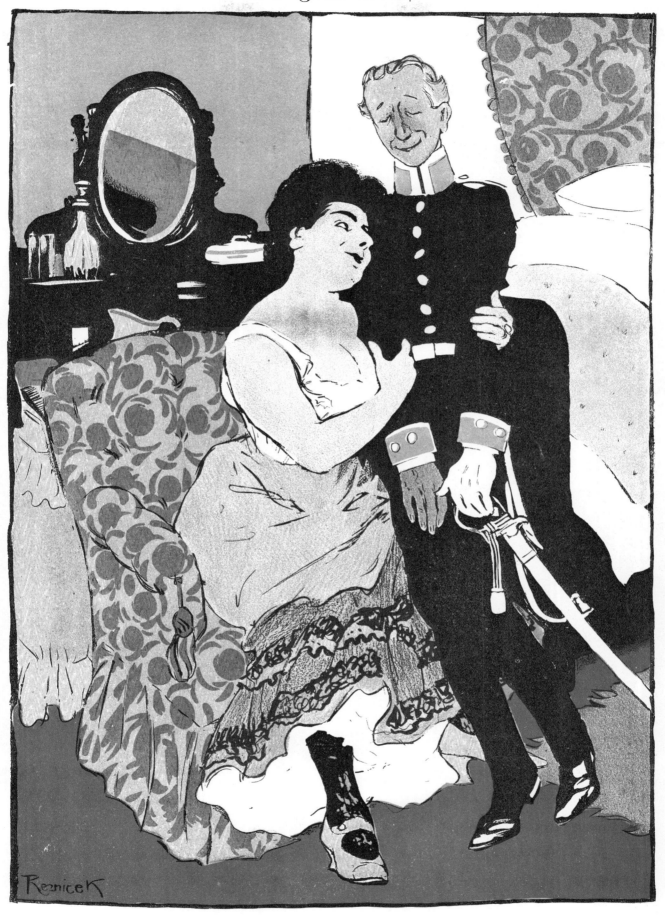

„Also Kopp hoch un man nich so ängstlich, mein Junge, ich spreche jetzt zu Ihnen nich als Vorgesetzter, sondern als Freundin."

**The Colonel's Lady.** "Head high and not so nervous, my boy. I'm talking to you now not as a superior, but as a friend." [Vol. VIII (1903/4), No. 37.]

FERDINAND VON
REZNICEK

# Unerbittlich

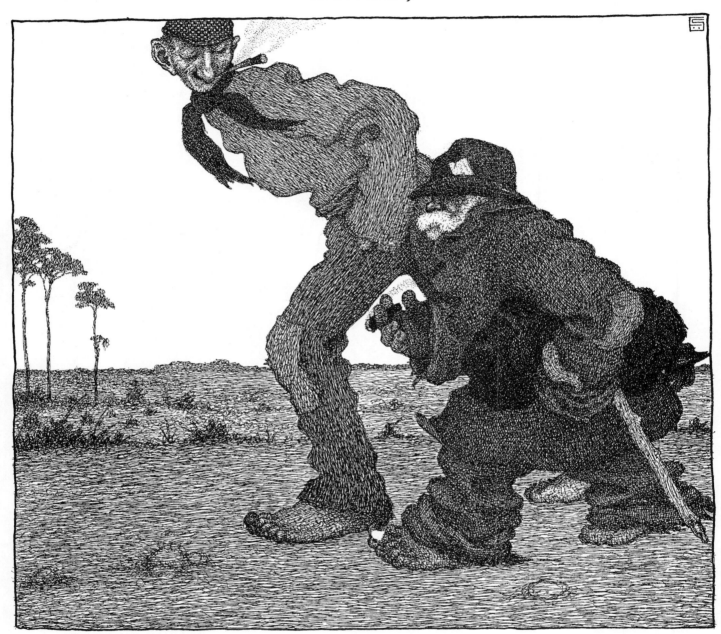

„Na, olle Töpperseele, wat sagst denn du zu 's Branntweinmonopol?" — „Frag nich so dußlig, dummes Luder! Keen Troppen wird mehr jesoffen, wenn's injesiehrt wird — Abstinenzler wer' ick! Die können lange warten, bis ick 'n ihre Panzerplattenpolitik bezahl'."

ERICH SCHILLING
130

**Implacable.** "Well, old souse, what do you say about the whiskey monopoly?" "Don't ask such stupid questions, dummox! Not another drop will I drink if it's imported. I'll become a teetotaler! I'm not about to pay for their militaristic politics!" [Dec. 30, 1907.]

# Der Prinzen=Mops

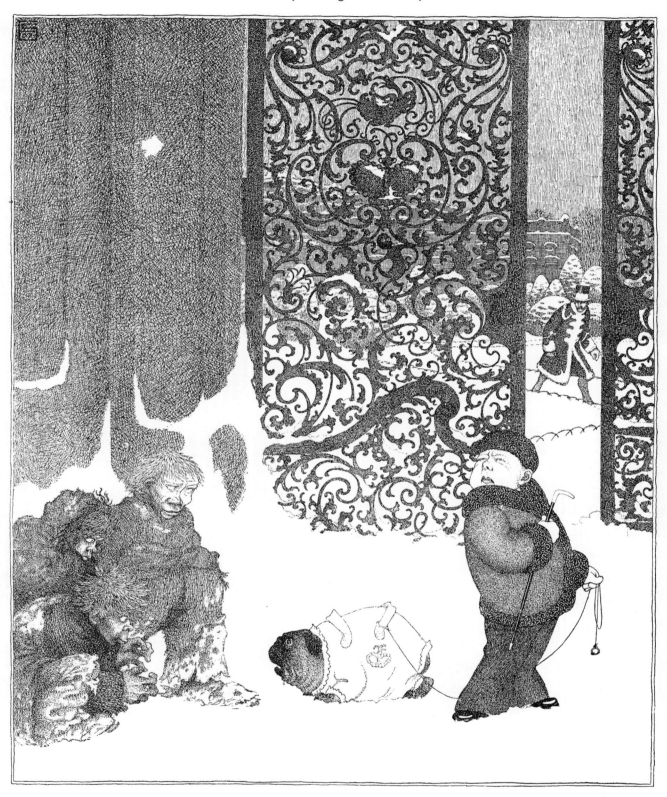

„Wir ham ooch mal 'n Hund jehabt. Vata hat 'n aba schon lange jeschlacht', weil 's Fleisch so teier is. Schlacht' dein Vata den Mops nich ooch bald?"

**The Prince's Pug.** "We once had a dog, too. But Father slaughtered it long ago, 'cause meat is so dear. Is your father going to slaughter the pug soon, too?" [Jan. 27, 1908.]

ERICH SCHILLING

131

# Die Giftmörderin

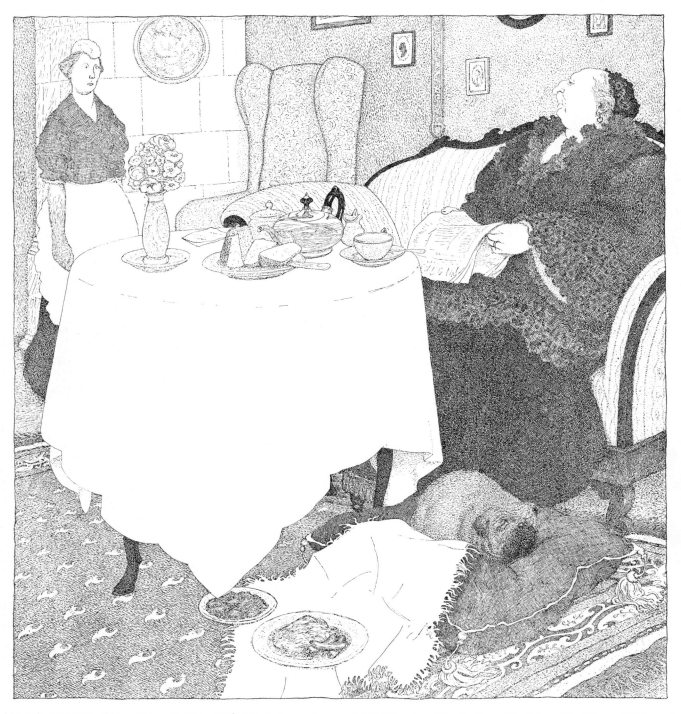

„Sie sind entlassen, Sie gemeine Person, Sie! Sie haben mein armes Hündchen vergiften wollen, Sie haben sein Essen mit Margarine gekocht."

ERICH SCHILLING
132

**The Poisoner.** "You are discharged, you common person, you! You wanted to poison my poor little dog. You cooked his food with margarine." [May 17, 1909.]

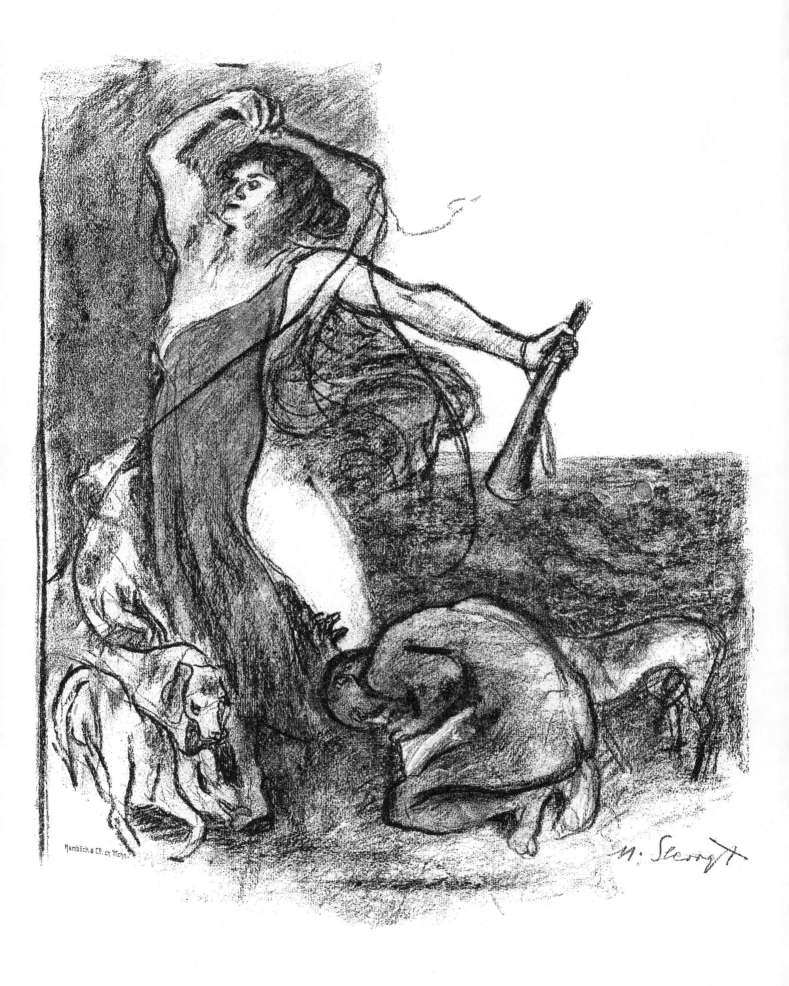

**Kathja.** [Illustration for a poem by Frank Wedekind.] [Aug. 22, 1896.]

MAX SLEVOGT
133

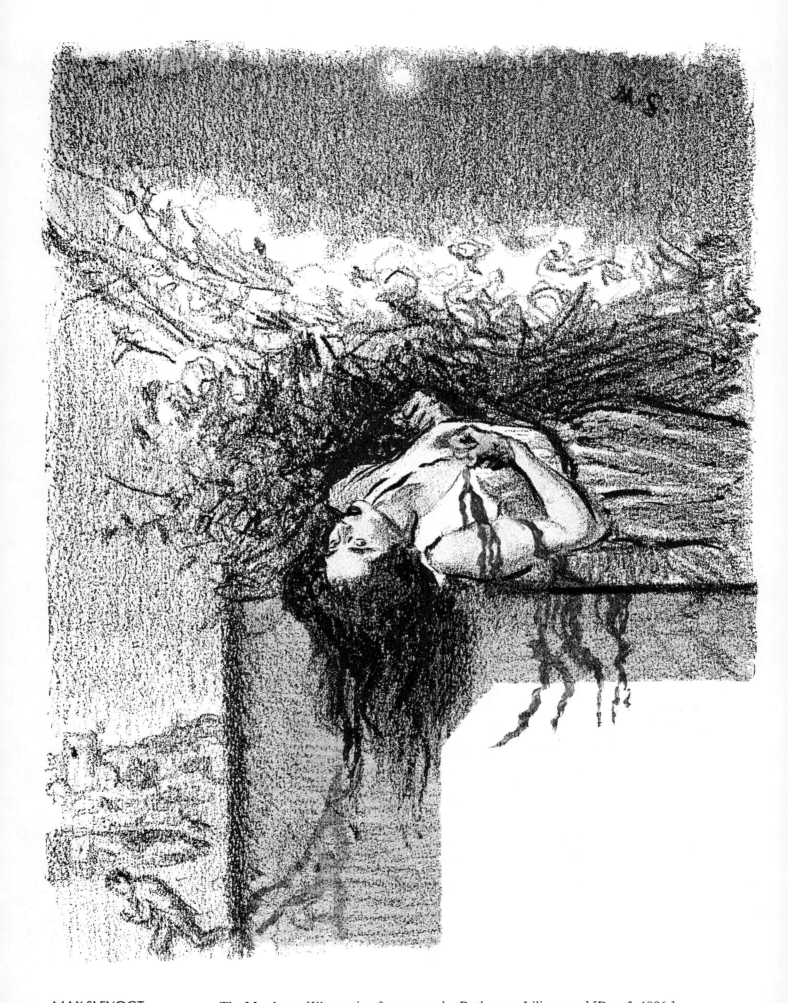

MAX SLEVOGT      **The Murderer.** [Illustration for a poem by Detlev von Liliencron.] [Dec. 5, 1896.]
134

MAX SLEVOGT

MAX SLEVOGT
136

Above: [Vol. II (1897/8), No. 12.] Below: [Vol. II (1897/8), No. 34.]

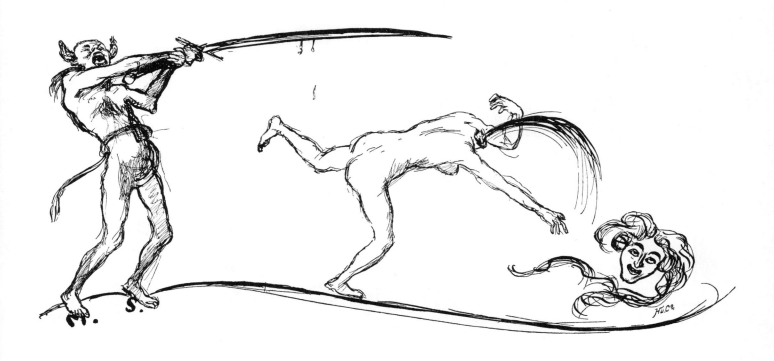

Above: [Vol. II (1897/8), No. 48.] Below: [Illustration to a rhyme: the devil
decapitates Modern Youth because it is too old-fashioned, and the head proves to be
that of a rouged old tart.] [Vol. III (1898/9), No. 27.]

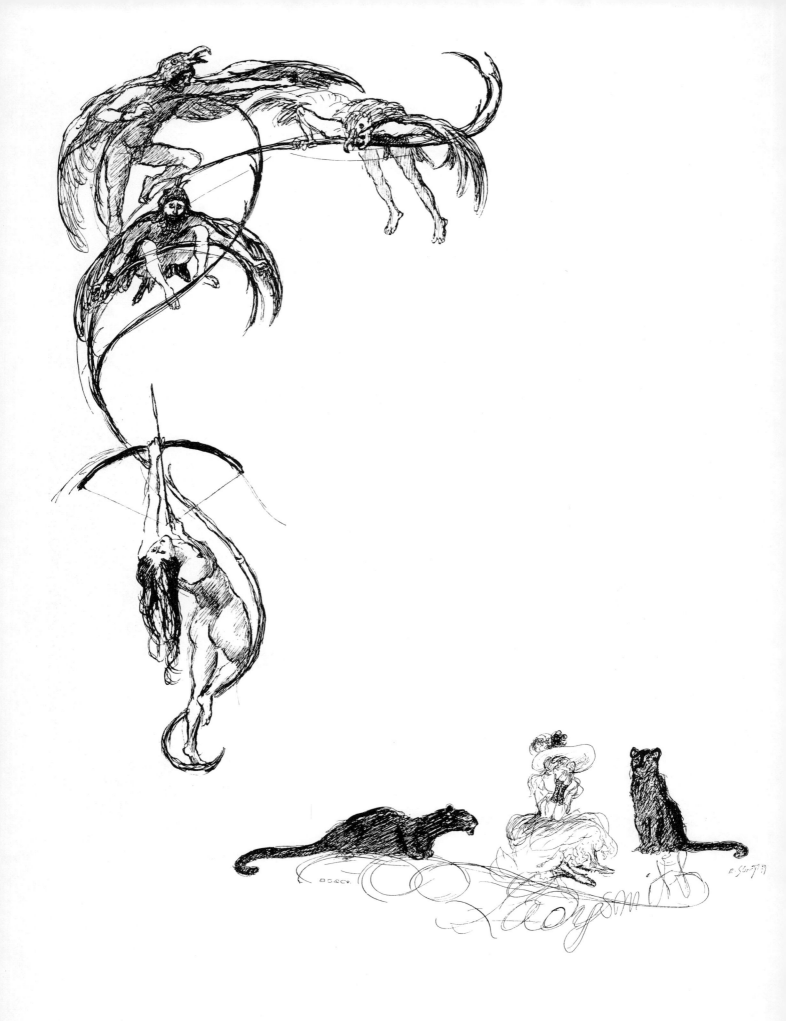

Left: [Vol. IV (1899/1900), No. 10.] Right: [Ladysmith in South Africa was being held by the British and besieged by the Boers at this time.] [Vol. IV (1899/1900), No. 42.]

# Im Augustiner-Bräu

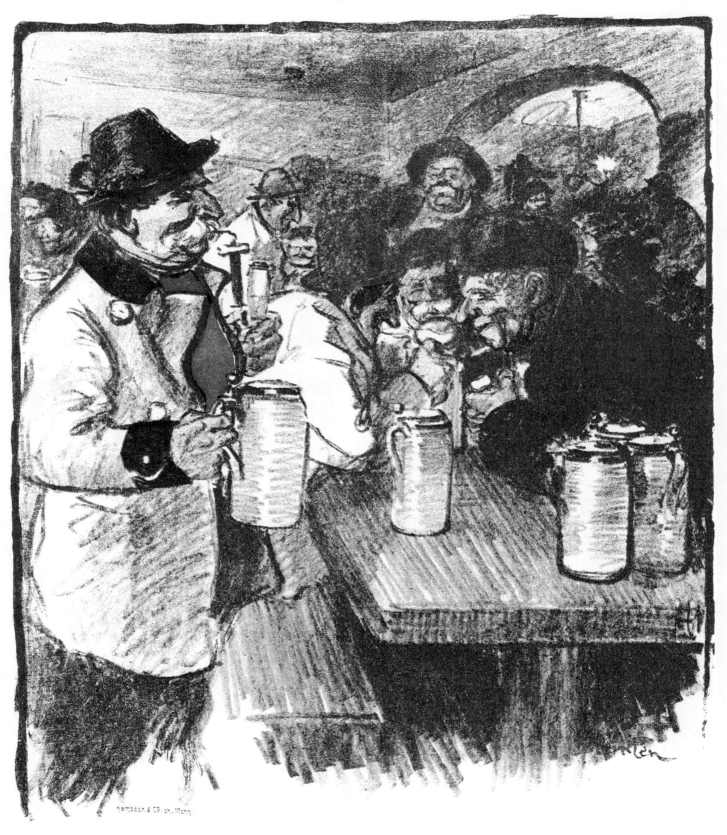

**In the Augustiner-Bräu** [Drawn during a visit to Munich.] [Jun. 20, 1896.]

THÉOPHILE-ALEXANDRE
STEINLEN

139

# Vorstadt

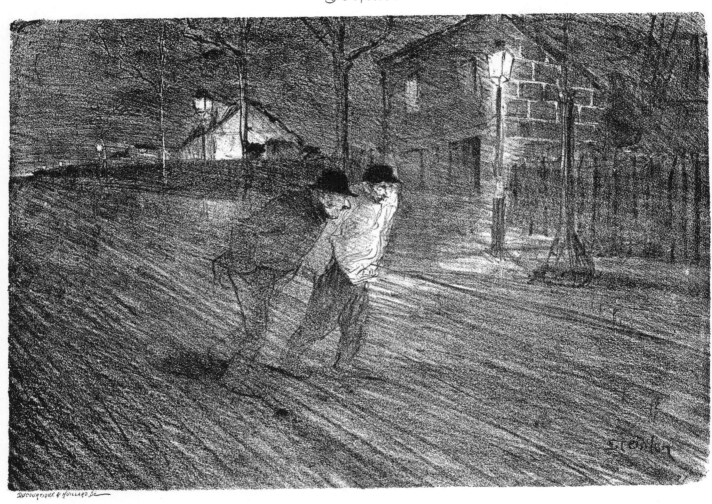

THÉOPHILE-ALEXANDRE  **The Suburban Slum.** [Vol. II (1897/8), No. 18.]
STEINLEN
140

## Befcheidener Wunfch

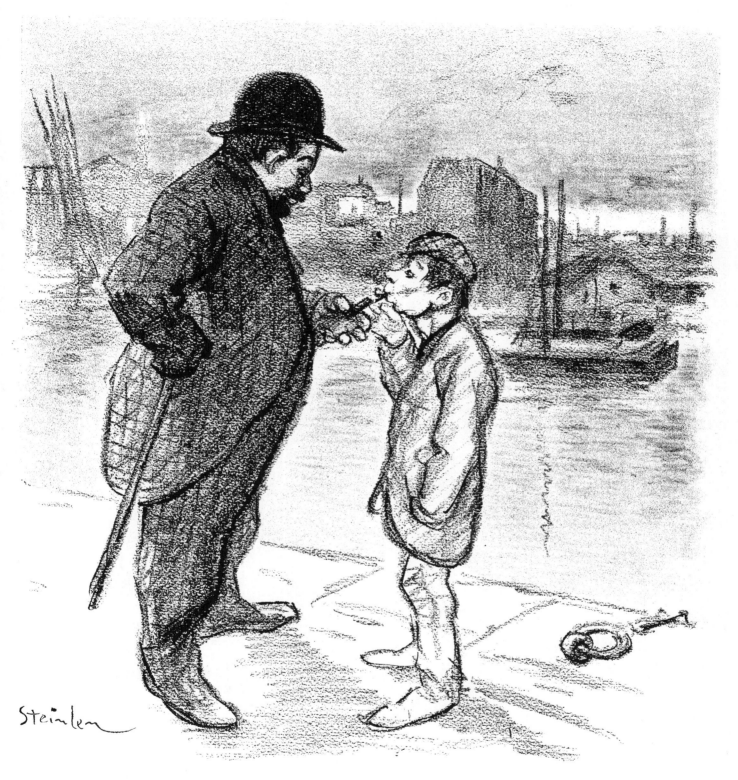

„Darf ich Ihnen um Feuer bitten, Herr Jraf, ick habe heute noch nicht Warmes im Munde jehabt."

**A Modest Request.** "May I have a light, your lordship? I haven't had anything warm in my mouth all day." [Vol. II (1897/8), No. 21.]

THÉOPHILE-ALEXANDRE
STEINLEN

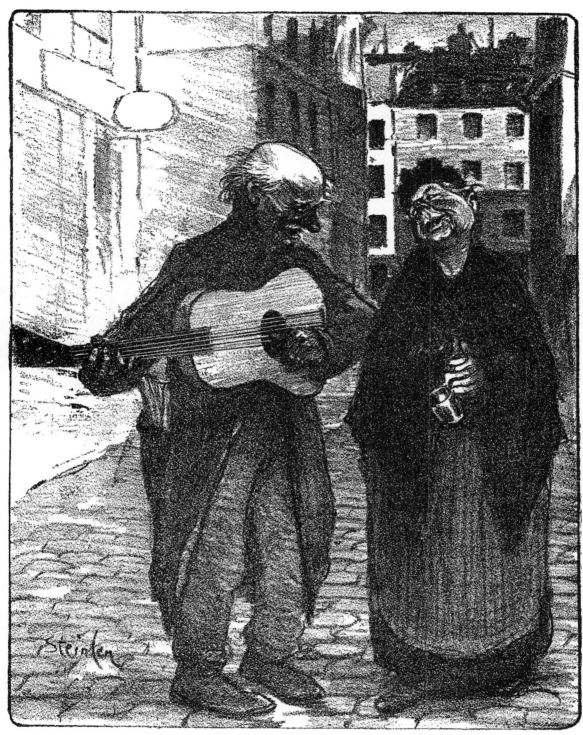

„Leiſe flehen meine Lieder . . .‟

THÉOPHILE-ALEXANDRE    "My songs quietly implore . . . " [Words from Schubert's "Serenade."] [Vol. II
STEINLEN              (1897/8), No. 22.]
142

# A Wurz'n

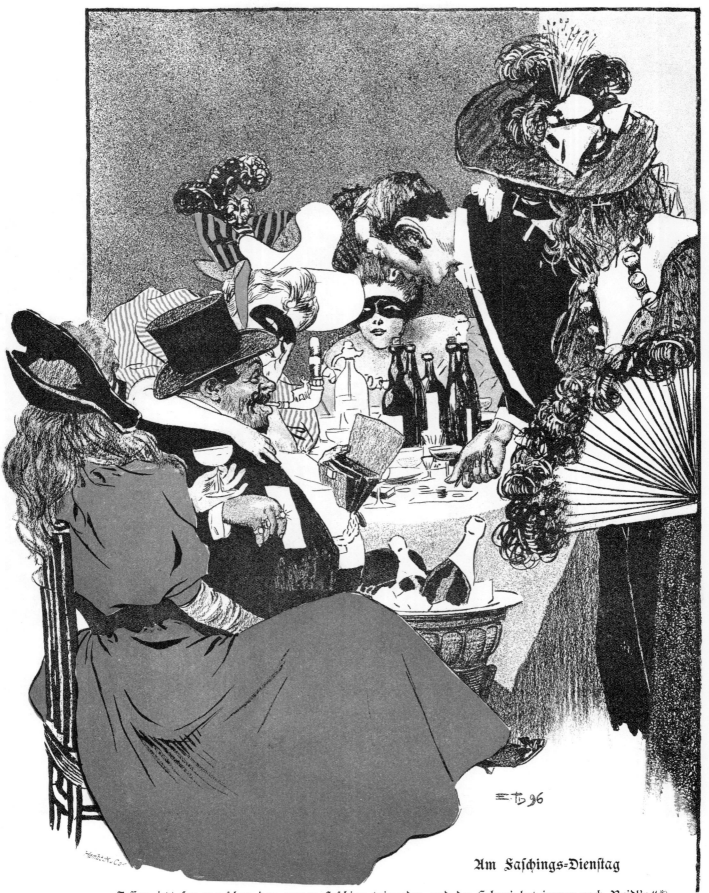

Am Faschings-Dienstag

„Jessas, jetzt san ma schon den ganzen Fasching beinander, und der Schani hat immer noch Buidl'n." *)

---

* Banknoten.

**An Easy Touch.** On Shrove Tuesday. "Gosh, we've been together all through
Carnival, and Johnny still has banknotes." [Mar. 6, 1897.]

# Excellenz Goethe

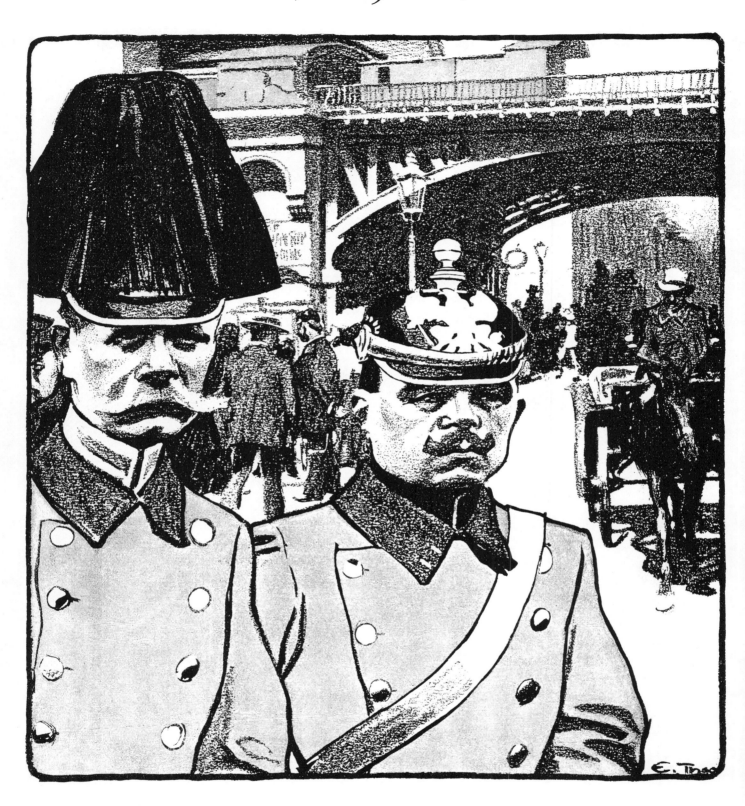

„Ich begreife jar nich, wie 'n Staatsminister Zeit hatte, so 'n Haufen Jedichte zu machen."

**His Excellency Goethe.** "I can't understand how a minister of state had time to write such a load of poems." [Vol. IV (1899/1900), No. 23.]

# Der Landesvater

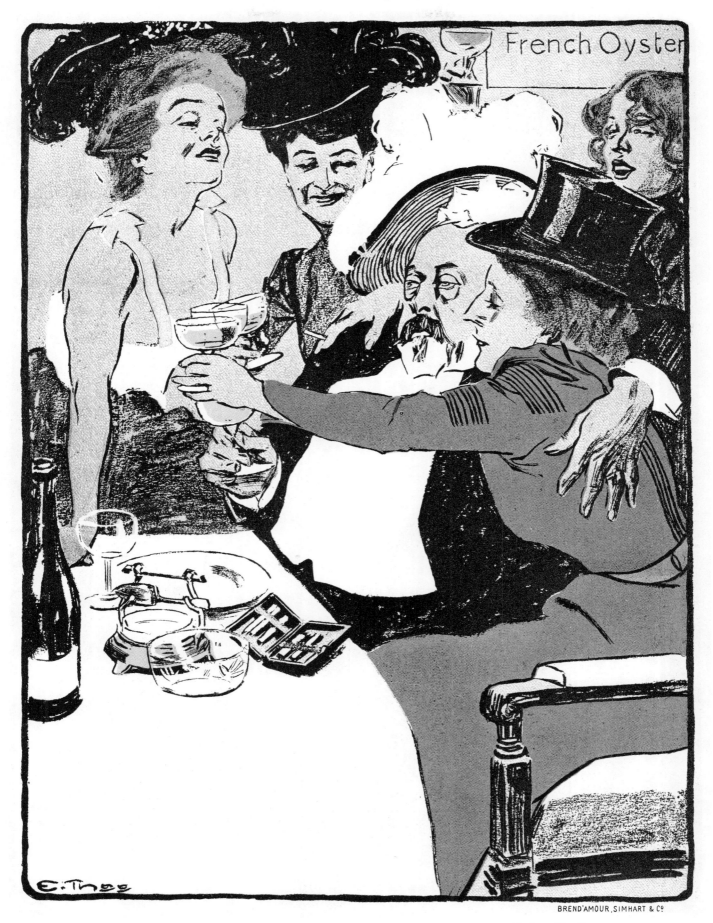

„Gelt Dicker, du gehst nicht nach Südafrika?" — „Nein, ich muß die Witwen und Waisen trösten."

**The Father of His Country.** "Say, Tubby, you aren't going to South Africa, are you?"
"No, I must console the widows and orphans." [The Prince of Wales, later Edward
VII.] [Vol. IV (1899/1900), No. 42.]

EDUARD THÖNY

# Warnung

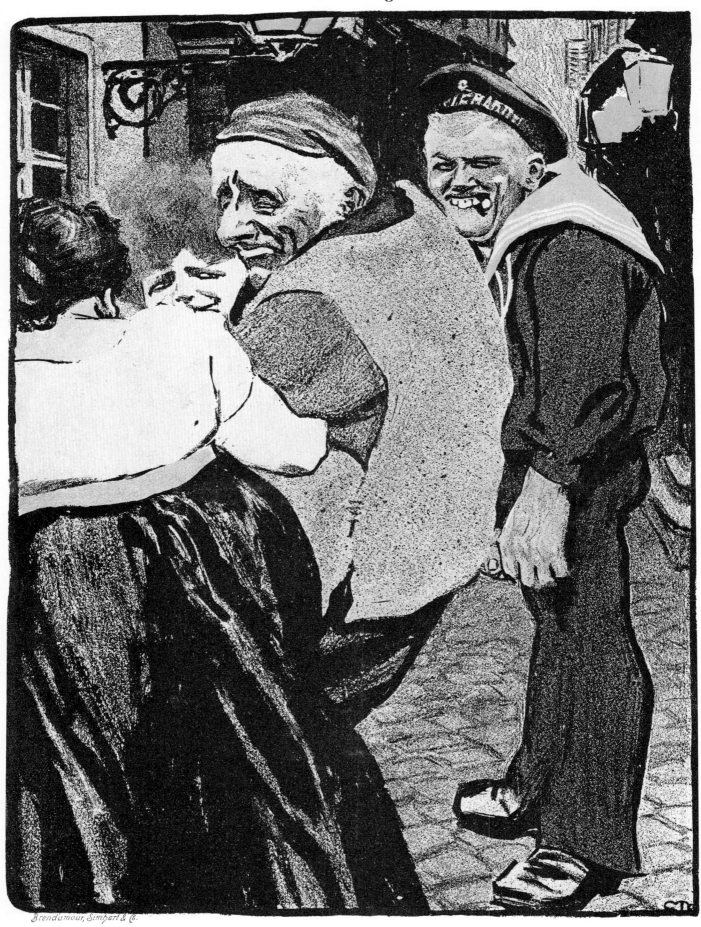

*Brendamour, Simhart & Co.*

*„Mächens, beißt den ollen Kerl nur nich in die Neefe, sonst seid ihr acht Tage lang besoffen."*

**Warning.** "Girls, don't bite the old guy in the nose or you'll be drunk for a week."
[Vol. VI (1901/2), No. 28.]

# Ein Philosoph des Unbewußten

„Jo Hein, wat ick all in mi heff, dat ohnst du nich, dat weit ick selbst nich mol all."

**A Philosopher of the Subconscious.** "Yep, Hank, you got no idea what I got in me—I myself don't even know." [Vol. VII (1902/3), No. 2.]

EDUARD THÖNY

# Junges Glück

„Emil, ums Himmels willen, schneid ein glückliches Gesicht, wir sind an der Kirche!"

EDUARD THÖNY
148

**The Happy Pair.** "Emil, for heaven's sake, put on a happy face. We're at the church!"
[Vol. IX (1904/5), No. 27.]

# Es war einmal

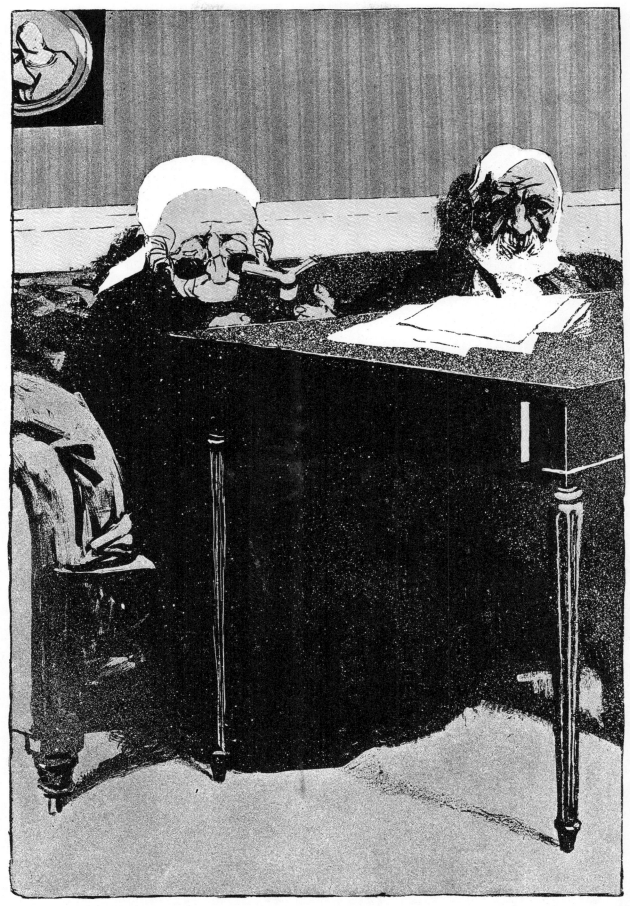

„Ich habe einmal ein wunderhübsches Mädchen gekannt — Käthchen Gröner. Was mag nur aus dem Mädchen geworden sein?" — „Aber Alterchen, das bin ja ich."

**Once Upon a Time.** "Once I knew a terrifically beautiful girl—Kathy Gröner. What could have become of the girl?" "But, old man, that's me." [Apr. 16, 1906.]

EDUARD THÖNY

# Reklamefuhre

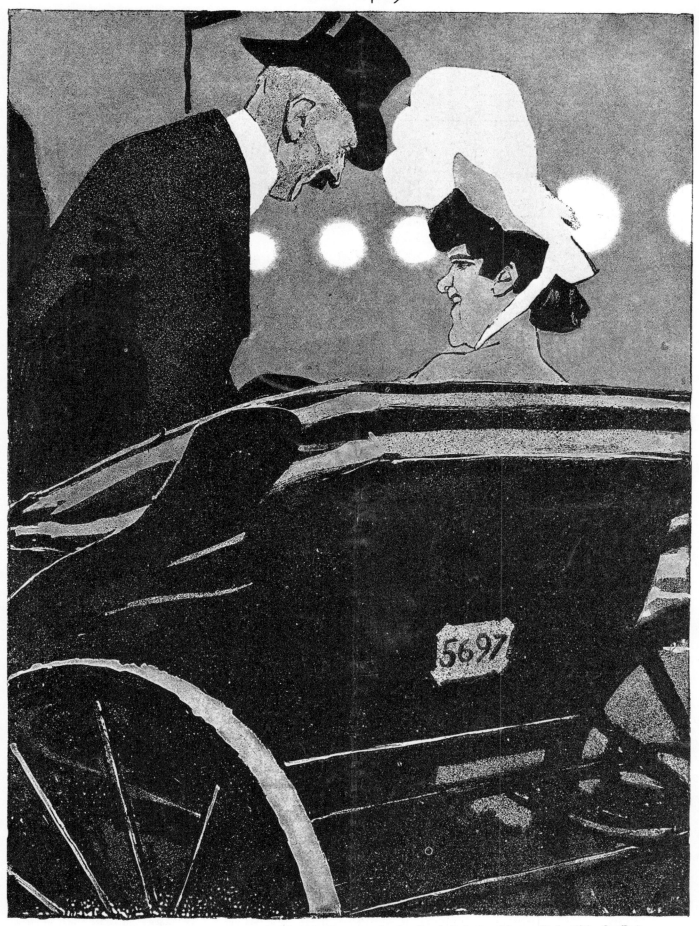

„Jetzt fährste erst dreimal mit mir die Friedrichstraße auf und ab. Du haft so 'ne feine ariftokratische Frefle."

EDUARD THÖNY
150

**Advertising Van.** "First ride with me up and down the Friedrichstrasse three times. You've got such a fine aristocratic mug." [Feb. 3, 1908.]

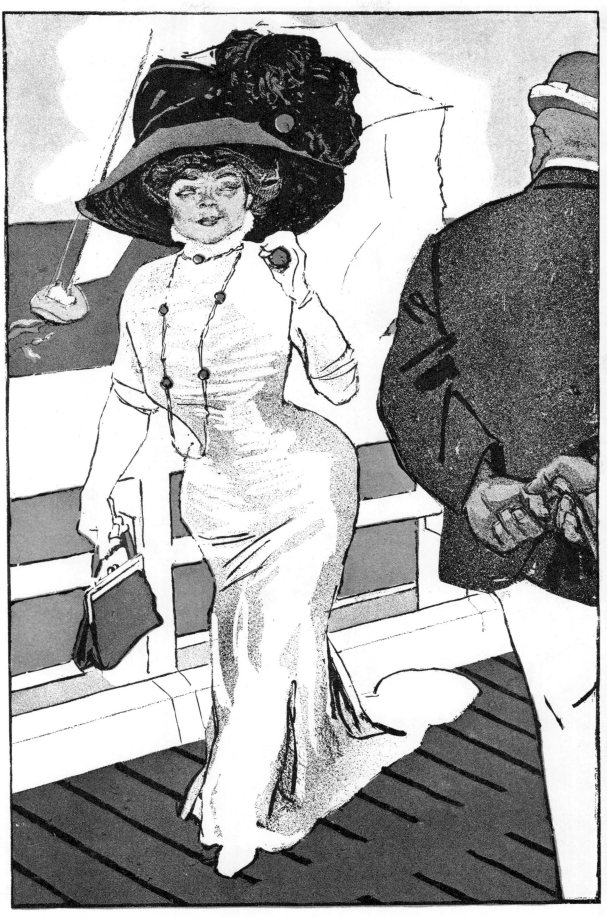

*„Na, wie wär's, Dicker? Franzöſiſcher Chic mit deutſcher Gründlichkeit?"*

**Ostend.** "How's about it, chubby? French chic combined with German thoroughness?" [Aug. 2, 1909.]

EDUARD THÖNY

# Das Wertobjekt

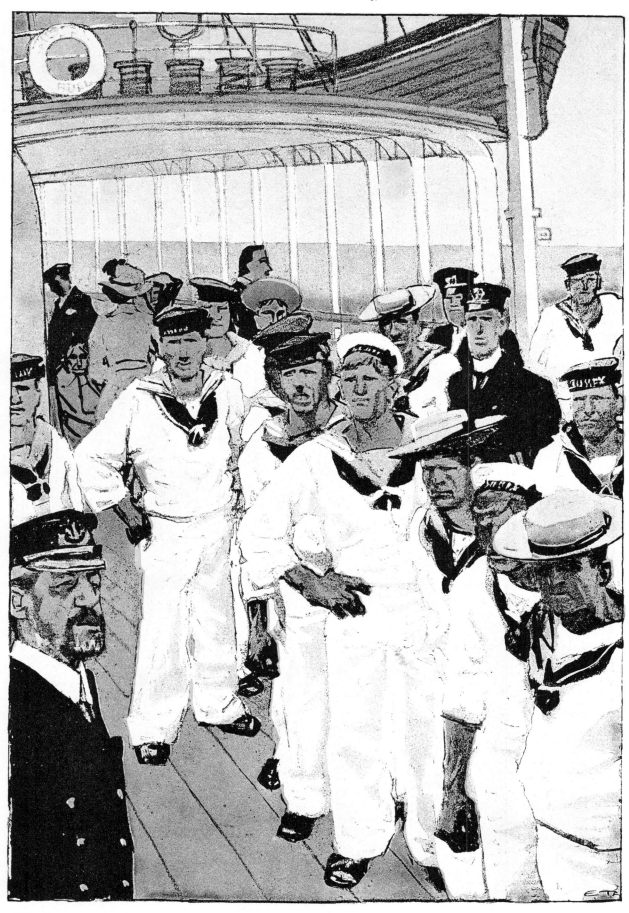

„Also, Leute, die alte Dame mit der blauen Brille ist Amerikanerin. Daß sie nicht einer aus Versehen rettet, wenn wir torpediert werden!"

EDUARD THÖNY

152

**The Valuable Object.** "All right, men, the old lady with the blue glasses is an American. Nobody save her by mistake if we're torpedoed." [The ship is British. This is a sarcastic comment on neutral America's complaints during the German U-boat campaign.] [Apr. 25, 1916.]

# Kommunismus

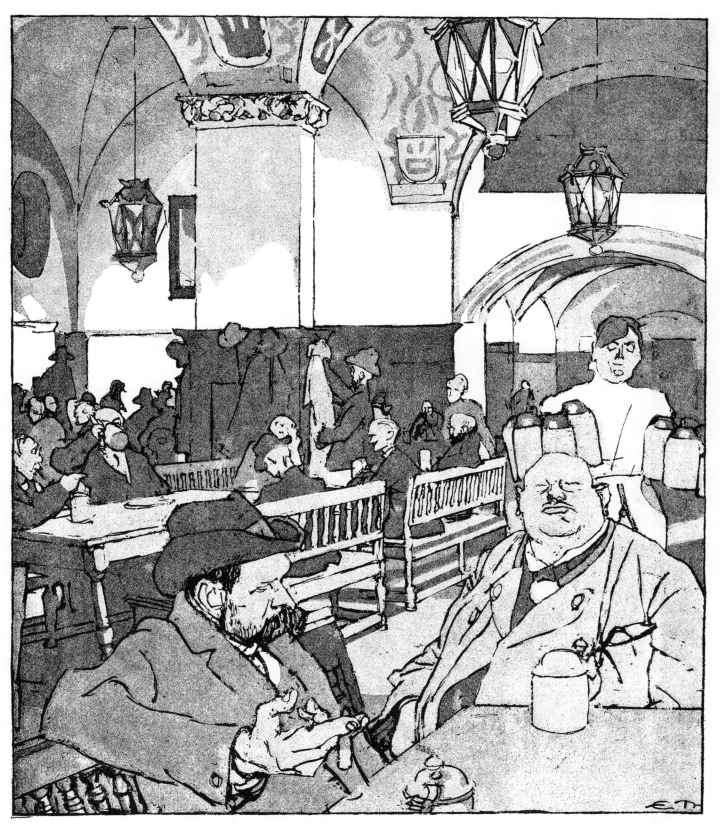

„Bals b'zwoa Häuſer hätt'ſt, g'höret oans mir?" — „G'wiß!" — „Bals b'zwoa Roß hätt'ſt, tät'ſt mir oans geb'n?" — „Freili." —
„Bals b'zwoa Säu hätt'ſt, kriaget i oane?" — „Naa... i hob zwoa Säu!"

**Communism.** "If you had two houses, would one be mine?" "Sure!" "If you had two horses, would you give me one?" "Of course!" "If you had two sows, would I get one?" "No—I have two sows!" [Jan. 7, 1920.]

# Schieberseelen

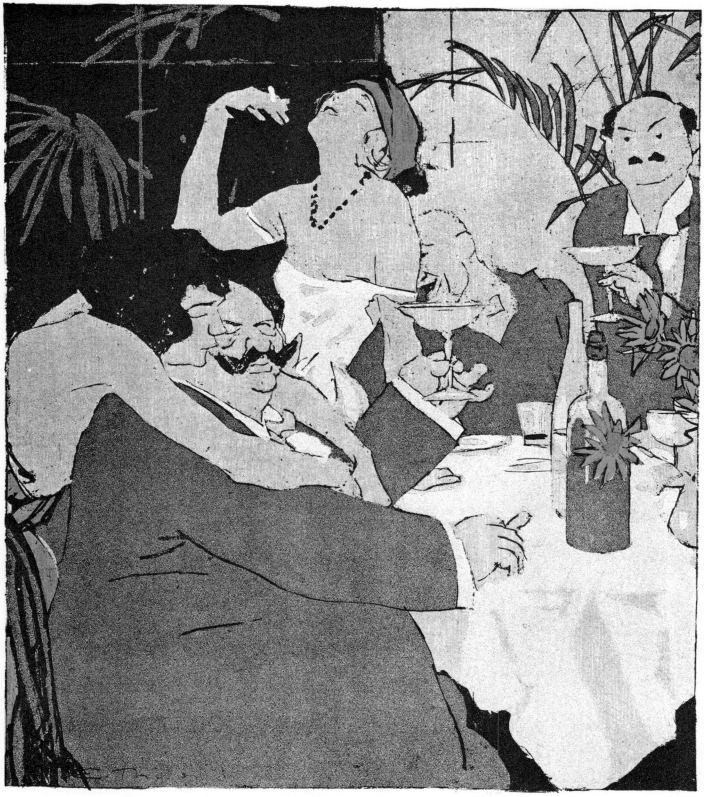

„Der Sekt ist ja viel zu kalt . . . na, trinken wir ihn auf das Wohl unserer gefangenen Brüder in Sibirien!"

EDUARD THÖNY
154

**The Soul of a Profiteer.** "The champagne is much too cold . . . let's drink it to the health of our brothers who are prisoners in Siberia!" [Jan. 1, 1921.]

# Maskenverbot

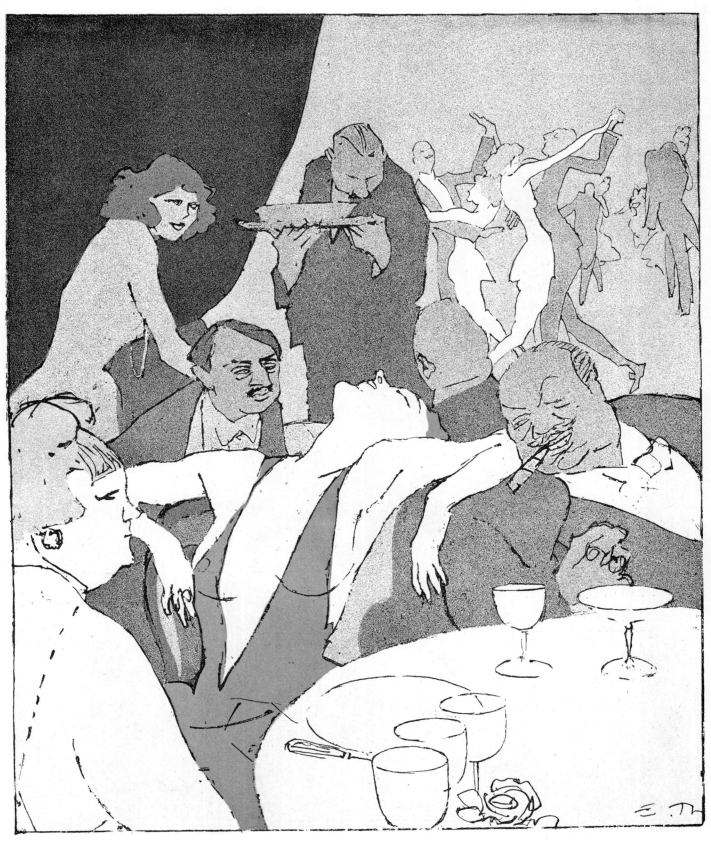

„Was brauchen denn mir Trachten, bal die Weiber so nix anhaben?"

**Masquerading Forbidden.** "Why do we need costumes, if the women don't wear anything anyhow?" [Jan. 26, 1921.]

EDUARD THÖNY

# Deplaciert

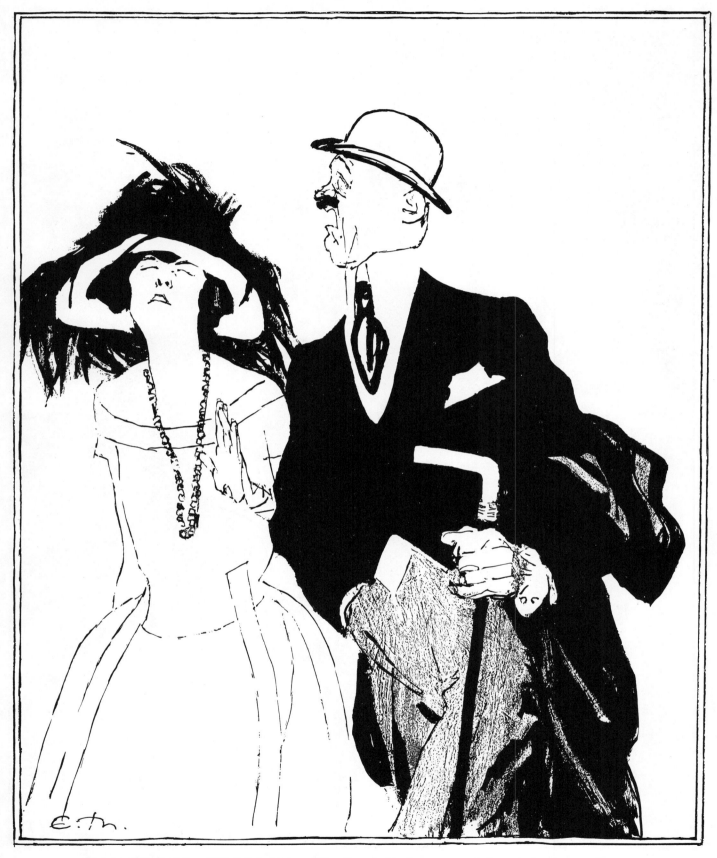

„Auf der Straße laß gefälligst dein ewiges Nörgeln und Zanken — wozu haben wir denn unſer Heim?!"

**Inopportune.** "When we're on the street, please drop your eternal nagging and quarreling. What have we got a home for?" [Sept. 9, 1921.]

# Frau En-gros-Schlächter

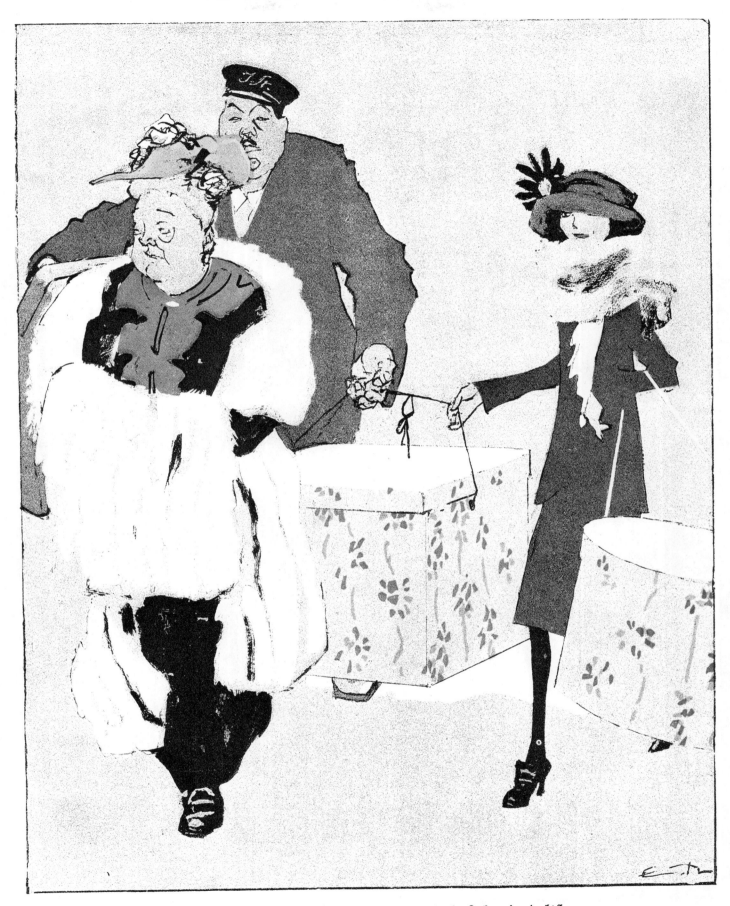

*„Ich habe mich jetzt mit modernen Kostümen auf zehn Jahre eingedeckt."*

**The Wife of the Wholesale Slaughterer.** "Now I've provided myself with up-to-date outfits for the next ten years!" [Nov. 9, 1921.]

EDUARD THÖNY

# Heimkehr nach Paris

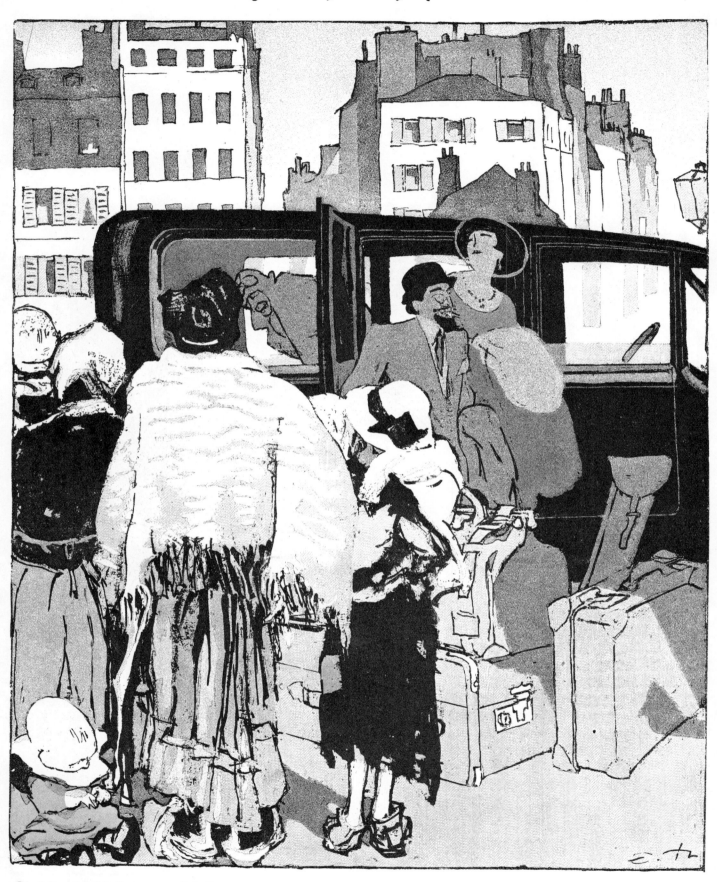

„Die haben sich fein herausgemacht! Die waren bei einer Kommission in Deutschland!" — „Nur Geduld, Germaine, unsre Männer kommen alle noch dran."

EDUARD THÖNY
158

**Back Home in Paris.** "They made out well! They were on an official committee in Germany." "Have patience, Germaine, our husbands will all have their turn." [Apr. 5, 1922.]

# Irma

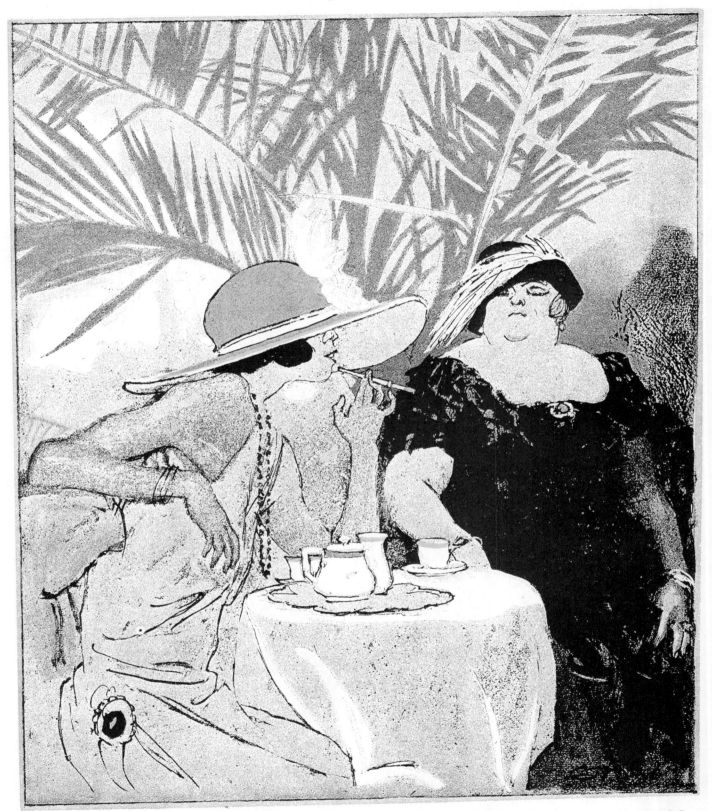

„Wat willste? Ick mache dir jederzeit wieder eene solide Dame. Die jefallene Mark hat sich ooch wieder uffepäppelt."

**Irma.** "What do you want? At any time I can make a respectable lady of you again. Even the fallen mark was coddled back to health." [May 12, 1924.]

# Wenn wir Toten erwachen

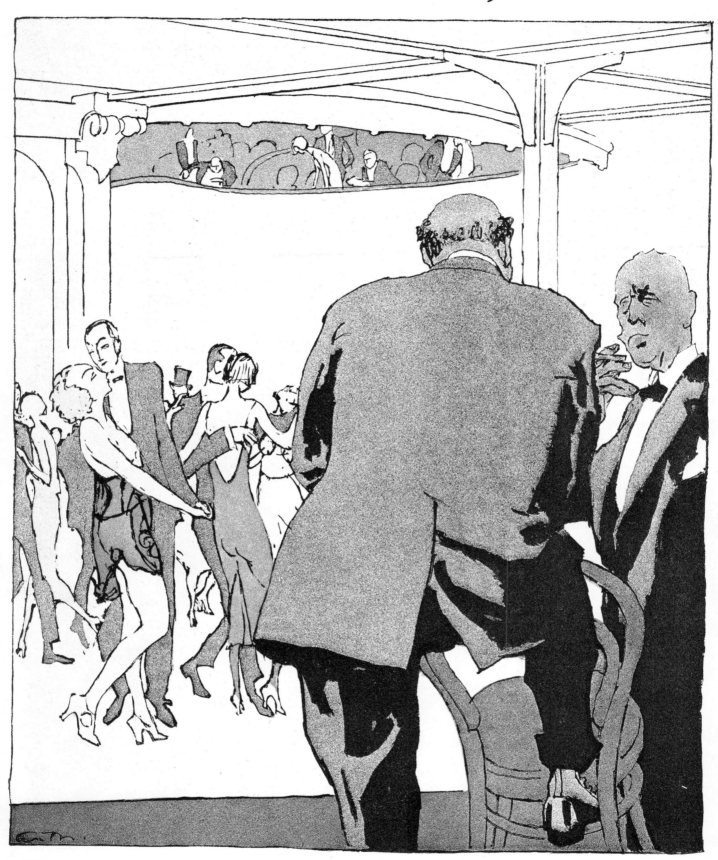

„Früher waren einem Korsetts und Dessous im Wege — jetzt wär alles recht, aber man kann keinen Gebrauch davon machen."

EDUARD THÖNY
160

**When We Dead Awaken.** "In the past, corsets and underwear got in your way. Now that's no problem, but we're not up to it anymore." [The heading is the title of an Ibsen play.] [Feb. 9, 1925.]

# Konkurrenten

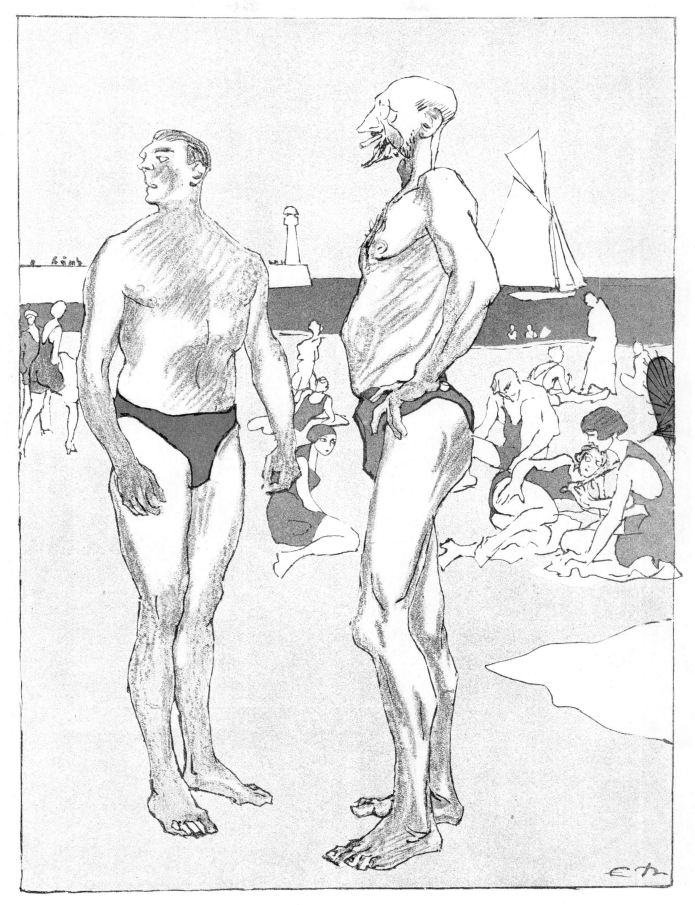

„Sie sind fein heraus — Ihre Vorzüge sieht sie auf den ersten Blick. Ich kann mir mein Scheckbuch leider nicht an die Badehose stecken."

**Rivals.** "You're better off—your assets are visible at first glance. Unfortunately I can't attach my checkbook to my bathing suit." [May 25, 1925.]

EDUARD THÖNY

161

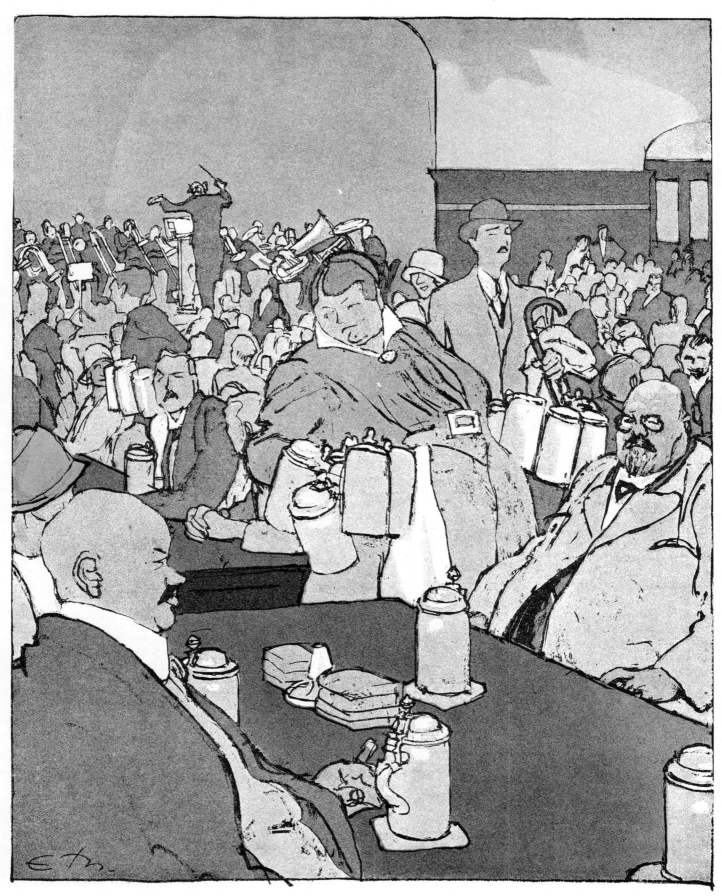

# Ehrt eure deutschen Meister

„Wagner kann man bloß in München hören — in Bayreuth gibt's nur in den Pausen Bier."

EDUARD THÖNY
162

**Honor Your German Masters.** "Munich is the only place to hear Wagner. At Bayreuth they serve beer only during the intermissions." [The heading is a quotation from *Die Meistersinger.*] [Aug. 24, 1925.]

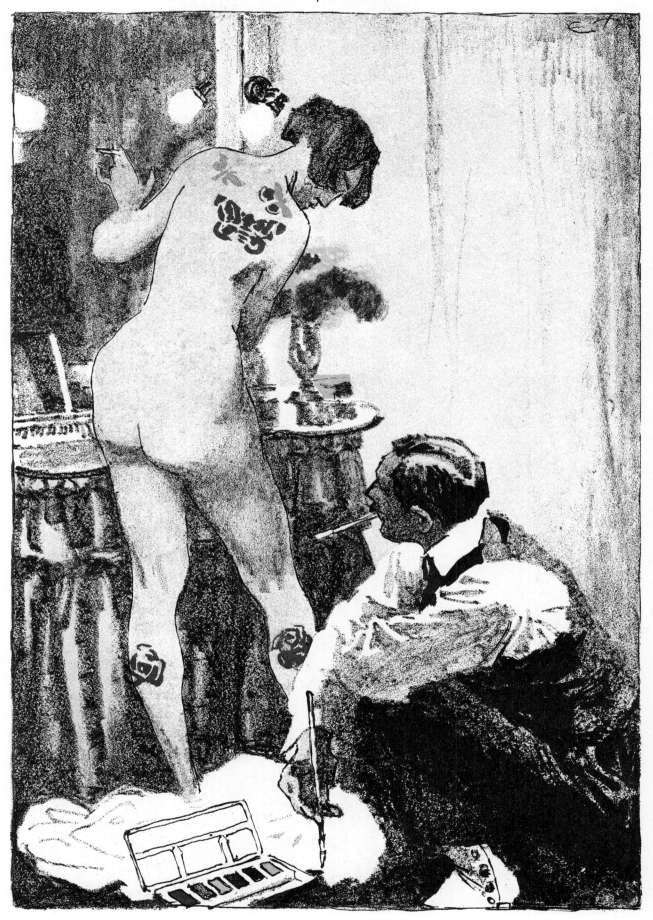

*„Nicht zu lebhafte Farben, bitte — ich habe Trauer!"*

**The Dress Designer.** "Don't make the colors too lively, please. I'm in mourning." EDUARD THÖNY
[Nov. 2, 1925.]

# Berechnung

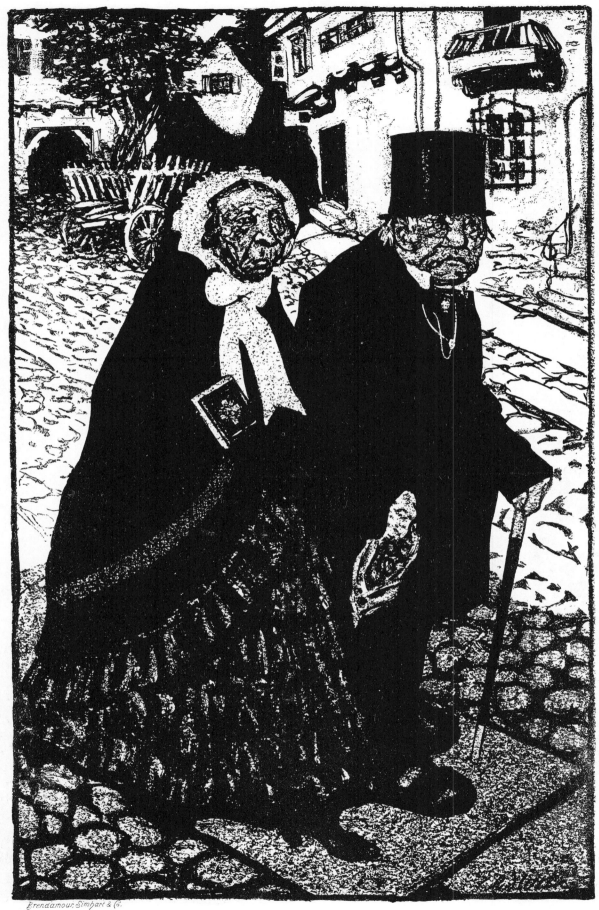

Brendamour, Simhart & Co.

"Dat 's doch 'ne Sün'n un 'ne Schan'n, Mariken, dat hützudag so wenig Lüd' in 't Gotteshus gah'n." — „Dat 's ganz recht, Jochen; denn kummt up unsereens mihr, wenn de leiwe Gott sin Lohn verdeelt."

RUDOLF WILKE
164

**Calculation.** "It's a sin and shame, Mary, that so few people go to church nowadays." "That's all right, old man. Then our sort will get a bigger share when God distributes His rewards." [Vol. IV (1899/1900), No. 40.]

# Ein Philosoph

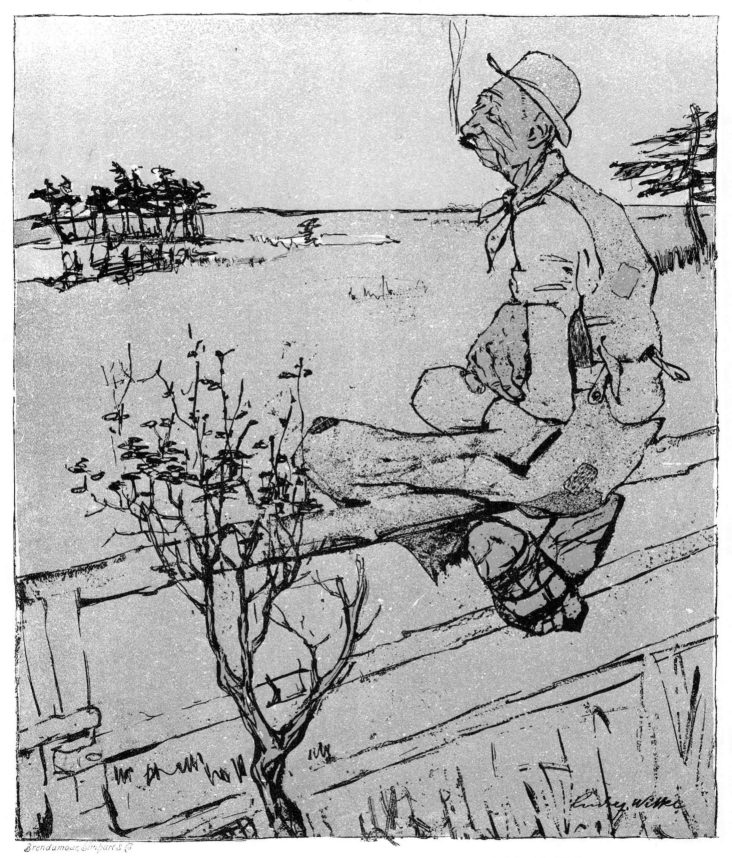

Brendamour, Simhart & C?

„Wenn ick Jeld hätte, wär' ick 'n „Lebenskünstler' — so bin ick man bloß 'n „Strolch'."

**A Philosopher.** "If I had money, I'd be an 'expert at organizing my existence.' This way, I'm just a tramp." [Vol. VI (1901/2), No. 40.]

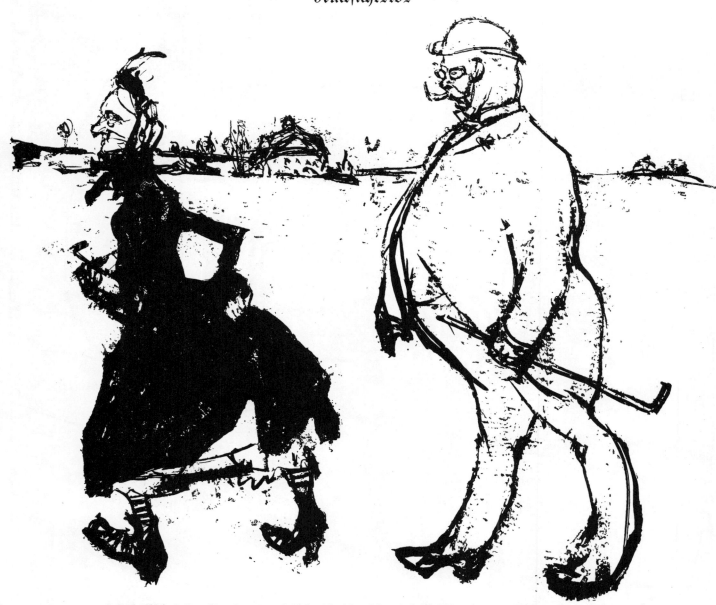

Rückſichtslos

„Laß die Röcke fallen, Auguſte; es muß doch nicht jeder ſehen, daß ich dich wegen des Geldes geheiratet habe.“

**Inconsiderate.** "Drop your skirts, Augusta. Everyone doesn't have to see that I married you for money." [Vol. VII (1902/3), No. 15.]

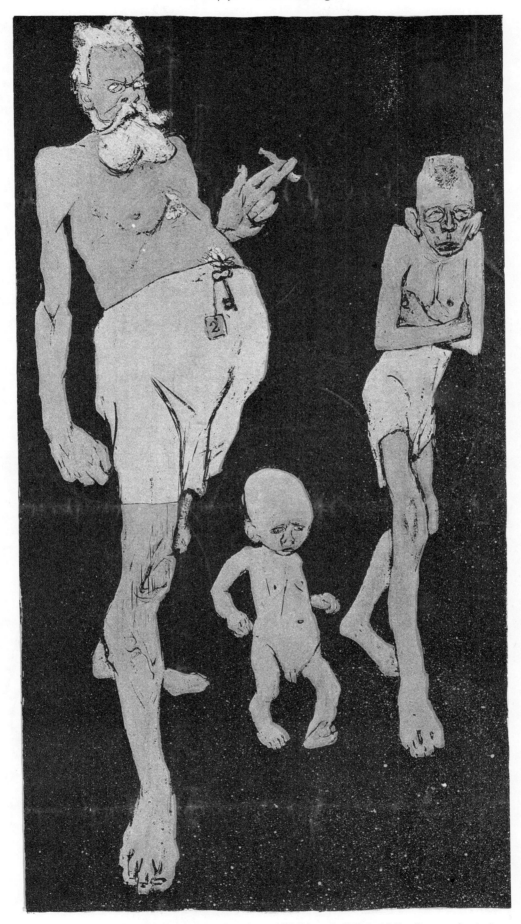

„Beim Betreten eines Schwimmbades denken wir unwillkürlich an die Schlacht bei Arausio, wo unsere tapferen Vorfahren durch den bloßen Anblick ihrer Leiber den Schrecken der Römer erregten."

**A National Memory.** "Upon entering a swimming pool we involuntarily recall the battle of Arausio, in which our brave ancestors frightened the Romans by the mere sight of their bodies." [Arausio, now Orange in France, was the site of the defeat of a Roman army by Germanic tribes in 105 B.C.] [Vol. VII (1902/3), No. 24.]

RUDOLF WILKE

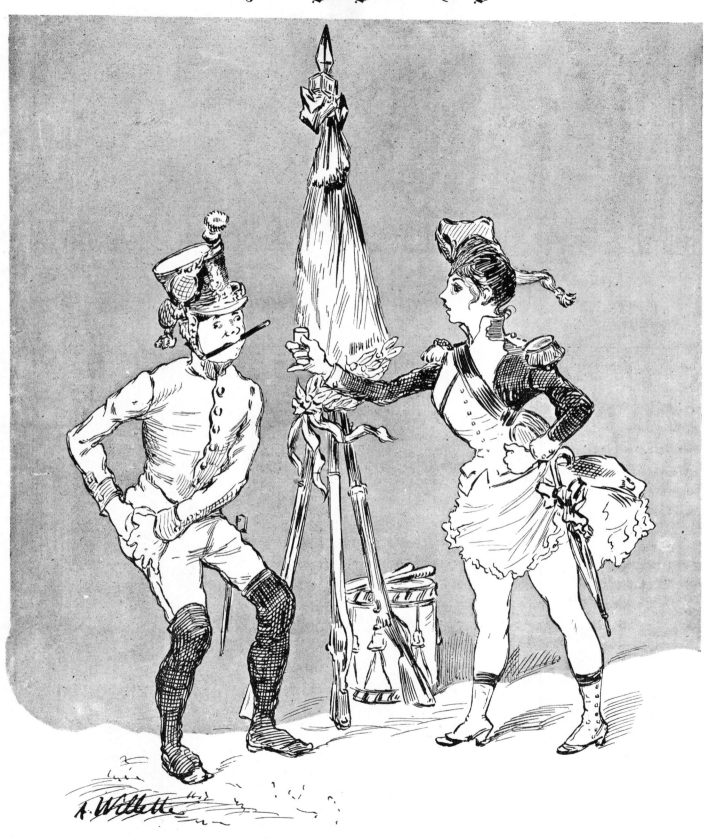

ADOLPHE WILLETTE
168
      **Out of the Past.** [The illustration accompanied a translation of Béranger's "Le roi d'Yvetot," a song about a popular monarch.] [Sept. 19, 1896.]

# Frau Storchens Ruhetage

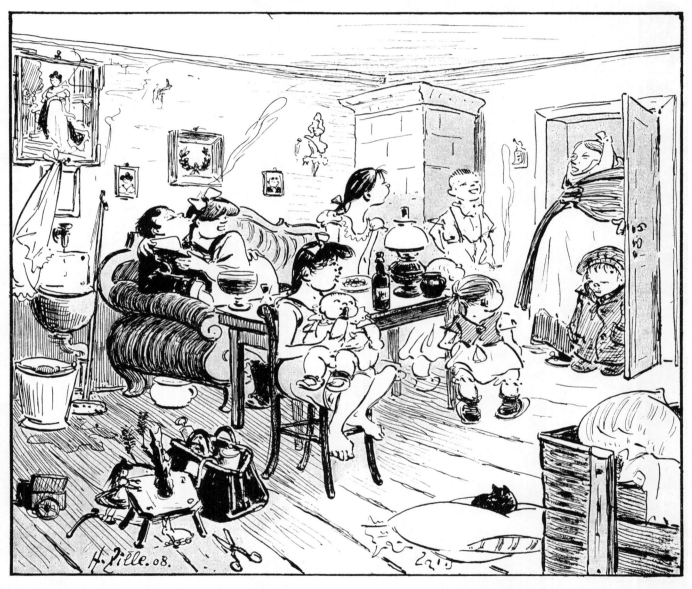

„Wo is denn eire Mutter, Kinder? Is se uff Kundschaft?" — „Uff Muttern kenn Se dies mal nich rechnen, die sitzt schon drei Wochen, die hat Mißgeburten jemacht."

**Mrs. Stork's Days Off.** "Where's your mother, kids? Is she out reconnoitering?" "You can't count on Mother this time. She's been in jail for three weeks now for performing abortions." [Jan. 18, 1909.]

# Pause

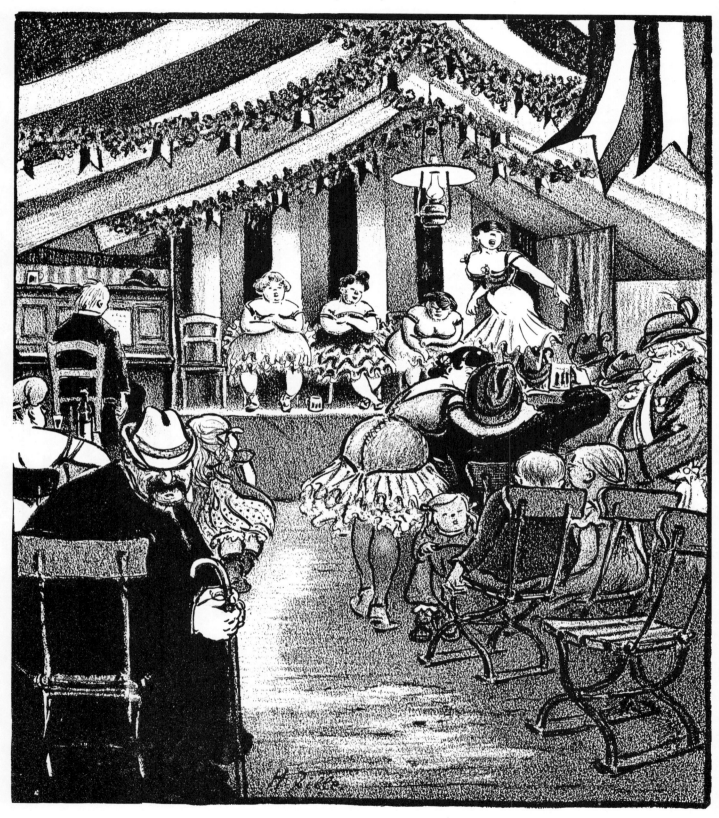

„Frau Direkter! Uff de Jarderobe is schon wieder ken Eimer!"

**Intermission.** "Boss! There's no pail in the dressing room again!" [It is a lady boss or a boss's wife who is being addressed.] [May 30, 1910.]

# Das Talent

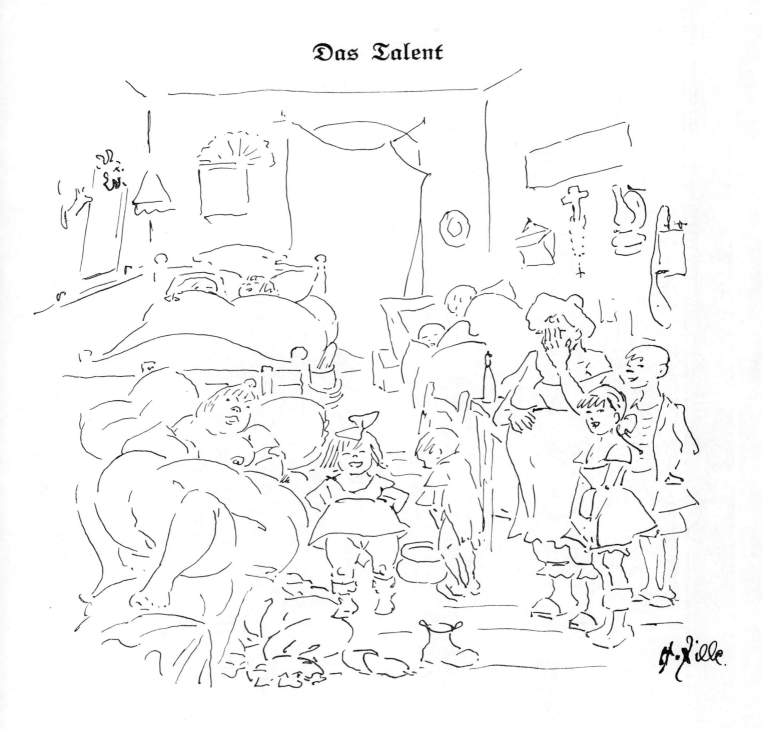

**The Talent.** [The illustration accompanied a brief text by the artist about this unsavory household. The "talent" is the five-year-old girl, who can already sing off-color songs.] [Aug. 20, 1923.]

# Patzkopps Mariechen

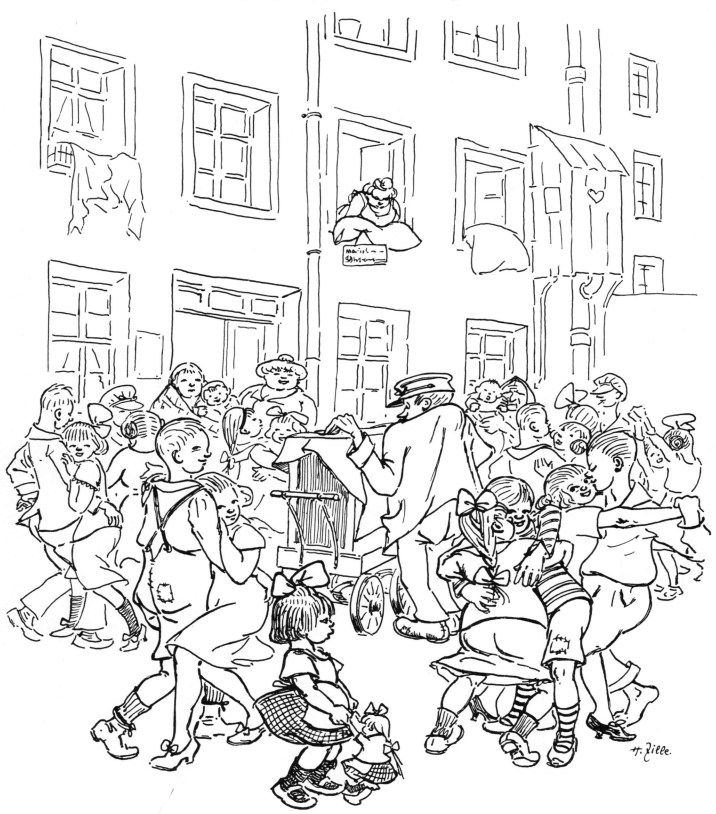

„Jott nee, wat der Maxe for ne kesse Sohle tanzt!"

**Little Mary Patzkopp.** "Gosh, what a nifty hoofer that Maxie is!" [Dec. 3, 1923.]